ALTERNATIVES TO PUNISHMENT

Solving Behavior Problems with Non-Aversive Strategies

Gary W. LaVigna
and
Anne M. Donnellan

 Irvington Publishers

Irvington Publishers
Customer Service and warehouse
1-800-218-1535 - Fax (212) 861-0998

ISBN 08290-5204-6

Printed in the United States of America

The paper used in this publication meets the minimum requirements of American
National Standard for Information Sciences — Permanence of Paper for Printed Library
Materials. ANSI Z39 48-1984

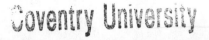

CONTENTS

Figures

Tables

DEDICATION

This book is dedicated to the spirit and memory of these fine professionals who, in the short time available to them, taught us so much about the positive potential of behavioral technology.

John Farmer, Ph.D.

1932 - 1969

Mark Gold, Ph.D.

1940 - 1982

Sandra L. Bailey, Ph.D.

1946 - 1983

ACKNOWLEDGMENTS

As the development of this material has been such a long and arduous process, there are more people to thank than we can publicly acknowledge. We hope this book represents a contribution that makes their efforts worthwhile.

There are some who must be acknowledged individually. First among these is Jeanne L. Connors, friend and typist extraordinaire, who had to be surgically removed from her word processor after the last draft was finished. Thank you! To Charlotte Ahlgren and Ann Johansmeyer-Gutierrez who contributed so much of their time, sparkling intelligence, and editing talent to make this readable, we also owe a deep debt of gratitude. Others contributed their knowledge and skill to proofread, locate references, review and improve various versions of this material. Among the friends to whom we are so very grateful are: Pat and Bill Denkner, Travis Thompson, R. H. deFran, Tom Donnellan, Lynette Fassbender, Bill Gardner, Bob Ahlgren, Rick Mesaros, Pat Mirenda, Nan Negri, and Sue Wassweiller.

Most specially, we want to acknowledge the intellectual debt we owe to Israel Goldiamond, Gary's major professor at the University of Chicago. "Izzy's" brilliance lights many paths. We have traveled down one of them, for the past ten years. This book is a culmination of that journey.

Ultimately, of course, we owe most to our families. To our children, John Douglas Donnellan-Walsh and to Bill, Dina, David, Ayndrea, and Grant LaVigna we offer humble thanks for your love and willingness to sacrifice so much. And, most of all, we thank Gary's wonderful wife, Brenda Pires LaVigna who provided endless love, support, patience, tea and pasta and who never ceased asking "But what's taking you so long?"

PREFACE

Written by professionals, for professionals, and about professional contributions to applied behavior science, this book hits the mark at which it aimed. It provides a comprehensive treatment of alternatives to punishment in dealing with behavior problems evidenced by human beings at various levels of development and in various circumstances. Based upon their own extensive observations and a thorough-going analysis of relevant experimental studies, Gary LaVigna and Anne Donnellan have put together a document that is at once a teaching instrument, a summary of research, and an argument for the use of positive reinforcement in the treatment of inadequate or undesired behavior. It is also, I believe, a book that can be read with profit by psychiatrists, by educationalists, and by clinical psychologists of every stripe—especially those who are acquainted with the basic concepts of present-day behaviorism.

To one who can remember the practical psychology of the twenties and the thirties (or the lack thereof), and the primitive applications of reinforcement theory in the forties, the broad array of methods treated in this book is both illuminating and impressive. We've come a long way and in the right direction. These techniques belong to 1984, but a 1984 without aversive features. Some of them are drawn directly from the animal laboratory—the differential reinforcement of low-rate responding, for example. Others are a step or two removed, as in the chapter on *Instructional Control*; and one or two of them (covert responding and respondent conditioning procedures) will test the limits of acceptance by dyed-in-the-wool behavior analysts.

In *Alternatives to Punishment*, the authors have a thesis to defend, but there is nothing sketchy or simplistic in the way they do it. The problem situations, the individual behaviors, the different pro-

cedures, and the relevant published data all are treated in detail, together with appropriate cautions and suggestions for research. The end result, in my opinion, is a landmark volume which should forever lay the ghost that aversive methods (even the ubiquitous "time out") need to be applied to the delinquent, the retarded, or the normal "learner," whether in the home, the school, the clinic, or other situation. Positive procedures such as those delineated here, when used with some imagination, will do what can be done.

Fred S. Keller

INTRODUCTION

This book is both an ending and a beginning. It is the end product of our effort to identify "normalized" (Wolfensberger, 1972) and non-aversive methods and procedures to deal with a variety of behavior problems presented by learners with severe and often dangerous behaviors.

This book resulted from frequent observations in a wide range of applied settings in which interventions for reducing or eliminating behavior problems most typically involved the use of an aversive procedure. For our purposes, punishment refers to one of two possible operations. The first involves the response-contingent presentation of a stimulus or event. The second involves the response-contingent withdrawal or termination of a stimulus or event. When these procedures result in a decrease in the frequency, intensity, and/or duration of the response, they are punitive (Catania, 1968).

We believed then, and now, that this emphasis on aversive intervention is contrary to the positive and constructive thrust of behavioral psychology. Moreover, it is unnecessary. Given the alternative procedures reported in the literature, we were concerned with the question of why this imbalance appears to exist in the field; that is, why the emphasis appears to be on aversive intervention. One possible explanation is that these alternative, non-aversive procedures have not been as widely known to those responsible for decision making. Professionals tend to use the materials, procedures, and programs most familiar to them (Donnellan, 1980a). We hypothesized, therefore, that to the extent the primary alternatives known to the field are aversive, emphasis would remain on the aversive control of undesired behavior. Since many alternatives are available, this need not be the case. While the accumulation of empirical data from experimental and applied studies varies a great deal among these alternatives, together they represent a formidable

array of options available for consideration by an investigator or practitioner. The decision to attempt a reductive procedure can, therefore, be made within the context of many non-aversive alternatives. (See Footnote 1.)

Upon extensive analysis (LaVigna & Donnellan, 1976), it seemed clear: To enable practitioners to consider a wider range of procedures, it is necessary to make the non-aversive options more visible and available. As a first attempt in this direction, we wrote a paper briefly describing ten alternatives to the use of punishment in behavior management programs (LaVigna & Donnellan-Walsh, 1976). In our work and that of colleagues and associates, we found that attention to these ten starting points typically resulted in the decision to use a non-aversive intervention. In the vast majority of cases, aversive intervention never became necessary. In one of our own studies, for example (Donnellan and LaVigna, in press, the classroom behavior of five autistic and severely handicapped adolescent students was modified with exclusively non-aversive procedures such as differential reinforcement of competing behavior, differential reinforcement of low rates of responding, stimulus control, and information feedback. Throughout the school year all target behaviors, many of them severe, were eliminated or reduced to an acceptable level. When the procedures were phased out, the target behavior did not return nor did there appear to be a substitution of other problem behaviors. An acceptable level of classroom control was maintained for the year without resorting to the use of punishment.

In Donnellan, LaVigna, Zambito, & Thvedt (in press), an attempt was made to reduce serious behavior problems of children, adolescents and adults with developmental disabilities who had been referred to an intensive intervention team as part of an effort to support placement in a community setting. The procedures were implemented in a wide variety of settings, with varying levels of support and skill on the part of the caregivers. The intensive intervention team was able to eliminate or reduce to an acceptable level the problem behaviors virtually without punishment. In only one case out of 16 was it necessary to use even a mild "time-out" procedure. Follow-up measures were taken for almost two years. In most cases the target behavior did not return nor was there a substitution of behavior problems.

Similar experiences have been reported to us anecdotally by many others who read the 1976 papers. These very positive results of our efforts to identify and present some alternatives to punishment, together with the large number of reprint requests we continue to receive so many years later, have convinced us of the contribution a

book could make in disseminating this information to an even wider audience. This book is an effort to expand the earlier work and thus provide a systematic discussion of available non-aversive technology. It is our hope that this work will make available to practitioners a wider repertoire of behavioral techniques and thereby increase treatment potency without continuing reliance on punishment procedures.

Accordingly, this book is also a beginning, since the work cited and described here may provide a stepping stone and point of departure for further, systematic development of a non-aversive technology. Controlled clinical testing, evaluation, and further development is a logical and responsible next step to making these procedures even more widely known, effective and available in natural, non-experimental settings.

The book is divided into two major parts. The first part provides a background for this technology. It presents our philosophical position regarding the purpose of programming as well as some ethical considerations one ought to address in any behavioral change program. Some administrative and legal considerations, including the problems raised by sanctions and guidelines on the use of aversive, behavioral interventions are addressed. Finally, the section includes procedural considerations which, in our opinion, also argue for a non-aversive technology.

The second part, and the bulk of this work, is a presentation of a variety of procedures from the experimental and applied literature which either have been or could be used to bring about the reduction of a wide range of problem behaviors. Most of the chapters have been organized around the following headings: Introduction (which includes definitions and a literature review); Advantages; Cautions; Suggestions for Implementation; and Research Ideas. The material was written for the practitioner who has a solid understanding of the basic principles of applied behavior analysis. (Readers unfamiliar with these principles are referred to one of the fine basic texts available such as Sulzer-Azaroff and Mayer, 1977; or Martin and Pear, 1983).

Non-sexist language was employed to the best of our ability. When we were unable to avoid the use of a general pronoun with a gender reference, we arbitrarily chose to alternate gender by chapter. Hence, odd chapters have female pronouns and even chapters have male pronouns.

While we have attempted to develop a comprehensive presentation of non-aversive techniques for behavior reduction, we do not pretend to have exhausted the topic. In fact, the reader will find an emphasis in our examples and our review of cases involving severely

impaired populations and severe behavior problems. We acknowledge our limitations with the following explanatory points:

1. It is our hope that presentation of the successful application of these techniques to deal with severe disturbance will begin to put to rest the notion that extreme problems call for extremely intrusive interventions.

2. The preponderance of behavior reduction strategies used with severely impaired populations is punitive. Mesaros (1983), for example, reviewed the major behavioral journals from 1968 to 1982. He found that of the 96 articles dealing with autism, 85% of the behavior reduction strategies reported were punitive.

3. Given a choice between examples of the use of these strategies with those who are severely handicapped or with normal or moderately impaired populations, we chose the former as it seemed more likely that our readers would generalize from the most to least severe case.

4. The most challenging problems we experienced professionally involved extreme examples of disturbance.

Nonetheless, we trust that we have provided a sufficient variety of examples that the applicability of these strategies to deal with the behavior problems of virtually any population, normal or impaired, will be evident. Additionally, it is our hope that this material will be useful to a variety of practitioners, including educators, psychologists, psychiatrists and others interested in expanding the use of non-aversive technology. Because of the broad applicabililty of these techniques, we were concerned about the potential confusion of interspersing descripters such as "client," "patient," "student," "child," etc. One alternative, of course, would have been to use the conventional/experimental term "subject." Instead, we wished to emphasize specifically the need to see the individual with the problem as an active participant in the process rather than as a passive recipient of behavioral technology. Therefore, we have chosen the term "learner," which has, for our purposes, at least two advantages. First, it is in keeping with the behavioral literature, which operates from the premise that behavior is learned and lawful. Second, it emphasizes the notion that the person contributes the learning without which the practitioners would have no function. It is our premise that the best program/intervention is one emphasizing a dynamic relationship between the person and the practitioners (Wolf, 1978). Though the term may not be totally adequate, it more closely meets our need. Therefore, except where we are specifically referring to the work of others, or for clarity, we have chosen the term "learner" to refer to any client population.

We hope that by systematically presenting procedures proven successful for reducing the behavior of a variety of learners under many different conditions, we will have contributed to a beginning. If we have succeeded, this work will be but one of a continuing series of books, articles, and studies addressing behavior problems in the context of life style enhancing and normalizing conditions using systematically applied non-aversive behavioral techniques.

Footnote

1. Our use of the phrase "alternatives to the use of punishment" should be read to mean alternatives to the use of aversive intervention in behavior reduction programs, although, technically, aversive intervention is a more inclusive term than punishment. For example, we will not include extinction as one of the alternative options. While extinction may not be a punitive (Catania, 1968) procedure, it can be considered aversive given some of the negative side effects and disadvantages it shares with punishment (Sulzer-Azaroff & Mayer, 1977).

CHAPTER I

ETHICAL CONSIDERATIONS

I. Introduction

The effectiveness of a procedure in reducing a behavior problem of a learner is one of the criteria for its use, but not necessarily the most important. Treatment decisions must also include many complex value issues which cannot be empirically supported by a summary graph (Kazdin, 1975a). Webster (1977) has suggested that the use of punishment raises the kind of basic philosophical questions which concerned Dostoyevsky in *Crime and Punishment* (1966). A central theme in Dostoyevsky's classic is whether anyone has the right to make another suffer even if it seems certain that the suffering will ultimately yield benefit to that person. The issue of whether intervention ends justify means cannot be adquately addressed here. Our purpose is to at least raise awareness of some of the definitional issues and value judgments which lend credence to the central theme in this book—the need to continue to develop and use the non-aversive technology available to us in our efforts to control problems in human behavior.

II. Behavioral Definitions

Before the question of different treatment strategies can be addressed, it is important to discuss some of the factors inherent in iden-

tifying a behavior as "undesirable" and, therefore, a problem to be targeted for an intervention program. At a minimum, these issues should influence which techniques will be used during a clinical or experimental intervention. Among the factors to be considered are: The non-dichotomous nature of definitions such as "undesirable," the relative and conditional nature of such definitions, and the functional value of undesired behavior.

A. Non-dichotomous Definitions

Behavior is not either desirable or undersirable. Rather than being a dichotomy, desirability can be measured on a continuum and behavior has degrees of desirability. The same holds for many other adjectives, such as "appropriate" or "acceptable." Therefore, in defining a behavior in such terms, it is important to understand that one is judging the *degree of appropriateness* of a given behavior. There is always implied in such a judgment an objective standard against which a given behavior can be measured and found to be "undesirable." Degrees of undesirability depend on both the standard chosen and the behavior. For example, one standard might be "life." The question then would be: To what extent is the behavior in question interfering with the quality or quantity of the person's life? Using this as a standard, it should be clear that suicide attempts are highly unacceptable in that they threaten to shorten the quantity of a person's life. Toward the other end of the continuum might be an adolescent's use of obscenities. Such verbal behavior might interfere with the quality of the person's life by antagonizing others in his social arena. However, it clearly would not be seen to be as undesirable as suicide attempts.

The degree of inappropriateness of a behavior has ethical implications for the kinds of intervention procedures that might be used. One could hypothesize, for example, that severe, self-injurious behavior might, in some rare case, justify the use of a highly intrusive, aversive contingency. Certainly, the cursing of an adolescent would never justify such intrusiveness. We maintain that behaviors which are relatively mildly undesirable or inappropriate justify and require non-punitive intervention procedures. The reverse, however, does not necessarily hold. Extremely undesirable behaviors do not necessarily justify and require aversive procedures. Considerations of immediacy and urgency notwithstanding (see Footnote 1), if non-punitive procedures work for one set of behaviors (the midly unacceptable), then they should also be effective for another set (the highly unacceptable). Given two or more effective procedures from

which to choose to reduce or eliminate an undesirable behavior, the least aversive procedure should be used. Moreover, we suggest a similar attitude for research; given two or more possible effective procedures, the least aversive procedure should be investigated first.

B. Relative Definitions

We have suggested that definitions of innappropriateness might be based on the standard of the quality of life. Other standards, however, could also be used, such as "social acceptability," "religious acceptability," or "political acceptability." Standards change from person to person or from group to group. For example, consider an autistic child who has three behaviors which are "undesirable:" overeating of candy, masturbating, and head banging. The degree of undesirability would have to be measured against some standard. If measured against the standard of life, head banging might rate as the most unacceptable. Candy eating, which could contribute to obesity and dental caries, would also be undesirable but less so than head banging. Masturbation would have a low degree of unacceptability—except, of course, for those who think it causes blindness. If however, "religious acceptability" is the standard, masturbation could be viewed as the most unacceptable of these behaviors. Head banging could be considered an acceptable form of "self flagellation" by some extremist sects, while candy eating, since if falls within the general category of gluttony, might be moderately unacceptable. Finally, using a "social rules" standard, the ranking of these three kinds of behaviors would depend on where the behavior took place and whether or not the citizenry was forced to witness it.

Even in circumstances where life itself could be threatened, there appears to be no absolute standard to apply; behaviors cannot be judged independent of the conditions under which they take place. Few citizens, for example, would deny that murder is wrong and should be eliminated. Yet, it would be extremely difficult to persuade a group of people to agree on a brief all-inclusive definition of murder, as witnessed by the ongoing public and private debates about abortion, euthanasia and capital punishment. The determination of what constitutes "murder," therefore, is based not on the actual response, nor even necessarily on the imputed motivation of the individual, but on circumstances surrounding the behavior and societal attitudes regarding the victim.

The standard being applied, the relative appropriateness of a given behavior, and the conditions that surround that behavior

should all influence the decision-making processes of the clinician, teacher or other practitioners. We have cited these examples to underscore that decisions about changing another's behavior contain a certain and inherent subjective value judgment. Thus, the value system of the practitioner, the society and, of course, the learner must be acknowledged in judging whether a behavior is unacceptable and which procedures should be used to reduce that behavior.

To the extent that a targeted behavioral change is consistent with the values of the individual—that is, she wants the change to take place and has solicited your help in achieving it—then aversive procedures might be used if 1) she understands the nature of the procedure, 2) she agrees to its use, and 3) no less aversive procedure is effective. To the extent that a targeted behavioral change is inconsistent with the values of the individual or her guardian, then there is no justification for the use of aversive procedures. In this latter case, positive reinforcement procedures should be used; that is, you must make it worth the person's while to make the desired change. Both cases call for a full command of the available alternatives to the use of punishment.

C. Functional Definitions

Obviously, a good deal of reflection must go into determining by which standard and to what degree a given behavior is maladaptive or inappropriate. Having made that determination, and before any intervention takes place, it is then important to analyze the behavior to determine what functions it might serve for the individual. The function might, in fact, be very appropriate. Many of us have had experience dealing with a child engaged in absolutely horrible behavior, to the point of doing great physical damage to himself or to others in order to receive some measure of attention and/or affection (Lovaas, Frietag, Gold, & Kassorla, 1965). In such a case, the goal of the learner's behavior must be available to her under other conditions. Obviously, conscientious clinicians would assume the necessity of such a functional analysis for procedural reasons (see Chapter III), but the ethical considerations are important as well.

III. Procedural Evaluation

As judgments about human behavior are complex and value laden, the process of choosing an intervention procedure also involves complex ethical considerations. Accordingly, the following

discussion addresses the non-dichotomous evaluation, the relative and conditional value, and the functional value of a procedure.

A. Non-dichotomous Evaluation

As behavior falls on a continuum of desirability, so a procedure falls on a continuum of value. Procedures are not dichotomously good or bad; rather, their place on a continuum is based on the standard of measurement being used. Against what standard should the value of a procedure be measured? Again, many say that a procedure should be measured by its effectiveness. We find this to be a limited and naive way to evaluate procedures because of questions inherent in defining procedural effectiveness, the relative effectiveness of different procedures, and the limitations inherent in using efficacy as the sole standard of evaluation.

Determining procedural efficacy is a complicated business involving many factors (Homer & Peterson, 1980). At a minimum, these factors include the speed with which the behavior problem can or must be brought under control, the generalization of this effect across other (in this case, undesired) responses, across other stimuli and conditions (such as other people, places and activities), and across time.

Another important aspect of efficacy is the issue of "side effects" such as aggression, avoidance behaviors, and other emotional reactions. Kazdin (1975a) comments, "Even though the target behavior may be eliminated, other consequences resulting directly from punishment may be worse than the original behavior, or at least be problematic in their own right." Certainly, if a procedure were effective in reducing property destruction but brought with it the side effect of serious aggression, then, all other things being equal, it could be considered less effective than an intervention which did not have this "side effect."

B. Relative Definitions of Procedural Effectiveness

In choosing an "effective" procedure, the question is not only how effective, but also how effective *in relation to the available alternatives.* Unfortunately, not all of the relevant aspects of a procedure are considered, investigated, and reported in the literature. This makes it difficult to accurately place procedures on a continuum of effectiveness in relation to one another. More often than not, speed of effects is the only aspect considered and we find ourselves selecting one procedure over another simply on this basis. In addition to knowing the

rapidity with which we can expect a procedure to work, we should know what we can expect in terms of generalization of these effects across responses, stimuli, and time, and then possible side effects. Otherwise, our decisions are made on the basis of partial and incomplete information. We should be particularly cautious about this incompleteness when choosing an intrusive intervention.

The problem of partial information concerning effectiveness is further compounded by the fact that punishment procedures have been studied and reported to a greater extent than have the available alternatives for reducing problematic behaviors (Kazdin, 1975a; Gardner & Cole, 1983). The number of studies offering partial and incomplete information about punishment procedures is greater than those offering information about non-aversive procedures (Benasi, 1976). We believe that this difference has created the false impression that punishment is more effective than the available alternatives. We also consider it unfortunate that many procedures are ethically defended on the basis of this impression. This book presents information to strongly challenge this position.

Further, while effectiveness is an important consideration, other values should be considered as well. The intrusiveness, restrictiveness, and social acceptability of an intervention are also among the standards that should be considered in selection. One could argue, for example, that a locked iron mask would prevent nail biting, but the law and common sense would argue against such an intrusive intervention. It is, perhaps, the use of effectiveness as the sole criterion for selecting a procedure that partially accounts for much of the public outcry against behavior modification in general and punishment in particular in behavior management programs (Clurman, 1983). Greater attention to these additional considerations is warranted and would result in greater utilization of non-aversive internventions (see Chapter II).

Obviously, the evaluation of restrictiveness, aversiveness, or social acceptability is no simple process. In ordering stimuli on a continuum of aversiveness, for example, we immediately run into the problem of individual differences. A highly aversive procedure for one person may be only mildly aversive or even reinforcing to another. A classic example of this is the procedure of isolating a person from social contact for a brief period of time as a consequence to an undesired response. For one individual, this may represent timeout from (social) reinforcement. Accordingly, the event would be aversive and its implementation would have a punishing or decelerative effect on the rate of target behavior. For another person, the same intervention might constitute "escape" from an aversive situa-

tion. Consequently, the event would have a (negatively) reinforcing or accelerative effect on the rate of the target behavior. Considerations of intrusiveness, restrictiveness, and social acceptability frequently lead to the decision to use a non-aversive intervention if the information about such interventions is readily available. Ethical decision-making should take these factors into account.

C. Functional Value of Procedures

In choosing a procedure, we must always ask what the intervention contributes to the life of the learner. It is not enough that it reduces the behavior problem. If our only interest were the elimination of behavior problems, we would need to use nothing more than a "flaming arrow through the heart," a very effective reductive procedure, to be sure. Rather, the emphasis in the evolving field of behavior modification has been on the development of more adaptive and desired behaviors. Our goal as a profession has not been to create non-behaving people but rather individuals who are more effective in leading their lives with dignity and happiness as independent and productive members of society. When we select an intervention, we are obligated to ask ourselves in what way this contributes to positive growth (see Footnote 2).

All other areas of consideration being equal, we want to select the intervention that can contribute most to the learner's skills and competencies. For example, practitioners are frequently faced with the problem of aggression on the part of some learners who use this response to get their own way. In such situations, a program to teach assertiveness skills would be evaluated as a more favorable intervention strategy compared to an intervention that merely punished that response (see Chapter IV). In fact, we might be willing to give up some speed of effect for an intervention that is highly constructive and contributes significantly to the learner's expanding repertoire of socially acceptable skills and competencies.

IV. Summary

We conclude, then, that careful attention to ethical considerations supports the utilization of a non-aversive technology for behavioral interventions. As delineated in the following chapter, however, such an approach may also be required of the field because of administrative and legal considerations.

Footnotes

1. A number of training manuals and programs have been developed which teach staff how to physically manage assaultive and destructive behavior in an effort to minimize injuries (e.g., Palotai, Mance, & Negri, 1982; Zivolich & Thvedt, 1983). The techniques taught are not intended to be behavior reduction procedures. They are and should be considered emergency intervention procedures intended merely to establish control over an unsafe crisis situation. In fact, an emergency procedure may have an inadvertent punitive or even reinforcing effect on the problem behavior in question. Given the philosophy expressed here, we recommend minimizing any unavoidable aversive component and, obviously, any possible reinforcing component. Crisis procedures should therefore be as neutral as possible in establishing safety. Strategies to reduce the behavior problems over time should be reserved for the behavioral treatment technique specifically designed for that purpose.

2. The question of constructive contribution may be difficult to answer for practitioners in an institutional or other setting providing limited opportunity for the learning and maintenance of socially appropriate and functional skills. In a setting devoid of these opportunities, efforts to reduce behavior problems might not only be programmatically difficult but ethically untenable.

CHAPTER II

ADMINISTRATIVE CONSIDERATIONS

I. Introduction

Practitioners in the field of behavior modification are recognizing more and more that in addition to the ethical/philosophical considerations for developing, identifying, and carrying out non-punitive behavioral interventions, there is a host of administrative and legal issues supporting the development of such techniques. These issues are of concern for all practitioners, but particularly for those who work in or administrate publicly funded programs. This chapter addresses some of these, including: the increasing regulation of the field by administrative and legal bodies, clients' rights, legitimacy, consent to treatment, and the administrative implications regarding personnel competency to use potentially harmful interventions.

II. Regulation by Responsible External Agencies

Many practitioners are questioning the growing regulation of behavior modification. Goldiamond (1975) offers one explanation of this development. In a commentary written for the Arizona Law Review entitled "Singling Out Behavior Modification for Legal Regulation," he related the story about the drunk who was observed on all fours circling the only illuminated lamp post on a dark street.

A patrol car stopped and a policeman stepped out. The drunk explained that he was looking for his keys. Where had he lost them? "Oh, somewhere down the block," said the drunk, pointing to the dark street. Then why was he looking here? "Where else can I search, Officer?" was the indignant reply, "It's the only place that's lighted."

We certainly concur with Goldiamond's suggestion that behavior modification is under close scrutiny to the point of regulation because of the clarity and explicitness with which it describes its goals and procedures. In addition, however, it should not be denied that many violations of human and civil rights have been perpetrated in the name of "behavior modification therapy." Because it is not possible to certify persons to enable them to use the procedures, the ill-informed and poorly trained often abuse from ignorance. Anyone can become a self-styled "behavior modifier." Nonetheless, even those who are well trained and licensed in their field, and who ought to know better, occasionally have been found to violate standard professional practices and even good sense in the use of some behavioral procedures (Martin, 1979).

One concern about the "singling out" of behavior modification for regulation is that if it becomes too difficult to employ behavioral techniques, more and more practitioners will resort to other practices which may amount to a restrictive dead end for the learner. Instead of using an effective behavioral intervention for severe aggressive behavior, for example, staff may choose to use restraints, thus limiting the potential of the learner to acquire other skills and appropriate behavior. Similarly, it is easy to imagine that if programs find it administratively too cumbersome to use behavioral technology, they will likely increase the use of tranquilizers and other chemical restraints for client control. It can then be argued that regulation ought also to scrutinize other intervention practices. We are particularly concerned with those which appear more benign but restrain learners either physically or chemically without also teaching them more appropriate ways to function in their environment.

Regardless of whether the regulation of behavioral technology is fair or appropriate for the practitioners or learner, regulation appears inevitable. Unfortunately, regulations and guidelines will not solve the problem of abuse. Even the best developed attempts to guide or regulate clinical practice have limitations. Among these are at least the following:

A. Any regulations of human behavior meant to cover a broad area geographically and politically will have to be broadly written to encompass as many unique situations as possible. Therefore, those who administer the regulations will also be those who must interpret them. Whenever the interpreter is excessively permissive or restrictive, abuse of learners (in terms of the developing right to effective treatment as well as right to freedom from abuse) is likely to continue.

B. The judicious use of behavioral principles has resulted in an enormous positive contribution to the welfare of many thousands of citizens. "Judicious" means, however, just that, and the individual judgment of the conscientious practitioner is essential for positive therapeutic gain. It is not possible through regulations to ensure this kind of judgment. It is, however, possible to so restrict the professional that the exercise of clinical judgment is severely curtailed. Regulations or guidelines which are overly prescriptive are likely to have this effect, to the detriment of the learner.

C. The tendency following the application of "minimal standards" is for poorly informed persons to design programs which are "minimally" acceptable.

D. Regardless of the restrictiveness of the regulations or guidelines, unscrupulous persons will find ways to avoid legitimate oversight and monitoring of their programs. We are acquainted with a program which operated in a state hospital where strict human rights and human subject regulations existed, overseen by a human rights committee of staff from other hospital units. In this particular unit, the entire therapeutic intervention technology, in fact the entire program, consisted of the contingent application of electric shock for a variety of severe behavior problems. The sparsity of data, barren nature of the environment, and lack of positive programming could not possibly have met the standards of most regulations or guidelines. Upon investigation it was noted that the human rights committee had been implicitly threatened that attempts to interfere with the operation of the "behavior modification" program would result in severely disturbed clients being denied access to the treatment in question. Therefore, under pressure from their staff and superiors from their own units, members of the human rights committee neglected the ethical and other problems in the shock program.

E. We can attest from our own attempts to develop guidelines for the use of aversive procedures for the state of California

11

(Bronston, 1979) that it is essentially impossible to please everyone concerned. The mere mention of the topic of aversive intervention will raise an alarm among those who are concerned about "clockwork orange" control. Likewise, practitioners are often reluctant to allow any monitoring or regulating of their behavior. One side sees that the regulations "condone" abuse; the other sees that regulations can eliminate effective treatment. The result often is regulation which either does not present sufficient safeguards or is so cumbersome that it can neither be used nor enforced.

F. We argue that some of the greatest abuses against learners in our mental health/education delivery systems come not from inappropriate utilization of behavioral intervention but from the lack of application of such technology in situations that clearly warrant it. Such "sins of omission" can be observed in programs which make no legitimate demands on a particular learner because to do so requires programming, intervention, and staff effort. Thus, many learners in schools and other institutions are allowed to languish because this is easier for the staff. At a minimum, therefore, guidelines ought to include a provision identifying non-intervention as another possible violation of the learner's human and civil rights. Without this provision, the imposition of regulation is likely to increase the possibilty that no treatment will occur, or that administrators will proscribe the use of certain interventions due to the difficulty in meeting the guidelines. As mentioned earlier, this is also likely to increase the risk that chemical or physical restraint will be the treatment of choice.

Regardless of the form in which regulation comes, and regardless of the usefulness of a set of guidelines or lack thereof, regulation is upon us. It is thus clearly incumbent upon the field to develop and make available to practitioners a wider variety of non-aversive intervention strategies which are able to meet high professional standards but which do not raise some of the major ethical and political questions inherent in the use of punishment procedures.

III. Client Rights and Administrative Responsibility

In addition to legislation restricting the use of behavior modification technology, there is a growing body of legislation and case law regarding the rights of clients in residential and day treatment

centers and schools. Many of these laws and judicial findings raise highly complex legal questions beyond the scope of this work. The reader is, instead, referred to the work of Martin (1979 and 1980), and Perlin and Martin (1980) for a review of these issues.

Our concern here is with the *spirit* of the law. Beyond even the ethical questions already noted, we who function as program administrators and other practitioners have the responsibility to be our clients' advocates. Often we are the people most familiar with the needs of the learner and the activities of the program. In some cases there are no other advocates, or the existing advocates are ill informed. An effective program takes an affirmative stand for the protection of client rights far beyond the exigencies of meeting regulations or avoiding lawsuits. Nowhere is protection more essential than in programs concerned with reduction of behavior.

Practitioners in such programs need to be aware of the legal notion of a balance between the good that can be obtained and the means the state (Footnote 1) can use to achieve that good. This is known as the "less drastic means" test (see Martin, 1979, for a discussion of this important concept). The practical implication for those concerned with altering human behavior is that the more intrusive, restrictive, or potentially stigmatizing the intervention to be used, the greater the attention to be paid to client rights.

Most of us are aware of client rights in regard to procedural due process. As client advocates, however, we know that it is possible to meet all the regulatory requirements for giving notice and gaining consent, yet not really protect the client. For example, the Individualized Educational Program (IEP) process can be used to place a child in a minimally acceptable classroom because that is all that is available. In terms of behavioral intervention, in particular, advocates must look beyond procedural protection and at least address issues such as legitimacy and truly informed consent.

A. Legitimacy of Intervention

For the purpose of our discussion of behavior reduction, legitimacy will be addressed in terms of issues related to the behavior itself and the setting in which it occurs.

1. The behavior. As practitioners, we must continually address the question of whether or not the particular behavior we wish to change falls within the purview of our program. For example, changing the assaultive behavior of an adolescent might well be an appropriate goal of a program for "emotionally disturbed"

learners. However, there is serious question as to whether it is within the purview of a program to set up a "gender indentification program" because the learner appears to have homosexual tendencies. Even if serious consideration leads one to believe that sexual preference is a legitimate program concern, a decision to use an aversive intervention to affect sexual preference would raise further issues of legitimacy. An even higher standard might be required to protect the rights of the learners.

2. *The setting.* Practitioners frequently find themselves in a position of dealing with a behavior which is either produced by the setting or is problematical only because of some characteristic of the setting. For example, the tendency of our human service systems is to place persons homogenously. In the case of individuals with severe behavior problems, the logic of homogeneity (Brown, Neitupski, & Hamre-Nietupski, 1976; Donnellan, 1980b; 1984) can have a synergistic effect in which one person's behavior "sets off" another and the net effect is far worse than if the learners were in different settings.

Similarly some settings are so barren, poorly staffed, ill-organized or inherently restrictive, that behaviors which would be fairly inconsequential elsewhere take on great importance. The aggressive behavior of a large adult who receives "attention" by pushing others becomes far more dangerous if he has been placed among non-ambulatory persons who cannot defend themselves or avoid the aggressor. The learner who masturbates publicly may not have access to privacy in a given residential setting. Before a procedure is implemented to deal with a behavior, it should be established that the behavior is legitimately related to agency goals and that it is not a function of the setting. The use of an aversive intervention in these instances requires an even higher standard of legitimacy. For example, use of a "stimulus control" procedure (see Chapter VIII) to teach a learner to masturbate only in privacy certainly raises different questions about client rights than use of a punishment procedure to deal with the same behavior.

There are many other issues related to the legitimacy of intervening in a learner's life, some of which are discussed under other topics in this book. At a minimum, however, the state of the art in terms of kind and quality of services to meet a wide variety of learner needs, and the fluctuating standards of "appropriate" or "abnormal" behavior raise serious questions about the legitimacy of much of what we do in human services. Certainly, many of these conditions are beyond the control of the individual practitioner. Just as certainly, however, they lend further impetus to the need to

develop "less drastic means," such as non-aversive strategies, for altering human behavior.

B. Consent to Treatment

It should be noted at the outset that some interventions, even those considered procedurally "aversive," are so minimal that they probably do not require specific consent. Rather, they often can be routinely handled through a person's Individual Education Plan (IEP) or Individual Habilitation Plan (IHP) or could readily be defended as routine program management. For example, having a student repair a sloppily done assignment after school hours, or having an adult learner who is working too slowly finish kitchen chores before watching TV would seldom require special notice and consent. If, however, the same student or learner rarely was able to play or watch TV because of such restrictions, the situation might warrant due process procedures. Every case is different, of course, and some clearly merit special consideration while others generally do not. It is analagous to a situation in which medical staff might not have to seek written consent to remove a splinter from a child's finger; however, removing a similar splinter from a child's eye could be considered surgery and require a different level of protection for the staff. Again, the more intrusive the intervention, the higher the standard of protection which must be met.

Most regulations and laws governing programming for persons in need of behavioral intervention refer to the need for informed consent to protect the client's right to refuse treatment. Minimally, this requires that a person agreeing to a given procedure (or the person's representative) be informed of the risks, problems, and evaluation strategies involved in the procedure. In addition, there is implied in the presentation of the procedure to be used that it is the least instrusive procedure likely to bring about the required effect. Administratively, we contend that this raises at least the following questions:

1. How informed is the informant?

Practitioners need to assess their own knowledge (and staff knowledge) about the specific procedure in question and any other procedures already attempted. Often, for example, people believe that "time-out" is the only effective deterrent for a given behavior when in reality it is merely the only procedure they know (Donnellan, 1980a). In such a case, they may not be qualified to obtain informed consent because they are unable to provide appropriate information to the consentors. Similarly, program personnel

should document for the learners or their representatives which less or non-aversive alternative procedures have already been considered, tried, or rejected. If they have never learned about such procedures, they are unlikely to be able to share that information in the process of obtaining consent. The question for the practitioner/ administrator then is not only "Have the consent forms been completed?" but "How informed is the informant?"

2. How competent are the practitioners?

When the issue is a behavior reduction procedure with the potential to harm the client physically or emotionally, it is presumed that in obtaining consent the program is assuring that the practitioners are qualified to implement the intervention appropriately. The burden, therefore, is on the administration to indicate how they know the staff are competent, how the staff acquired the competencies, how the competencies were documented, how the procedures are documented, supervised, and evaluated, and the competencies of the persons performing those tasks. The list can be endless, and most attempts to deal with the issue of staff competencies to use aversive interventions have been less than perfect (e.g., Minnesota Department of Public Welfare Rule 40). The need to obtain truly informed consent before initiating an intrusive behavioral intervention has provided further impetus to the development of behavior reduction strategies which are alternatives to punishment.

3. How free is the consent?

Consent for any intervention procedure ought to be given freely and without pressure. Yet, in reality, the very need for an intervention is often prompted by desperate situations. Parents and/or guardians, for example, may agree to a given intervention or class of interventions because they are concerned that the continuation of the child in a given program is contingent upon their agreement. Even if staff do not mean to give such an impression, the reality may be that the parents are intimidated, as no alternative programs exist in their area. Similarly, the most conscientious of administrators may find themselves faced with a situation in which a given procedure is the only approach that they believe can work. Wittingly or not, they are likely to place pressure for consent, since the alternative is to keep the child in the program without treatment, in which case he could worsen and ultimately be removed from the program. Paradoxically, then, the more drastic the intervention being considered, the more critical is the need for consent to be free and often the less likely it will be obtained freely.

Clearly, the issues regarding client rights are fraught both with legal complexity and ethical nuance. Far too often the learner loses either because permission is given too readily based on too little information or because permission is denied for what may be the only legitimate procedure documented to be effective. The very question of whether a third party, be it parent or guardian, ought to be able to give consent for a potentially harmful behavioral intervention is likewise heavily laden with ethical and legal confusion. Such issues will not readily be resolved. It is our position that the best ultimate solution is to develop an armament of non-punitive, less stigmatizing, and less restrictive effective procedures for behavioral intervention which will, by their nature, raise fewer concerns about protection of human or civil rights of our clients. That is the purpose of this book.

Footnote

1. In the last quarter of the 20th century, most professionals concerned with services to developmentally or mentally disabled clients are agents of government insofar as they are either public servants or are employees of agencies which are funded and supervised by the state. Thus, their actions come under the scrutiny of U.S. Constitutional due process protections as state action under the Civil Rights Act of 1871 (42USC 1984). Practitioners are, thereby, personally liable in cases of violation of client rights.

CHAPTER III

THE FUNCTIONAL ANALYSIS
OF BEHAVIOR*

I. Introduction

Human behavior never occurs in a vacuum. As we have discussed earlier, there is a legal and ethical responsibility on the part of the practitioner to consider the conditions under which a behavior takes place before attempting an intervention to reduce or eliminate that behavior. In addition, this is sound practice procedurally. Without an analysis of the context, and an intervention based on the resulting information, one risks having to deal with a seemingly endless series of behavior problems which are at least in part a function of that context. For example, a boring unit on obscure mathematical correlations may produce acting out behavior on the part of otherwise well-behaved middle school students. To the extent that the material can be delivered in a more imaginative and motivating fashion, many problems can be eliminated effectively and efficiently. Likewise, it might be a never-ending task to attempt to manipulate the many discrete "unacceptable" behaviors presented by a big city "bag lady" without prior establishment of a richer behavioral repertoire supported by financial, social, and personal effectiveness assistance.

In an optimum society, all learners with whom we work would have an enriched, supportive and individualized environment in which to learn and grow. Unfortunately, in reality such is seldom the case and practitioners are often coping with problems in less

*This chapter was written with Richard A. Mesaros, Ph.D.

18

than optimal situations. A major task for all concerned practitioners is to advocate for appropriate, interested and supportive environments for all learners. Even under the best of all circumstances, however, we would still conduct a functional analysis of problem behaviors before discussing any procedures for behavior change. A functional analysis may include:

A. An analysis of the ecology of the person and the presenting problem (i.e., an analysis of all that surrounds the behavior and provides the context for its occurrence);

B. A specific analysis of the antecedent and consequent events that have a functional relationship with the presenting problem (i.e., the discriminative stimuli setting the occasion for the behavior and the consequences which follow and serve to maintain the behavior);

C. An analysis of the communicative functions a behavior may be serving for an individual (i.e., the message the person may be communicating through the use of an inappropriate behavior).

Though each type of analysis will be discussed separately, it is not our intent to imply that they are distinct or mutually exclusive. Rather, by asking questions in these different ways, additional useful information may be provided. Before that discussion, we will present a framework for the functional analysis of behavior.

II. Functional Analysis

The applied behavioral literature provides considerable support for the need to assess many variables in carrying out a functional analysis of behavior (Touchette, 1978; Kanfer & Saslow, 1969; Schwartz, Goldiamond, & Howe, 1975). Kanfer and Saslow (1969), for example, identify a number of dimensions which must be considered in carrying out such an analysis. These include analyses of historical setting events, antecedent events, consequent events, organismic variables, motivation, and skills. Similarly, the description by Schwartz et al. (1975) of the operant paradigm reflects their acknowledgement of the complex interaction of context and behavior which ought to be analyzed prior to intervention:

The variables and sets of variables which are called "contingencies" provide a framework for the analysis of problematic situations. This operant orientation can provide leads, techniques, and avenues for intervention that are observable and measureable. The variables that have been discussed are

the following: The events that follow behavior (consequence); the events that precede behavior (discriminative and instructional-abstractional variables); the procedures that precede it (potentiating variables); events that prop behavior (ecological or stimulus props); and the procedures that provide change (programs). When put together, these are called the "operant paradigm" (p. 39).

This conceptualization of the operant paradigm provides a basic framework for a comprehesive functional analysis, beginning with an analysis of the ecology of the person and behavior.

A. Behavioral Ecology

Definitions of behavioral ecology are many and varied (e.g., Barker, 1968; Rogers-Warren & Warren, 1977; Scott, 1980). For our purposes, ecology subsumes all that surrounds the behavior, including physical characteristics, behavior-like attributes of roles and social rules, a specific time, a place, object props, a system of intrapersonal behavior and the general milieu of contingency rules.

Through analysis of the behavioral ecology, practitioners may identify many vairables that potentially impact on behavior and thereby allow them to "smooth the fit" between the environment and the person (Rhodes, 1967). For example, overcrowding, stimulus deprivation, availability of attention, stimulus overloading, task difficulty, instructional demand characteristics, motivation, prerequisite skills, effective instruction and teaching techniques, curricular options, and a thorough task analysis have been carefully examined by many researchers in relationship to behavior problems (e.g., Baker, 1980; Center, Dietz, & Kaufman, 1982; Etzel & Leblanc, 1979; Weeks & Gaylord-Ross, 1981; Volkmar & Cohen, 1982). This approach is certainly to be encouraged, for at a minimum it will help guard against the tendency to intervene on discrete behaviors in isolation, a tendency which has caused so much justified and unjustified criticism of behavioral technology (e.g., Gardner & Cole, 1983).

Table 3.1, adapted from Donnellan, Mirenda, Mesaros, and Fassbender (1984b) and Rogers-Warren and Warren (1977) suggests factors to consider when conducting ecological analyses and provides a format for doing so. From this more global ecological analysis, the practitioner may begin to address more adequately those antecedent stimuli that are specifically discriminative for the behavior and the consequences engendered by the behavior which serve to maintain it.

Table 3.1

Factors to Consider When Conducting Ecological Analyses

1) Identification of the target behavior.

2) The learner's expectations about the enviornment.

3) The expectations of others in the environment concerning the learner.

4) The nature of the materials and physical objects available to the learner.

5) The reinforcement and preference value of materials/objects available.

6) The nature of the activities in which the learner is engaged in terms of difficulty, interest level, etc.

7) The number of persons present in the learner's environment.

8) The behavior of other persons in the learner's environment.

9) Environmental pollutants such as noise, crowding, etc.

10) The time of day.

11) The persons's physiological state (e.g., hunger, medication, general health, pain, etc.).

12) Sudden changes in the learner's life, environment or reinforcement schedule.

13) Individual abilities, such as general and communication skills and adaptive ability.

14) Level of difficulty.

15) Efficiency of reinforcers operating.

16) Variety of materials/activities.

17) Variety of grouping arrangements.

18) Opportunities for interactions with others.

19) Environmental constraints.

20) Environmental arrangements to facilitate the behavior intervention.

B. Analysis of Antecedent and Consequent Stimuli

When discussing the operant paradigm, most behaviorists would espouse a position similar to that of Kanfer and Saslow (1969) and Schwartz et al. (1975), as described earlier, in arguing for a comprehensive functional analysis. A through analysis of the antecedent stimuli and consequent events is crucial, but it is only a part of such an analysis. Specifically, the practitioner describes which stimulus events are functioning as discriminative stimuli for the behavior, i.e., setting the occasion for the response to occur. Generally, these are the stimuli that directly precede the behavior under investigation. The practitioner then delineates those enviorn-

mental events that support or inhibit the behavior. Typically these are stimuli or consequent events which occur immediately after a response or behavior is exhibited. This contingency relationship—Discriminative Stimulus-Response-Consequence—is basic to the operant learning paradigm. Once determined, the practitioner typically manipulates either the antecedent stimuli, the consequence, or both to alter the behavior of concern.

Unfortunately, the literature provides a limited number of examples where even this basic level of analysis is employed. Even this limited degree of assessment appears to be lacking from most intervention efforts (Gardner & Cole, 1983). This state of affairs appears to be true whether the intervention employed is aversive or non-aversive (e.g., Foxx and Arzin, 1973; Frankel, Moss, Schofield, & Simmons, 1976). In fact, much of the research cited in this book suffers from the same problem. While the target behavior in most studies is defined with the usual attention to objectivity and the need for reliable measurement, there is often little attempt to analyze the ecology of these behaviors, the functions these behaviors may be serving for the person exhibiting them, or the other variables which may be playing a functional role.

Why are assessments based on a functional analysis, including an anlysis of the antecedent and consequent stimuli, missing from so much of the treatment literature? We suggest the following factors as contributory:

1. Uninformed but technically well-designed behavior modification procedures have often been very effective in the short run.

2. Uninformed interventions may have a lower response cost when compared with the more comprehensive interventions that may follow from a functional analysis.

This combination of reinforcement and response cost may have helped divert the field from carrying out and utilizing the information obtainable from functional analyses. (See Gardner & Cole, 1983, for a more detailed examination of why even a limited behavior assessment is typically not carried out in the field).

Ecological analyses and analyses of antecedent and consequent events go far to delineate the complex relationships of an individual in her environment. An attempt to understand the message value a behavior has may also provide additional and useful information.

C. Communicative Functions of Behavior (Pragmatic Analysis)

Many behaviors exhibited by human beings may appear to be

devoid of any meaning—random, "bizarre" behavior without function and serving no social purpose (e.g., Repp, Dietz & Spier, 1974). Yet, the results of other behavioral and related studies indicate that behaviors such as stereotypic responding, aggression, self-injury, echolalia, property destruction, and similar examples often serve definite and sometimes quite complex communicative and social interactive functions (Carr, 1977, 1983; Carr, Newsom, & Binkhoff, 1976; Prizant, 1978; Frankel, 1982; Lovaas, 1982; Lovaas et al., 1965; Schuler & Goetz, 1981). Obviously, an understanding of such functions could contribute substantially to the design of intervention.

A pragmatic analysis begins with the assumption that all behavior has message value. Although such an assumption may be more interpretive than what is typically suggested in the behavioral literature, it is valuable and reasonable for at least the following reasons:

1. As mentioned ealier, there is considerable literature isolating some quite complex communicative and social interaction functions of atypical behavior (e.g., Carr, 1977, 1983; Durand, 1982; Frankel, 1982; Iwata, Dorsey, Slifer, Bowman & Richman, 1982; Schuler & Goetz, 1981; Schroeder, Mulick, & Rohjan, 1980).

2. The literature is replete with examples of attempts to change behaviors which occur "for attention" (e.g., Lovaas et al., 1965; Harris, Wolf, & Baer, 1964; Williams, 1959). The pragmatic analysis approach acknowledges the legitimacy of the attention seeking and, in fact, is an attempt to delineate a taxonomy of other possible functions for such behaviors (Donnellan et al., 1984).

3. Acknowledgement of function does not preclude intervention. The recognition that a behavior serves a legitimate function does not mean that it can or should continue in its present form. If the pragmatic analysis indicates that a person is physically aggressive as an expression of boredom, for example, any attempt to reduce aggression minimally would include an instructional program to teach some non-dangerous way of expressing this emotion.

4. Given the limited repertoire of many of the learners with whom we work, we believe it is a "less dangerous assumption" (Donnellan, 1984, see Footnote 1) to analyze for function before attempting to deprive them of a potentially communicative behavior.

In order to facilitate such an analysis, a tool was developed by Donnellan and her colleagues at the University of Wisconsin (Mi| renda et al., 1983; Donnellan, et al. (1984) that provides a list of some of the functions a behavior may serve (see Table 3.2). The emphasis is on

the communicative and social interactive nature of behavior and draws heavily on the literature concerned with the pragmatic analysis of behavior (e.g., Miller, 1978; Prizant & Duchan, 1981; Prutting, 1982; Schuler & Goetz, 1981).

Table 3.2
A Tool for Identifying Possible Communicative
Functions of Problem Behavior*

*See Appendix D for the definitions of the behavioral categories in this Table. See also Donnellan, et al. (1984b)

This tool illustrates possible functions and means for communication. It demonstrates the refinement with which we can begin to understand the various roles that behavior can play and provides a means to systematically analyze those roles. It should be noted that the tool was developed for use with non-verbal and/or non-language learners as a means of identifying the possible communicative functions of their behavior. Certainly, with less impaired learners the tool would serve primarly as an adjunct to their own descriptions and evaluations of their behavior.

The best analysis of the communicative functions of problem behavior by use of the tool in Table 3.2 requires that several conditions be met.

1. The practitioner must have the opportunity to observe and interact with the learner regularly over a period of time.

2. The behaviors of concern must be observed in a spectrum of environments including educational, community, and home settings. A pragmatic analysis attempted in a single environment will rarely provide the analyst with sufficient information to pinpoint the important functions of a particular behavior.

3. The assessment of the communicative functions of behavior must be made on an individual basis after consideration of the behaviors of concern in context, and must reflect an attempt to objectively validate the conclusions drawn. Without these critical elements, the practitioner has no means for controlling the highly variable interpretive nature of the analysis.

The tool can be used to:

1. Conduct a general survey of various functions and their related behavioral manifestations. This kind of pragmatic analysis might be useful for example, to determine the communicative needs of an individual prior to designing an augmentative communication system (Yoder, 1980); to gather initial assessment information, and/or to describe a person's communicative needs in a particular environment.

2. Conduct a general survey of behaviors and the communicative functions they serve. This type of analysis would typically be done to obtain pragmatic information before designing a functionally-related behavior management strategy.

3. Conduct a specific examination of a behavior and isolate functions. This type of analysis would be useful for examining one or two targeted behaviors to obtain information as to their functions before designing the behavior management strategy.

In any case, once the function(s) or behavior(s) of interest have been identified on the tool, the practitioner forms hypotheses re-

garding function-behavior relationships. These hypotheses are based on the dynamic relationship and examination of the ecology or context in which the behavior occurs as well as the specific antecedent and consequent stimuli related to the behavior. The practitioner begins to match functions and behaviors by moving across or down the tool and noting the point of intersection. The question is, "In the present context, what does the person seem to be communicating and how does she do so?" Once the hypothesis has been formulated, it should be reflected in and, accordingly, tested through its incorporation in the intervention programs as described in the following chapters.

Knowledge about the pragmatics of behavior is, unfortunately, limited. Nonetheless, along with the ecological assessment and the analysis of antecedent and consequent events, this additional perspective can contribute to an understanding of the functions of behavior which may be invaluable for developing successful interventions.

The remainder of this chapter will address ecological interventions that may preclude the occurrence of behavior problems. The environment so established should provide the context for positive programming and other specific intervention strategies as described in the following chapters.

III. Ecological Interventions

Before we discuss ecological interventions, it should be noted that the use of stimulus control to reduce undesirable behavior (Chapter VIII) is related to ecological manipulation to alter behavior as we described it here. Chapter VIII discusses the identification or establishment of specific stimuli exerting discriminative control over the target behavior. Further, it addresses the use of that control to influence the frequency of the behavior in question and/or the settings and conditions under which it will occur. Environmental manipulation is, of course, conceptually similar. For the purposes of this discussion we present ecological manipulation as a much more global effort to change the general context in which the behavior occurs or to more generally establish a context that will make the behavior less likely to occur. It is an attempt to prevent/preclude the occurrence of behavior problems through a change in the general context within which the behavior occurs

rather than to manipulate the behavior through the direct variation of specifically identified or established discriminative stimuli.

As noted, the environment-person system—the ecology of the situation—is a viable intervention base to prevent/preclude behavior problems. Depending on the behavior of concern, these can be short term interventions or sufficient for long term positive effects. Many authors have examined the utility of ecological interventions and provide strategies for conducting them. For example, Menolascino, Wing, Casey, Pew, and McGee (1983) have discussed what they call "gentle teaching" techniques, which include such ecological manipulations as errorless learning, environmental engineering, teaching to appropriate individual modality strengths, programming consistency and scheduling, individualization, and flexibility with the learner and staff.

Olley (in press) has discussed the need to consider classroom scheduling in careful detail to prevent/preclude behavioral problems and to adapt to the learning characteristics of handicapped students. He suggests prerequisites for a successful class including: the physical arrangement of the room, materials, general and specific curricular organization, sequence of activities, material presentation, and timing of activities.

Illustrative of the notion of ecological analysis and subsequent environmental intervention is the example of a 15-year-old adolescent recently referred for severe aggression toward staff, tantrums, and destruction of property. After observing and assessing the learner, several options for intervention were available. For example, an aversive program such as electric shock, time-out, restraint, etc., contingent upon the targets behaviors, could have been utilized.

Alternatively, a non-aversive procedural intervention of Differential Reinforcement of Other Behavior (DRO) (Chapter VI) or Differential Reinforcement of Alternative Behaviors (Alt-R) (Chapter V) might have been instituted. Based on an environmental/ecological assessment, the following environmental ecological interventions were implemented: Staff were instructed to task analyze and deliver instruction with fewer words to maximize the probability that the student would understand the instructions. Material/program activities were modified to provide high interest value. The schedule was reorganized to allow for shorter but more frequent "free" periods for break. A thorough cognitive assessment was done so teachers could more successfully tap into this learner's cognitive strengths. Finally, inservices on programming and curriculum were provided to staff. Anecdotally, this package of ecologi-

cal manipulation was reported to have had a profound effect on the student's behavior—the "misfit" of the environment/student system was made to fit more smoothly. That is the essence of ecological interventions.

Footnote

1. According to the "criterion of the least dangerous assumption," in the absence of conclusive data, educational (and clinical) decisions should be based on assumptions which, if incorrect, will have the least dangerous effect on the learner.

CHAPTER IV

POSITIVE PROGRAMMING *

I. Introduction

The functional analysis of behavior as described in Chapter III provides the practitioner with information about the ecology of the problem behavior, the environmental context, the contingency rules, and the message value of the behavior. With this rich information base, the practitioner may more fruitfully consider various behavioral interventions. Among the most important and useful of these interventions is that of positive programming. We make the distinction here between positive programming and other procedures for behavior change. For example, the contingent use of rewards or punishment to manipulate discrete behaviors is characterized by "on" or "off" conditions. On the other hand, positive programming, as we are defining it here, is a much more gradual educational process for behavior change involving systematic instruction in more effective ways of behaving. Positive programming teaches new behavior over time and is based on a full functional analysis.

Although positive programming options for behavior reduction have not received extensive focus, some literature exists on these strategies. There are at least four variations on the basic programming theme. It should be noted that these categories are not

*This chapter was written with Richard A. Mesaros, Ph.D.

mutually exclusive or exhaustive. For purposes of clarity, they will be described as:

A. teaching a new behavior or class of behaviors;

B. substituting communicative means;

C. substituting a more socially appropriate behavior; and

D. assigning meaning.

A. Programs such as the work of Liberman and colleagues (e.g., Liberman, King, DeRisi & McCann, 1976) in personal effectiveness training typically involve gradual changes in behavior and represent an indirect and perhaps a longitudinally more effective approach to controlling undesirable behavior. For example, you may be presented with a person who exhibits severe introversion to the point of not even venturing out of his house. On the basis of a functional analysis, the behavior is shown to be related to the person's inability to be assertive in social situations. The solution here may not be a change procedure that focuses on manipulating the behavior of introversion, but rather a systematic program to teach more effective ways of asserting oneself.

B. While Liberman et al. (1976) may systematically teach a package of new social skills or assertive behaviors without a concomitant pragmatic analysis of the communicative functions the behavior may serve, others (Carr, 1983; Donnellan, Mirenda, Mesaros, and Fassbender, 1984) specifically analyze the communicative functions of problem behavior and suggest replacing the communicative means with more appropriate behavior. (See Chapter III for more detailed description of this analysis.) The difference lies in the type of analysis, not in the level of programming intervention.

C. Eason, White, and Newsom (1982) have used a programming strategy to address functions of problem behaviors, though they did not address communicative functions. These authors decreased self-stimulatory behavior by implementing a program to systematically teach appropriate toy play to replace the hypothesized function of self-stimulatory behavior. Obviously, when employing programming strategies, interventions and behavioral replacements may look very different, depending on one's orientation regarding function.

D. Mesaros (1982) has presented a strategy for behavior change in which one responds to an atypical behavior as though it were an appropriate and functional communication rather than attempting to replace it with another more typical communicative behavior. In one example, an adolescent with severe retardation and autism was observed to make eye contact somewhat randomly throughout his school day. In addition, he was observed to place himself periodically near his instructors. As the student had a paucity of appropriate

communicative initiation strategies, staff were instructed to attend to eye contact and proximity behavior and to deal with these as though they were appropriate communicative initiations. In so doing, these responses were brought under more appropriate stimulus control and became more communicative. This approach is consistent with Bruner's (1975) notion that when caregivers assign meaning to infant behaviors, they give feedback to the child which enables him to learn the basic rules of social interaction and language. This strategy is characterized as a programming intervention due to its systematic development of communication skills that gradually supplant the more atypical means previously used by this learner.

Again, all the interventions described are merely variations on a central theme: The process of behavior change over time via systematic instruction versus procedures for behavior change focusing on more discrete manipulations of undesirable behavior.

It is interesting to note that though we have exemplified these variations with several classroom reports, there are in fact very few reported classroom interventions employing positive programming. More typically, researchers have explored positive programming options in non-classroom settings. Stednitz (1982) studied the effects of a skills training model on the communication of adolescent psychiatric patients. Smith (1982) evaluated the effectiveness of graduated modeling to teach improved communication skills among couples who were dating. Zodrow (1982) also investigated interpersonal communication and problem solving skills training for couples prior to marriage.

As noted earlier, Liberman and his colleagues have done extensive work on social skills training, particularly with schizophrenic individuals and other impaired populations (e.g., Austin, Liberman, King, & DeRisi, 1976; Liberman, 1972; Liberman, 1982; Liberman, Wallace, Falloon, & Vaughn, 1981; Wallace, Teigen, Liberman, & Baker, 1973). These are some of the best examples of systematic instructional sequences to teach alternative forms of behaving to decrease and prevent behavioral problems.

Skills training and enhanced problem solving have been investigated for treatment of alcoholism (Chaney, O'Leary, & Marlatt, 1979; Goldsmith & McFall, 1975); drug dependence (Callner & Ross, 1978; Intagliata, 1978); dating skills and anxiety (Curran, 1975; Curran & Gilbert, 1975); and stress management (Benson, 1974; Navaco, 1975; Shaw, Bensky, & Dixon, 1981).

There is also extensive literature specifically regarding assertiveness training for non-impaired and impaired populations (e.g., Blau, 1980; Eisler, Miller, & Hersen, 1973; Galassi & Galassi, 1974;

McFall & Marston, 1970; Rathus, 1973; Rose, Hanusa, Tolman, & Hall, 1982).

While the literature cited is by no means exhaustive, it is heartening to see so many investigators examining human behavior problems from a positive programming perspective. What appears clear is the need to extend this work to populations exhibiting severe retardation and other developmental impairments, as well as to school related problems.

II. Advantages of Positive Programming

There are a number of advantages to using programming as a strategy for the reduction of behavior problems in applied settings. Together, these advantages make programming the most preferable alternative to the use of punishment. They include its positive and constructive nature; its long term and lasting effects; its potential for the prevention of future problems; its efficiency; its social validity and the contribution it makes to the learner's dignity.

A. Positive and Constructive Nature

Programming is a positive approach to the solution of behavior problems and avoids most of the difficulties inherent in using an aversive procedure. Assuming efficacy comparable with other approaches, it can withstand any questions which may be raised on ethical, administrative or legal grounds. Rather than simply eliminating or reducing an undesired response, it contributes to the learner's repertoire of functional skills, enabling him to be more effective in his interpersonal and environmental interactions.

To illustrate the positive and constructive nature of programming, let us use an example of a non-verbal learner who hits staff. Perhaps our analysis reveals that this occurs most often when he is engaged in a task which he understands but does not enjoy doing. In such a case, our assessment might conclude that aggressive behavior is the learner's attempt to communicate his desire to terminate the task and take a break. A positive programming approach to solving this behavior problem could involve teaching this learner that his presentation to the teacher of a word card imprinted with the word "BREAK" will communicate his intent. This could be established by having the staff respond by granting a five minute break whenever the student presents the card. It could also be kept within reasonable bounds by giving the learner limited access to the card, as would be necessary if the learner used unrestricted access to avoid all other educational activities. Finally, using a DRO schedule (see

chapter VI), limited access to word cards could be made contingently available for specified periods of time without hitting the teacher. Such an approach is positive in that it avoids punitive consequences for aggression. It is also constructive in that it teaches a new communicative response, i.e., the use of a word card. Having passed the crisis, the staff are then in a position to inventory and develop alternative instructional tasks which might accomplish the same educational ends but which the learner is more likely to enjoy.

B. Long-Term Effects

If positive programming builds in a novel response which can be maintained by the natural contingencies in the environment, there is greater likelihood for generalizing treatment gains across time. That is, to be long term and lasting, the effects of intervention should not rely on artificial consequences which may be difficult to maintain indefinitely. In the example described above, such long term and lasting effects could be further maximized if the word card read: "May I have a five-minute break, please?" Such explicit wording would likely bring a favorable response from most persons to whom it was presented.

C. Prevention

To the extent that we increase a learner's repertoire of functional skills, the presence of those skills may prevent the development of future problems. First, to the extent that a learner engages in a variety of socially acceptable activities, he has that much less time to engage in inappropriate behavior. Second, to the extent that he has socially acceptable ways of obtaining what he wants, there is a decrease in the functional necessity for socially unacceptable behavior which could potentially serve the same purpose. Therefore, by increasing the amount of time the learner spends engaging in socially acceptable behavior and by giving him additional effective ways for getting what he wants, programming has the potential for preventing the occurrence of future problems. In the case under discussion, an effective and socially acceptable way of temporarily avoiding an unpleasant task may prevent the development of other, socially less acceptable ways of achieving the same result.

D. Efficiency

Programming is efficient because it uses whatever limited resources may be available in a given setting and derives two results

for the price of one. All direct approaches to reducing behavior problems consume staff time and energy which is then unavailable for general educational or developmental programming. In taking certain programming approaches, we reduce the behavior problem while contributing to our general educational and developmental goals. Readers who have experience in settings in which staff spend most of their time reacting to behavior problems will be particularly attracted to this attribute of programming as an alternative strategy.

E. Social Validity

Programming has great social validity (Kazdin, 1977a; Wolf, 1978), both for the strategy it offers for intervention and in the goal it serves as the result of that intervention. Good positive programming is strongly proactive, and its proactive nature may often preclude the occurrence of behavior problems. Such a situation is obviously desirable to learners, their advocates, program personnel, and the community at large. Other approaches tend to be more reactive and are, therefore, more likely to be associated with a negative social response.

In addition, social validation requires that we attend to the "feelings" of the individual learner about our intervention (Wolf, 1978). As presented here, functional analysis coupled with positive programming attempts to assess the message no matter how aberrant the form, and to give the learner an option of delivering the message in a more conventional and acceptable manner.

F. Human Dignity

Finally, positive programming contributes most to the individual learner by enabling him to participate actively in the management of his life. Whether or not one wishes to speculate on the possibility of an innate drive toward "self-actualization" (Maslow, 1954) or "identity" (Erickson, 1950), such active participation in the process of becoming a more fully functioning person certainly enhances the dignity of any human being. We believe readers who are sensitive enough to the issues to want to read this book will agree that to the extent our programs enhance individual dignity they also dignify us. Thus, on the basis of this advantage alone, positive programming stands out as the most preferred of all the available strategies for dealing with problem behaviors.

III. Cautions

As a specific strategy for the reduction of problem behaviors, positive programming has generated only a limited number of empirical studies. There is, however, a body of literature substantiating the application of behavioral technology to the development of skills with a variety of populations. These include but are certainly not limited to discrete trial procedures (Donnellan-Walsh et al., 1976; Koegel and Rincover, 1977), task analysis procedures (Gold, 1980), programmed instruction (Skinner, 1968), and role playing with practice and feedback (McFall & Marston, 1970; Goldsmith & McFall, 1975). We have been unable to identify through our review of the literature any negative side effects or other ramifications of these approaches to programming that would raise concerns vis-a-vis applying this technology as a strategy for behavioral reduction. Nevertheless, a number of empirical questions remain, as discussed in the closing section of this chapter. It seems clear that this relative lack of empirical data lends added weight to some of the cautions indicated below. These include the response cost of positive programming, speed of effects, the available resources in various settings, possible cross-setting complications, and some special problems connected to this approach.

A. Response Cost

One of the reasons for the paucity of studies examining positive programming as an alternative to punishment may be the greater response cost to staff compared with some of the other approaches presented in this book. As we will discuss in our suggestions for implementaion, positive programming requires a thorough functional analysis, the targeting of appropriate instructional objectives, and the careful and systematic design and implementation of a longitudinal instructional sequence using the most powerful technology at our command. Obviously, this approach takes energy, creativity, and determination. Relative response cost cannot be overlooked in selecting one strategy over another. However, response cost must be referenced against the benefits derived. When one applies a full cost/benefit analysis, we believe that the greater response cost associated with a programming effort yields a correspondingly greater return to the learner and hence a greater return on our efforts.

It appears that the lower response cost and frequent success of a few other strategies for behavior reduction often preclude consideration of a programming approach. This is one of the unfortunate by-products of the fact that the more traditional approaches to behavior management are so powerful they often preclude professional staff from having to evaluate the content of their programs. Programs that rely excessively on traditional approaches often miss opportunities to teach their learners appropriate, useful, and functional behaviors while decreasing or eliminating those which are problematic (Mesaros, 1983). Our feeling is that the greater response cost associated with a positive program strategy should not be a prima facie reason for avoiding it. Behavior change efforts should be continuously validated by reference to broad constructional and social concerns (Goldiamond, 1974). Rather than remediating behavioral excesses in a vacuum, we should subscribe to a broader view, i.e., considering the learner in the context of his total learning environment.

B. Speed of Effects

Until further research provides additional information on methods of applying positive programming most effectively to reduce behavior problems, this approach may not have the same speed of effect as some of the more traditional approaches. The process of developing a new set of responses to replace the problem behavior is likely to require a more complex and longitudinal effort. This concern may justify particular caution when the behavior problem represents a danger to people or property, as is the case with aggression, self-injurious behavior, and property destruction. In cases where speed of effect is an urgent consideration and there is good reason to believe that a strict positive programming approach to a behavior problem may not result in a sufficiently rapid reduction of that problem, prudence requires that additional procedures be used in combination with the program. Needless to say, we believe that these additional approaches should be selected from among the alternatives discussed in the subsequent chapters of this book.

C. Available Resources

Different settings have varying resources to bring to the problems and learning needs of diverse populations: staff-to-learner ratios, professional resources for program design and consultation, and different access to supplies and materials all may vary. Lack of

optimal resources is not an excuse, however, for avoiding a positive programming approach to behavior problems. However limited a setting's resources, staff can maximize them by focusing them to the greatest extent possible on the design and implementation of programs to teach functional, interesting, age appropriate skills, using natural materials in a normalized fashion (Wolfensberger, 1972) across a variety of domestic, vocational, recreational, and general community settings (Brown et al., 1976).

When the settings in which we work preclude the possibility of such programming, it becomes important to question the fundamental appropriateness and ethics of attempting any effort to reduce behavior problems in such environments. This is certainly a major issue in terms of institutionalization (Blatt, Ozolin, & McNally, 1979). However, it is not only isolated institutional and other segregated settings that create environments which are devoid of the opportunity to learn and engage in functional skills. Other settings, because of prevailing philosophies, may also create an emphasis on: being still, being quiet and being good (Donnellan, 1980a; Winett & Winkler, 1972). If the work setting precludes or disapproves of positive programming, the first order of business may be to change it. If the setting is supportive of the notion of positive programming, even limited resources can result in optimal gains for the learner.

D. Cross-Setting Complications

Often we find that different program settings for a given learner have uneven commitments to positive programming, yet we may have direct influence only in our own settings. Sometimes this is appropriate. For example, as the school is usually better staffed than the natural home setting to carry out an intensive positive program, undue pressure should not be placed on families to comply with our suggestions (Vincent, Laten, Salisbury, Brown, & Baumgart, 1981). Regardless of the cause, we should not give up a positive programming approach in one setting simply because we cannot assure "consistency" across all settings. Positive programming in one setting is better for the learner than no positive programming in any setting.

E. Special Problems

A unique problem arises when we base our interventions on a thorough assessment and functional analysis. That is, we may find ourselves in a situation in which the learner is exhibiting

"problem" behaviors to communicate that he does not wish to participate in some or all of our program. This raises several issues. First, it is important to give the learner a more conventional method of communicating this message. As in our example of the mute learner who uses tantrums in order to cease working, it is more acceptable to teach him a signal to use when he wants a break. Coupled with a review of the appropriateness and interest level of the task at hand, this seems a reasonable approach to the problem.

Second, there will be those occasions where the message is unacceptable to those responsible for the learner's welfare. For example, a learner might be using tantrums to avoid all the instructional or self-care activities of bathing or eating. Whether or not we find the message acceptable, the learner has the right to communicate. Still, this kind of situation obviously requires caution. The first step is always to review the program, strategies, interest level, meal planning, etc., to ascertain whether changes are in order. Assuming that reasonable changes have been made as necessary, we still have a proactive responsibility to intervene; we cannot let the person die of starvation or otherwise deteriorate. In such cases, competing but reinforcing contingencies may be necessary to supplement positive programming.

Further, problem behaviors serving such communication functions require acknowledgement of the message whether or not we are able to comply with the mand (Skinner, 1957). Even under limited conditions in which we regard it as necessary not to comply with the mand for the learner's own sake, we can still develop means for indicating that we understand what is being requested. Such an "active listening" approach (Gordon, 1970) may have significant effectiveness in preventing behavior problems from escalating to unacceptable levels. At a minimum, it should be considered an essential strategy for dealing with any population.

IV. Suggestions for Implementation

It would be beyond the scope of this book to provide detailed suggestions for designing and implementing instructional programs based on behavioral technology. For such information, there are a number of other excellent resources (Donnellan et al., 1976; Gardner & Cole, 1983; Martin & Pear, 1983; Sailor, Wilcox, & Brown,

1980; Sulzer-Azaroff & Mayer, 1977). The major suggestions offered here concern the direct application of positive programming as a strategy for the reduction of a behavior problem. Specifically, we recommend a three-part process including: 1) a formal behavioral assessment and functional analysis of the presenting problem in context, 2) the design and implementation of postive program strategies and, if needed, 3) a provision for more traditional behavior reduction procedures (as described in subsequent chapters) when speed of effects is an urgent consideration. A sample format for reporting the results of this process including a full assessment and intervention plan, is included in Appendix A.

In addition to the studies cited in the review of the literature, any number of positive programming options is possible. Specific approaches will always depend on a particular problem behavior, the function it serves the learner and other information. Some examples are:

a. Social isolation in children—programs could be developed to teach appropriate playskills to children (e.g., Strain, 1983);

b. Inability to keep an orderly, healthy, clean home—home maintenance skills could be instituted (e.g., Pumpian, Livi, Falvey, Loomis, & Brown, 1980);

c. Conflict between parents and children—a "parent effectiveness" training program/package could be initiated (Gordon, 1970);

d. Marital conflicts—problem solving strategies to aid in resolution of stress areas could be taught (e.g., Zodrow, 1982);

e. Inability to procure employment—a package of job interview skills such as personal appearance and clothing selection might be helpful (e.g., Nutter & Reid, 1978);

f. Alchoholism and substance abuse—relaxation and covert conditioning technqiues could be taught (e.g., Upper & Cautela, 1979).

V. Research Ideas

A partial list of the questions we would like to see addressed through empirical investigations of positive programming can be found below. In addition, we encourage the reporting of case studies illustrating positive program strategy as it applies to different problems with diverse populations.

1. Under what conditions can positive programming result in a (rapid) reduction in an identified behavior problem?

2. In what measurable ways does positive programming contribute to the generalization and maintenance of treatment gains across settings and across time?

3. Can "active listening" (Gordon, 1970) techniques sufficiently reinforce the communicative function of problem behavior to prevent its escalation under an extinction paradigm?

4. What are the variables involved that make positive progamming a more effective context within which to carry out more direct methods of behavior management?

5. When staff begin to perceive inappropriate behaviors as possibly communicative and amenable to replacement strategies, what effect will this have on attitudes about impaired learners?

6. What is the public's perception of procedures for behavior change versus a positive programming approach (social validity issues)?

7. How can more objective strategies for determining functions of behavior be developed so as to lessen the possibility of over-speculation and subjective inference?

8. How is the learner/professional relationship perceived as a function of programming intervention versus other behavioral interventions?

9. How is outcome viewed by the learners involved in programming versus those involved in more traditional behavior management procedures?

10. Which ecological variables seem most critical to manipulate for individuals prior to implementing a positive program (e.g., crowding, pollutants, activity sequence, etc.)?

11. What are the optimal ways to train teachers, psychologists, and other practitioners in the methods of positive programming?

In summary, we believe that any intervention should take place in a full, supportive environment in order to ensure maximum potency. Additionally, we suggest that positive programming options offer the most appropriate ways to proceed in managing undesirable behavior. This process allows the practitioner to look at human behavior from a more global rather than myopic perspective; it also increases the potential for constructive living by systematically teaching new ways for behaving effectively.

The remainder of this book will describe non-aversive strategies to be used along with the programming options described here.

CHAPTER V

THE DIFFERENTIAL REINFORCEMENT OF ALTERNATIVE BEHAVIORS (ALT-R)

I. Introduction

The differential reinforcement of alternative behaviors, or alternative responses (Alt-R) (Boe, 1964; Mulick, Leitenberg, & Rawson, 1976), is perhaps the most widely recognized and used of the alternatives to punishment. As the name describes, this procedure involves the differential reinforcement of those behaviors which are topographically different from the target behavior. Its popularity was anticipated in that the first study published in the inaugural issue of the *Journal of Applied Behavior Analysis* reported the use of this procedure in a classroom setting. As described, Hall and his colleagues (Hall, Lund, & Jackson, 1968) investigated high rates of disruptive or dawdling behavior on the part of first and fifth graders. This undesired behavior was labeled "non-study" behavior. The alternative "study" behaviors were differentially reinforced by the teacher's attention, while the "non-study" behaviors were ignored, i.e., extinguished. Differential reinforcement of the study behaviors resulted in an increase in these alternative responses and a corresponding decrease in the disruptive and dawdling behaviors. In this application of Alt-R, the alternative responses were topographically incompatible with the undesired behavior.

Although we favor calling this procedure Alt-R, it has been used to reduce a wide variety of behaviors under the label of Differential Reinforcement of Incompatible or Competing Behavior (Sulzer-Azaroff & Mayer, 1977; Young & Wincze, 1974). In 1962,

Zimmerman and Zimmerman were successful in eliminating unproductive classroom behavior in two emotionally disturbed boys by reinforcing appropriate behavior with smiles, chatting, and physical proximity. The authors noted that some of the problem behaviors such as silliness, facial grimaces, etc., were often inadvertently reinforced by teacher attention and comments such as "try again." A combination of Alt-R and ignoring enabled the teachers to change the behaviors and learning atmosphere in only one month of treatment. This combination of Alt-R and ignoring was utilized by others including Patterson (1965), Hall and Broden (1967), and Becker, Madsen, Arnold, and Thomas (1967). Hall et al. (1968) also demonstrated early on that Alt-R could be taught to regular classroom teachers to enable them to deal with off-task and other undesirable behavior in classroom settings.

Similar procedures were taught to pre-school staff to enable them to deal with a variety of problems including regressive crawling (Harris, Johnston, Kelly, & Wolf, 1964); social isolate behavior (Allen, Hart, Buell, Harris, & Wolf, 1964; Russo, 1964); and other child behavior problems (Allen, Turner, & Everett, 1970; Harris, Wolf, & Baer, 1964). In the same vein, the parents were taught to use Alt-R procedures to deal with troublesome behaviors in their children. Among those dealt with were aggressive behavior (Hawkins, Peterson, Sahweid, & Bijou, 1966); sibling conflict (O'Leary, O'Leary, & Becker, 1967); and non-compliant and aggressive behavior (Zeilberger, Sampen, & Sloane, 1968). In an unusual experiment to control seizure activity in children, Zlutnick, Mayville, and Moffat (1975) applied reinforcers to behaviors that were not similar to typical pre-seizure activities or behaviors. This differential reinforcement program showed a promising reduction in seizure activity in contrast to similar situations that employed punishment.

Despite their wide application, Alt-R procedures have met with rather mixed reviews (Sulzer-Azaroff & Mayer, 1977). Part of the explanation for the apparently equivocal results comes from the variety of methods by which the strategy is defined and applied. It appears that Alt-R, despite its prominence as the alternative treatment of choice, is actually much more difficult to apply than many other procedures discussed in this book. It may be that this complexity partially accounts for the observation that punishment is so often used in applied settings. That is, Alt-R is often the only procedure attempted before punishment is introduced, and a lack of understanding of the complexities may produce an unsuccessful intervention.

We will discuss a number of variations of Alt-R in an effort to

understand the differential results reported in the literature, as well as the complexities involved in applying this procedure.

The first example is one in which the alternative response is defined as the absence of any motor behavior. The other variations include topographically similar versus dissimilar alternative responses, topographically compatible versus incompatible alternative rsponses, alternative responses that satisfy versus those that do not satisfy what we call the "100% rule," the presence or absence of the alternative response before intervention and, finally, variations concerning the reinforcement used to strengthen the alternative response.

A. The Absence of Motor Behavior as the Identified Alternative Response

In an effort to reduce stereotypic rocking, Mulhern & Baumeister (1969) reinforced the alternative response of "sitting still." Instrumentation carefully recorded any movement by the subjects in the experiment and it was only in the absence of such responding that reinforcement was delivered. That is, the alternative response of "sitting still" was defined as no behavior or as the absence of any motor response at all. This study was only partially successful in reducing stereotypic rocking and in creating a non-behaving person.

The authors suggested a "condition analogous to that of muscular spasticity" to explain the lack of success in eliminating every motor response in the learner's repertoire. A more parsimonious explanation may be that a certain minimum level of motor responses is present in all human organisms. The task of operant conditioning may be to vary and increase those repertoires in order to make them more functional. To eliminate all behavior is functionally equivalent to creating "deadman" behavior. Accordingly, we recommend against Alt-R procedures which define the alternative response as non-behavior.

B. Topographic Similarity versus Dissimilarity

A second variation of Alt-R concerns the topographic similarity or dissimilarity of the alternative response when compared with the target behavior. For example, the behavior targeted for reduction may be self-hitting involving blows to the head with a closed fist. A topographically similar alternative response would be for the

learner to comb his hair. A topographically dissimilar alternative response would be for the learner to play catch with someone else. Although there is no large body of literature on this issue, what does exist suggests that to achieve the greatest impact on the target behavior, the alternative response should be as topographically dissimilar to the target behavior as possible (Leitenberg, Rawson, & Bath, 1970). Most studies, however, do not directly address this issue and topographic similarity is rarely a controlled or even explicitly recognized variable. More research is needed in this area to determine the role the topography of the alternative response plays in the effectiveness of Alt-R.

C. Topographic Compatibility versus Incompatibility

Beyond the topographic similarity of the alternative response, a third variation of Alt-R involves its topographic compatibility with the target behavior. In our example of self-hitting, a topographically compatible alternative response would be singing. That is, it is physically possible to sing and hit oneself at the same time. Walking down the street with both hands in one's pocket is an example of behavior which is topographically incompatible with the target behavior. While it might seem obvious that the selection of a topographically incompatible Alt-R would increase the effectiveness of this strategy, not all studies have taken this approach. Again, the literature has neither controlled nor accounted for topographic compatibility as a significant variable (see Young & Wincze, 1974, as a notable exception).

D. Satisfying the "100% Rule"

Some studies have shown that even when the alternative response is topographically dissimilar and incompatible, the target behavior may not be reduced (e.g., Young & Wincze, 1974). Some interesting literature suggests, however, that increasing an incompatible behavior would be sufficient to reduce self-injurious or other problem behavior if what we call the "100% Rule" is satisfied. The 100% Rule requires defining the target behavior and the alternative response so that together they cover the universe of possibilities. That is, by definition, the learner can either engage in the target behavior or in the alternative response with no third option available. For example, a target behavior of disruptiveness in the classroom could be defined as "the student being out of his seat" (target behavior) while the alternative response of good study behavior might

be defined as the student being in his seat (Hall, et al., 1968). The time the student spends out of his seat added to the time he spends in his seat equals 100% of the time. If we reinforce him for being in his seat and if, as a result, we increase the time he spends in his seat over baseline levels, we will necessarily have decreased the amount of time he has spent engaging in disruptive classroom behavior.

On the other hand, when the target behaviors and the alternative response do not add up to 100% of the possibilities, it is possible to increase the alternative response without decreasing the target behavior, even if the two are incompatible (Sulzer-Azaroff & Mayer, 1977). For example, if during baseline conditions out-of-seat behavior occurs 10% of the time and writing occurs 20% of the time, we could reinforce writing to the point that it occurs even 60% of the time or higher without necessarily reducing out-of-seat behavior, even though the two categories of responses are incompatible.

In addition to time, the 100% rule can also be applied in cases where the target behavior occurs during a certain percentage of the given opportunities or trials. For example, if the behavior of non-compliance occurs 60% of the time that the learner is asked to do something, by definition 40% of the time he does not comply within a specified period of time. The 100% rule is satisfied, i.e., the desirable and undesirable behaviors are incompatible and are defined to comprise the universe of possibilities. If we reinforce and increase compliance, we will necessarily decrease non-compliance. While several studies have reported the ineffectiveness of Alt-R in decreasing undesired behavior, even when the alternative response was incompatible with the target behavior (e.g., Young & Wincze, 1974), every study of which we are aware that has implicitly applied the 100% rule has demonstrated effectiveness (e.g., Hall et al., 1968; Zimmerman & Zimmerman, 1962).

E. The Preintervention Status of the Alternative Response

Another reported variation of Alt-R concerns the presence of the alternative response in the learner's repertoire prior to the intervention. Technically, in applying a true Alt-R procedure, it is necessary for the alternative response to be already occurring during baseline condition in order to provide an opportunity to reinforce and therefore increase it. If an alternative response is specified which is not occurring at some pre-intervention level, it is not possible to apply an isolated Alt-R strategy since one cannot reinforce a behavior that does not occur. In such situations, therefore, it is nec-

essary to combine the Alt-R strategy with prompt and prompt-fading (e.g., Donnellan-Walsh, et al., 1976) or some other instructional technique in order to assure the development and occurrence of the alternative response specified for reinforcement.

We have no quarrel with and, in fact, even strongly encourage this combined approach. Studies which have utilized it have not always controlled for or factored out these additional training variables in reaching their conclusions about the functional properties of Alt-R as an intervention technique to reduce self-injurious or other undesired responding (e.g., Tarpley & Schroeder, 1979).

All of the variations of Alt-R described above concern the nature of the alternative response to be reinforced and increased in an effort to reduce some target behavior. The variations already discussed include topographic similarity and compatibility of the alternative response; definitions of the alternative response and the target behavior in such terms as to represent 100% of the universe of possibilities and, finally, the specification of alternative responses that are already in the learner's repertoire. One further variation of Alt-R as reported in the literature concerns itself not with the characteristics of the alternative response but with the nature of the reinforcement provided to increase that response.

F. Reinforcement Identification and Specification

In some studies, the reinforcers are specified to reverse the functional roles of the target behaviors and the alternative responses. For example, a number of investigations found that the target behaviors were being maintained by adult attention. Intervention consisted of specifying an alternative response, systematically paying attention to that alternative response (that is, reinforcing it with adult attention), and ignoring the behavior targeted for reduction. This strategy uses a natural consequence and simply rearranges the relationship between that consequence and the learner's behavior in the natural setting in an effort to increase desired responses and decrease undesired responses. Accordingly, it combines the strategy of Alt-R with the strategy of extinction. The effectiveness of Alt-R when it is combined with extinction appears very promising (Hall et al., 1968; Lovaas, et al., 1965; Zimmerman & Zimmerman, 1962). Results have been much more mixed when Alt-R has been applied in isolation, i.e., without an attempt to identify or control the reinforcer maintaining the undesired response (e.g., Mulick, Schroeder, & Rojohn, 1980; Young & Wincze, 1974).

II. Advantages

Sulzer-Azaroff and Mayer (1977) have identified three advantages of Alt-R as a strategy for reducing undesired responding: its lasting results, its constructive approach and its social validation.

A. Lasting Results

When reinforcing and increasing an alternative response results in the decrease of a target behavior, the reduction can be maintained over a long period of time. The major qualification is that it may be necessary to continue reinforcement of the alternative response indefinitely. We say it *may be* necessary, for again we have entered an area that clearly requires additional study. One set of variables which has not been experimentally addressed is the functional role of the reinforcement schedule for the alternative response in the rate of reduction of the target behavior and in its resistance to recovery post-treatment. Until more is known about this, preliminary findings suggest that target behaviors will recover after reinforcement for the alternative response is discontinued. We know, however, that certain sequences of reinforcement schedules (such as moving from a CRF to a VI schedule) make responding very resistant to extinction (Ferster & Skinner, 1957). If such schedules were used to make the alternative response as resistant to extinction as possible, perhaps the target behavior would be more resistant to recovery.

B. Constructive Approach

One of the most appealing aspects of Alt-R as a strategy for reducing behavior problems is its constructive approach. It does not merely eliminate or reduce an undesired response; rather, it increases the frequency and overall proportion of desirable behavior in the learner's observed repertoire. In that sense, it is not only a positive approach but also inherently a constructive one. For this reason alone, it calls for special attention as an alternative to punishment, for it shares this quality with positive programming. Positive programming is the preferred of all the alternatives, since its primary focus is nothing less than maximizing the development of the person as a dignified, productive, competent individual. In fact, the clearest distinction we can make between Alt-R and positive programming is that Alt-R typically uses a response already in the learner's repertoire and already being exhibited with some frequency dur-

ing baseline conditions. If this is not possible—if the alternative response has first to be taught using shaping, prompting and prompt-fading, chaining or another instructional technique or combination of techniques—we suggest that positive programming is being used. To further refine this distinction, if a target behavior is reduced as a function of the person learning a novel response, we have applied the technique of positive programming, as described in Chapter IV. If a target behavior is reduced as a function of increasing the frequency or duration of a response which is presently in the learner's repertoire, or which has just been developed, we have applied the Alt-R procedure.

C. Social Validation

It is undoubtedly because of its constructive and positive approach that direct care workers, consumer representatives, administrators, psychologists and other professionals find Alt-R such a comfortable and popular procedure to use (Sulzer-Azaroff & Mayer, 1977). It is also true that this procedure is probably the most widely known. Its popularity and recognizability are demonstrated time and time again. In fact, more frequently than we would like to see, it is the only alternative used. Nonetheless, Alt-R has the clear advantage of being familiar and comfortable for practitioners and others.

III. Cautions

As we have noted, the constructive nature of Alt-R justifies a prominent place for it on any list of non-aversive intervention strategies. Our concern is that its complexity and the resulting difficulty in its successful application also justify a number of cautions. Each of these is discussed briefly below.

A. Delayed Effect

Sulzer-Azaroff and Mayer (1977) suggest that the effects of Alt-R in reducing undesired responding may not occur immediately. (However, see Hall et al. [1968] for one example from many where control was rapidly established.) Positive reinforcement typically increases the frequency of a response only gradually. Therefore, even if the alternative response is physically incompatible with the

target behavior and even if the 100% rule is satisfied, the effect of the Alt-R procedure on the behavior targeted for reduction will be limited to the rapidity with which the alternative response is strengthened. If rapid control is urgently required, an alternative or at least additional approach should be considered.

B. Mixed Evidence of Effectiveness

As previously mentioned, there is mixed evidence regarding the effectiveness of Alt-R. In our review, we have attempted to explain these mixed findings as a function of variables which are unspecified, uncontrolled, and/or arbitrarily varied, each of which may play a vital role in the effects of Alt-R on the target behavior. Even when we review the literature carefully, there are few hints regarding the optimum design of an Alt-R procedure. There are several important research questions to be answered before we will be able to resolve all the complexities and confusion surrounding the procedure.

C. Complexity

As observed from the above discussion, Alt-R is much more complex than has typically been apparent. This factor and the paucity of definitive answers to many crucial questions makes it much more difficult to implement this procedure effectively than the more straightforward and direct strategies of DRO and DRL. This is not to say that Alt-R should not be used. On the contrary, we believe that under many conditions it can be a highly effective strategy and its constructive approach strongly recommends it. We suggest that the complexity involved in Alt-R requires careful thought and planning. This care is especially important since Alt-R often represents the only strategy attempted before an aversive intervention.

D. Recovery and Rebound

Undesired behavior which has been reduced or eliminated using an Alt-R strategy tends to recover to baseline levels when reinforcement for the alternative response is terminated (Mulick, et al., 1976; Pacitti & Smith, 1977). To avoid these problems, several suggestions will be made in the implementation section below. This recovery and rebound effect must be emphasized, as we may end up with higher rates of target behavior than when we began if these strategies cannot be followed.

IV. Suggestions for Implementation

Many complicated and interrelated decisions must be made in designing an Alt-R procedure for implementation. Some guidance is provided by the limited research findings available in the literature. In some instances, however, it has been necessary to rely on our clinical and classroom experience in making these recommendations. The following suggestions should help to make Alt-R a more effective strategy for reducing behavior problems in applied settings while simultaneously increasing the learner's frequency of desirable behavior.

A. General Recommendations

The following recommendations apply to all the procedures discussed in this book.

1. Strategies when target behavior occurs.

One characteristic of a non-aversive intervention strategy is that it does not prescribe a contingent consequence for the occurrence of a target behavior. In fact, rather than focusing on the problem behavior, non-aversive intervention typically focuses on the development and/or reinforcement of more desirable alternative behavior. As a result, program staff who are interested in taking a non-aversive approach to behavior management are often at a loss as to what to do when the problem behavior occurs. The first footnote in Chapter I addressed this issue when the target behavior is dangerous and threatens injury. When the target behavior is more innocuous, there are other options to consider: 1) Ignore the behavior in an effort to extinguish it in combination with the specific intervention strategy being utilized; 2) instruct the learner to stop in an effort to use whatever instructional control has already been developed (see Chapter IX); or 3) redirect the learner to engage in another behavior.

2. Evaluation.

A second general recommendation which applies to all the intervention procedures discussed in this book involves the need to evaluate our efforts. Obviously, the primary reason for collecting ongoing data during an intervention is to aid in assessing the effectiveness of the procedure being applied. Naturally, we try to arrange

for rapid and obvious improvement. However, this result is not always obtained. When improvement is not speedy and obvious, we must monitor our data summaries and decide whether the intervention is having the desired effect on the target behavior. It is difficult to say how many data points on a summary graph are necessary before a confident decision can be made to continue the procedure, revise it, or drop it in favor of another approach. How much data is necessary for an informed decision is a function of the frequency of the behavior, its variability, and the method of graphic summarization used. For example, assume a serious problem behavior occurs an average of three times a week within a range of one to five times a week. On a weekly or even a daily graph, a week's worth of data short of an immediate termination of the behavior problem is not likely to allow for an informed decision. In this case, even three weeks' worth of data may not be sufficient. On the other hand, if a problem behavior occurs an average of 20 times an hour within a range of 10 to 30 times an hour, and is summarized on an hourly graph, one day's worth of data may be sufficient to make a decision.

One guiding principle is to collect data until the behavior has reached a steady state (Sidman, 1960). A steady state exists when the measure of behavior being used is no longer in transition, that is, no longer decreasing. (Remember, we are discussing behavior reduction procedures. If the transitional trend of the behavior was an increasing one, we would immediately seek another solution to the problem.) There is no mathematical rule for this. It requires "eyeballing" the graph and visually determining that the behavior is varying around a horizontal line as opposed to a decreasing line.

If the behavior has been in a decreasing transitional state and reaches a steady state, one of two situations will exist. Either the behavior will have been eliminated, or at least reduced to an acceptable level, or it will have decreased but not to an acceptable level. If the former is the case, the task is to reach a point where the procedure can be phased out without losing the treatment gains. If, on the other hand, the behavior is still occurring at an unacceptably high level, we recommend continuing the intervention while adding another intervention, as described in Chapter XIII. Again, this suggested strategy for evaluation applies to all the procedures discussed in this book.

B. Specific Recommendations

Having discussed two major recommendations for intervention applicable to all the intervention chapters, we can now turn to specific recommendations for the implementation of Alt-R.

1. Different topography.

An alternative response should be selected which is as physically different from the target behavior as possible, in addition to being incompatible.

2. Incompatible topography.

It should be physically impossible for the Alt-R and the target behavior to occur simultaneously. In most cases, it seems logical to first select for incompatibility and then for topographic dissimilarity.

3. Presently occurring behavior.

We recommend that the alternative response be something already in the learner's repertoire, one that is already occurring at some rate above zero under the same conditions which provide the context for the occurrence of target behavior before treatment commences. If an existing response is not selected, training and other preliminary procedures may be necessary, further delaying the effects of treatment. If the learner does not have a rich array of alternative responses to choose from, you may want to use positive programming as a strategy along with some of the other procedures we will discuss.

4. Selecting a reinforcer for the alternative response.

If possible, the reinforcer used to strengthen the alternative response should be that which was previously maintaining the target behavior, and Alt-R should be used in combination with extinction of the behavior to be reduced. For example, a functional analysis of the target behavior may disclose that the resulting social interaction/adult attention has inadvertently maintained disruptive, undesirable behavior. In this case, appropriate attention could be provided for the alternative behavior and withheld for the disruptive behavior. Since social interaction is likely to be provided anyhow, its judicious use can solve problems. Also, its natural availability can prevent the problems of recovery and rebound which could occur if a contrived reinforcer not likely to be available in non-treatment settings is used. By definition, if social interaction is maintaining undesired behavior, it is available to reinforce desired behavior in that setting. If we select a desirable alternative response which is likely to attract positive attention in non-treatment settings, we may avoid the problems of recovery and rebound after formal treatment

is over as well as generalize the effects of intervention to non-treatment settings. Thus, whenever possible, reinforcers which are available for the alternative response in non-treatment settings should be used. Ideally, this should be the reinforcer which is maintaining the undesired response and Alt-R should be used in combination with extinction for the target behavior. If a contrived reinforcer is used, we should be prepared to continue it indefinitely, to shift to more natural consequences or to thin the reinforcement schedule gradually in order to make the alternative response resistant to extinction. These suggestions should help avoid the problems of recovery and rebound.

5. Applying the 100% rule.

Whenever possible, the target behavior and the identified alternative response should be defined in such a way as together to make up the universe of possibilities. In this way, an increase in the alternative response guarantees a decrease in the target behavior. Table 5.1 lists four sample target behaviors and sample alternative responses, some of which meet the 100% rule, and some of which do not. It should be noted that all the alternative responses listed are incompatible with the target behavior. Sample two and four do not meet the 100% rule, however. In sample two, aggression and card playing together do not account for 100% of the learner's time or behavior. Therefore, an increase in appropriate card playing may or may not decrease aggression. Similarly, in sample four, the person may exhibit tantrums on occasions other than when he does household chores. If so, increasing this appropriate behavior may or may not decrease temper tantrums.

6. Multiple responses.

If the 100% rule cannot be met, we recommend that several alternative responses be identified for reinforcement. With each incompatible response added, the 100% rule can be more closely approximated. In sample four above, for example, we may want to add other appropriate behaviors such as quietly watching TV, reading, playing catch, talking on the telephone, completing homework assignments, and meal completion to comprise a list of alternative responses. All of these could be reinforced and increased, in turn, improving our chances of reducing the frequency of temper tantrums. The more we fill the day with appropriate behavior, the less

Table 5.1
Examples of Alternative Responses Which Meet and
Which Do Not Meet the "100% Rule"

Target Behaviors	Alternative Responses	
	100% Rule Met	100% Rule Not Met
1. Disruptive classroom behavior defined as the student being *out of his seat.*	1. Appropriate classroom behavior defined as the student being *in his seat.*	
2. Aggressive behavior defined as the physical act of *striking another person with a closed fist.*		2. Appropriate leisure behavior defined as *playing cards.*
3. Non-compliance defined as *non-response to a request within ten seconds of presentation.*	3. Compliance defined as *response to a request within ten seconds of presentation.*	
4. Temper tantrums defined as *yelling, kicking, and falling down on the floor with flailing arms and legs.*		4. Appropriate behavior defined as *completion of household chores without tantrums.*

time there is for inappropriate behavior (see Chapter IV on Programming for more on this topic).

7. Mediating systems.

If one has identified a list of alternative responses to be reinforced in an effort to decrease undesired responding, a token economy (Ayllon & Azrin, 1968a) may be useful as a mediating sys-

tem. The learner could receive tokens as reinforcement following the occurrence of each of the severally identified alternative behaviors. These tokens would, in turn, be exchangeable for items, privileges and special opportunities that have been individualized on the basis of a formal reinforcement inventory. A form for carrying out such an inventory, which follows the models provided by Cautela and his colleagues (Cautela & Brion-Meisels 1979; and Cautela & Kastenbaum, 1967) is provided in Appendix B. This token economy could be designed, therefore, to reinforce a range of alternative responses, many of which would be incompatible with the behavior targeted for reduction. The token economy could also provide a medium for more direct efforts at reducing undesired behavior as described in the other chapters of this book. Once the behavioral objectives have been accomplished, however, we also recommend that the artifical token system be gradually faded out and control be shifted to the more direct delivery of natural consequences.

8. Schedules of reinforcement.

When alternative responses have been defined in terms of discrete frequencies, we recommend that a continuous reinforcement (CRF) schedule initially be utilized. As the alternative responses increase and reach a steady state, we recommend gradually thinning the schedule to a fixed ratio (FR), variable ratio (VR), and ultimately to a variable interval format (Ferster & Skinner, 1957). This should insure the maintenance of the alternative responses during the process of thinning the reinforcement schedule, and maximize the resistance of the alternative responses to extinction when and if reinforcement is discontinued.

If the alternative response has been defined in terms of duration, we recommend a variable interval schedule. For example, we might want to reinforce someone for being at his work station. To insure that the learner comes in contact with the reinforcement contingency, we calculate how many reinforcement deliveries we want to have occur over a given period of time. In doing this, we also take into account our concerns about satiation and set as the upper limit an amount of whatever is being used as reinforcement, less than the learner would seek given free access over this same period of time. At the beginning of each session, staff are given the predetermined number of tokens, pennies, or other cue reminders. The learner must be reinforced for being at his work station a sufficient number of times that no tokens, pennies, or other reminders remain at the end of the session. As Zimmerman and Zimmerman (1962) have

pointed out, intermittent schedules also allow more time for other clients and responsibilities than do requirements for continuous reinforcement, especially for those behaviors which have been defined in terms of duration. Such specification of reinforcement schedules is important with the Alt-R strategy and is likely to be more effective than the more open ended reinforcement patterns typically used.

9. Use with other procedures.

Our final recommendation is that Alt-R be used in combination with other procedures. This will enhance its effectiveness and contribute to the possibility of long term treatment effects. Specifically, we recommend the use of Alt-R with Positive Programming (Chapter IV), Differential Reinforcement of Other Behavior (DRO) (Chapter VI), Differential Reinforcement of Low Rates of Behavior (DRL) (Chapter VII) and Extinction.

V. Research Ideas

Though popular, as we discussed, Alt-R remains a complicated procedure that requires careful attention to detail in order to be used effectively. We believe that the confusion surrounding this approach and the different interpretations and variations which have been reported in the literature account, at least partially, for the inconsistent and contradictory findings noted by others (e.g., Sulzer-Azaroff & Mayer, 1977). We have reviewed the literature in an effort to make meaningful suggestions for implementing this procedure. In addition, we believe that research into the following questions would provide further useful information in understanding this important technique:

1. What is the optimum alternative response in relationship to the target behavior?

2. Must the alternative response be incompatible and dissimilar to obtain maximum results, or do these factors interrelate with other variables that also need to be controlled?

3. What reinforcers should be used to strengthen the alternative response? Should it be the natural one determined to be maintaining the target behavior?

4. Should Alt-R be used in combination with other non-aversive procedures, such as DRO or DRL?

5. What is the optimum reinforcement schedule to strengthen and maintain the alternative response?

6. How can the target behavior be made resistant to recovery and rebound when the reinforcement schedule is discontinued for the alternative response?

CHAPTER VI

DIFFERENTIAL REINFORCEMENT
OF OTHER BEHAVIOR (DRO)

I. Introduction

Differential Reinforcement of Other Behavior (DRO) is among the better researched alternatives to the use of punishment in behavior management programs. This procedure is defined as reinforcement for engaging in any response other than the target behavior for a specified interval of time (Reynolds, 1961). If the target response is shouting obscenities, and the specified interval is five minutes, a reinforcer would be presented after five minutes of no shouting. Such a schedule would involve the differential reinforcement of any behavior other than shouting.

This schedule was first described and used by Reynolds (1961) in a study which investigated the phenomenon of behavioral contrast as a function of different behavior reduction procedures. Although this initial report was of a non-applied animal study, it augured well for the use of DRO in applied settings with people. Reynolds found that when responses were decreased with a time out or extinction procedure under one stimulus, the same responses were increased when in the presence of another stimulus. This behavioral contrast was found to be a functional property of both time out and extinction but not of DRO. Unlike time out and extinction, decreasing behavior with a DRO procedure under one stimulus did not produce increases in that behavior under another stimulus.

A number of variations satisfy the above definition for a DRO schedule. Each involves a specification of the target behavior which must not occur and a specification of the interval that must be re-

sponse-free in order for reinforcement to be presented. The first of these is the classic variation. It requires that the interval timer be reset each time the response occurs (e.g., Repp, et al., 1974). For example, if the target behavior is assaultive behavior and the specified interval is one hour, the learner could be presented with reinforcement at the end of every hour in which an assault has not occurred. Each time a temper tantrum does occur, however, the clock would be reset and a new one hour interval would begin.

A second variation is to keep the interval schedule fixed and to provide differential reinforcement at the end of each interval if the response does not occur (e.g., Repp, Deitz, & Deitz, 1976). The difference is that the interval timer is not reset with each response. Rather, if one or more of the target responses occurs, reinforcement is simply not provided at the end of that particular interval. If the target behavior is assaultive behavior and the specified interval is one hour (every hour on the hour), reinforcement would be presented at 1 p.m. if no temper tantrums occur between 12 noon and 1 p.m. If, however, a tantrum occurs at 1:10 p.m., the clock would not be reset. Rather, at 2:00 p.m., reinforcement would not be presented and a new interval would begin. If no temper tantrums occur between 2:00 p.m. and 3:00 p.m., reinforcement would again be presented at 3:00 p.m. and so on.

Procedurally, it is also possible to specify a variable interval as opposed to the fixed intervals prescribed in the first two variations. Such variable intervals could be incorporated into DRO schedules which either call for a reset of the timer each time a target response occurs or those which establish an a priori schedule of intervals. In the former case, the interval timer would be reset for an average of one hour each time a target response occurs, while in the latter, the a priori schedule would include pre-determined intervals of an hour's length on the average. The differential effect of such variable DRO schedules on the rate of response reduction, resistance to recovery during extinction, and on generalization across stimuli, responses, and time have not been empirically investigated in either the animal or human literature.

A final variation of DRO involves the escalation of the interval size as a function of reinforcement delivery or on the basis of some other schedule (Pickering & Topping, 1974; Repp & Slack, 1977; Topping, Graves, & Moss, 1975). That is, if the specified interval passes without a target response occurring and reinforcement is subsequently delivered as prescribed, the next interval could be increased by a certain amount. If the response does occur, however, the next interval would stay the same. Such escalating DRO schedules have been suggested to result in more rapid reductions in the

target behavior (Homer & Peterson, 1980). For example, if an hour goes by and the assaultive behavior does not occur, the next interval may be set at one hour and 15 minutes. If an assault does occur, however, the next interval would remain at the one-hour level.

These variations of DRO schedules are listed in Table 6.1. While they all include a specification of the target behavior which must not occur during the prescribed interval of time in order for the criterion for reinforcement to be met, they vary in three ways. The first variation involves either resetting the interval timer each time a response occurs or setting the intervals on an a priori schedule. The second involves the specification of either a fixed or variable schedule of intervals. The third involves the escalation or nonescalation of the interval size. The functional properties which distinguish these variations of DRO have not been addressed empirically in either the animal or human literature. Together they represent an interesting and important area of study.

Table 6.1
Variations of DRO Schedule Parameters

Reset Intervals vs. Fixed Intervals
Fixed Intervals vs. Variable Intervals
Escalation of Interval Size vs. Non-escalation of Interval Size

While a number of variations of DRO are possible, DRO has sometimes been confused with other procedures. One of these is the reinforcement of specific alternative responses, i.e., Alt-R (Woods, 1983). While Alt-R represents a viable alternative to punishment, it is procedurally different from DRO and is discussed in detail in Chapter V. DRO has also been confused with response cost or time out (e.g., withdrawing continuously available attention and affection as a function of target behavior occurrence) (Peterson & Peterson, 1968). The contingent withdrawal of a reinforcing stimulus or event is a punishment procedure (Catania, 1968) and should not be confused with DRO, which involves the contingent presentation of a reinforcing stimulus as a function of the non-occurrence of a specified response for a predetermined interval of time. As contingent withdrawal of a reinforcing stimulus or event is punitive, it is not within the purview of this book to discuss it in detail. Rather, the reader is directed to reviews of the literature on response cost and time out procedures as they are applied in behavior management programs using aversive strategies (Sulzer-Azaroff & Mayer, 1977; Weiner, 1964, 1969).

It should be noted that there is no clear explanation as to how DRO operates to decrease behavior. First, as its name implies, it may act to decrease undesired behavior by the strengthening of unspecified alternative responses. Second, it may act to decrease the target response through the contingent delay of positive reinforcement delivery. Even if the latter were shown to be the case, the literature in the field overwhelmingly addresses DRO as a positive procedure which represents a viable alternative to punishment (Homer & Peterson, 1980; Poling & Ryan, 1982).

The literature provides many examples of studies demonstrating the application of DRO. Studies utilizing DRO with animals in laboratory settings include those of Zeiler (1976), Reynolds (1961), Mulick, et al. (1976), and Uhl and Garcia (1969). These studies dealt with DRO techniques employed in experimenting with pigeons and rats.

In one of the earliest applications of this procedure to human behavior problems, Peterson and Peterson (1968) utilized a DRO schedule paired with a brief walk to decrease the self-destructive behavior of a boy labelled as retarded. Bostow and Bailey (1969) also used a combination of brief time out and reinforcement for non-aggression to modify severely disruptive and aggressive behavior of subjects who were considered to be retarded. Their follow up probes indicated that the suppressive effect of the DRO schedule was very durable. In a study to demonstrate the effectiveness of DRO compared to the use of extinction, Repp, et al. (1974) lowered sterotypic reponses of three adults who were retarded. This reduction was accomplished by delivering the reinforcer following specified periods of time in which the target behavior did not occur.

Another examination of the use of DRO tested the reduction of inappropriate behaviors in a variety of classroom sessions that involved individual instruction (Repp, et al. 1976). Three persons diagnosed as mentally retarded and exhibiting behaviors such as hair-twirling, hand-biting and thumb-sucking reduced their rate of these inappropriate behaviors when specified periods of no such responses were differentially reinforced.

Frankel, et al. (1976) used differential reinforcement to inhibit the rate of aggression and head-banging in a six-year-old female labelled mentally retarded. In the combined application of DRO and DRI, Leitenberg, Burchard, Burchard, Fuller, and Lysaght (1977) suppressed sibling conflicts, once again demonstrating the effectiveness of positive reinforcement procedures.

Repp and Slack (1977) employed DRO schedules in ascending interval rates with retarded adults to decrease problem responses. In an attempt to reduce stereotypic rocking, Ball, McGrady, and Teix-

eira (1978) used a mercury switch and timer-controlled buzzer along with the DRO schedule to shape standing behavior. Lowitz and Suib (1978) reported the treatment of escalated DRO to eliminate thumb-sucking to avoid dental malocclusion. The goal was to transfer the deceleration of the behavior from the lab setting to more natural settings. This goal was met.

Another treatment of DRO was applied by Luiselli, Helfen, Collozzi, Donnellon and Pemberton (1978). A child diagnosed as mentally retarded suppressed self-injurious biting during treatment as well as in follow-up through the implementation of DRO on a fixed schedule of reinforcement. Most recently, Coleman, Whitman and Johnson (1979) explored the effects of a DRO schedule on an institutionalized boy labelled mentally retarded to decrease self-stimulatory behavior. The reduction rate was met, and the procedure proved successful in an attempt to generalize the reduction to other settings in the institutional environment.

While some of the early DRO literature cited above combined DRO with punishment, the more recent findings indicate that DRO can be effective *without* punishment. DRO is clearly a positive strategy that can stand on its own. It represents a strong contribution to our non-aversive technology (Homer & Peterson, 1980).

II. Advantages

Comparative research must still be considered in its infancy, given the difficulty in identifying and controlling all of the relevant variables involved (Homer & Peterson, 1980). Nonetheless, several preliminary studies from applied as well as animal research are encouraging. As a strategy for reducing problem behaviors in applied settings, DRO may have a number of advantages. These include the lack of behavioral contrast, minimal if any negative side effects, the generalization of effects, speed of effects and social validity.

A. Behavioral Contrast

The first advantage is the finding by Reynolds (1961) that, while extinction and time out reduced behavior under one set of stimulus conditions, those behaviors increased under stimulus conditions in which those procedures were not in effect. This behavioral contrast was not produced when the animals' behavior was reduced using a DRO procedure. Obviously, in programs designed to reduce problem behavior, one of the aims is to generalize treatment gains across settings. When behavioral contrast is produced, the opposite

occurs and behavior problems increase in extra-treatment settings. A reductive procedure which does not produce such behavior contrast would have a clear advantage over procedures that do. While Reynolds' (1961) work suggests that DRO may have this advantage, this issue needs to be investigated in applied settings. Further, this absence of behavioral contrast as a possible functional property of DRO should be compared to other aversive as well as non-aversive procedures.

B. Side Effects

A further advantage of DRO may be that it produces no negative side effects (Homer & Peterson, 1980). Generally, the side effects of behavioral intervention are not systematically measured and reported in the literature, in either comparative or non-comparative studies. When the side effects of extinction or punishment are reported, however, they are frequently negative, including such undesirable manifestations as agitation, aggression, escape, avoidance, and a decrease in social behavior (Foxx & Azrin, 1972; Hutchinson, Azrin, & Hunt, 1968; Kazdin, 1975a; Lawson, 1965; Martin, 1977; Meichenbaum, Bowers, & Ross, 1968; Pendergrass, 1972). In fairness we must acknowledge that these findings are not universal and that positive side effects are also sometimes reported even for such extreme procedures as contingent electrical shock (Lichstein & Schreibman, 1976). Nonetheless, no negative side effects have ever been reported for DRO. Pending the outcome of future research, we may infer at this time that DRO represents a lower risk of negative side effects than extinction or punishment. If this inference continues to be empirically confirmed, it represents an additional advantage of DRO in behavior management programs.

C. Generalization

The findings of preliminary research also suggest that DRO may contribute more to the generalization of treatment gains across settings than certain other intervention strategies (Barkley & Zupnick, 1976; Garcia & DeHaven, 1976; Lowitz & Suib, 1978; Weiher & Harman, 1975). Generalization across time has also been reported suggesting that DRO compares favorably to extinction and other procedures in terms of post-treatment recovery of the target behavior and resistance to reestablishment even after the original contingencies are reinstated (Barkley & Zupnick, 1976; Bostow & Bailey, 1969; Iwata & Lorentzson, 1976; Repp & Deitz, 1974; Weiher & Harman, 1975).

D. Speed of Effects and Social Validity

It appears that DRO can result in the rapid reduction of behavior problems (Deitz, Repp, & Deitz, 1976; Repp, et al., 1974; Repp, et al., 1976). Further, and perhaps most important, DRO is socially acceptable to on-line staff. Our experience is that staff and classroom personnel are in fact more comfortable with DRO procedures than with time out and other aversive interventions. This combination of attributes has considerable advantage over procedures which may even be more rapid but complex to administer and/or may draw negative attention to the client, the staff, and the program.

In summary, the advantages of DRO appear to include the lack of behavioral contrast, no known negative side effects, enhancement of the generalization of treatment gains across stimuli and across time, frequently rapid behavioral reduction, easy implementation, and social acceptability.

III. Cautions

Along with these advantages come a number of cautions pertaining to the use of DRO to reduce problem behaviors.

A. Non-specificity of Response

The first is that no specifically identified response is reinforced when using DRO. As long as the target response does not occur during the specified interval, reinforcement is presented. The procedure could result in inactivity, making it difficult to teach desirable behaviors. This is of particular concern if the learner for whom DRO is being applied does not already have a rich and varied repertoire of functional behaviors, as is often the case with those who exhibit serious behavior problems. Where this is a major concern, some have suggested that differential reinforcement of alternative responses (Alt-R) be used as a non-aversive strategy (see Chapter V). Unfortunately, the Alt-R approach makes sense only if the learner already has the competing response in his repertoire and if it can reliably occur at the appropriate time to provide the occasion for reinforcement delivery. Where there is no functional, competing response, DRO may be the only option of the two. To avoid the pos-

sibility of building in "dead man" behavior, it is important that DRO only be used in the context of a comprehensive instructional program designed to give the individual a variety of functional skills (see Leitenberg, et al., 1977 and Chapter IV).

B. Inadvertent Reinforcement

Using DRO, we reinforce any other behavior. This raises the possibility that we may inadvertently reinforce a non-targeted undesirable response or create superstitious responding. Strategies for dealing with this are presented later under suggestions for implementation.

C. Reinforcement Delivery as a Discriminative Stimulus

A final caution concerning DRO procedures is that the presentation of reinforcement can become a discriminative stimulus for the target behavior. This seems most likely to occur if the DRO interval is reset after each occurrence of target behavior. In such a case the specified interval might pass, reinforcement would be delivered and shortly after the interval timer was reset, the target behavior would recur, requiring that the interval timer again be reset. This pattern essentially allows the person to "have his cake and eat it, too." As the response is timed to occur immediately after reinforcer delivery, and since the timer is reset right after the response is emitted, careful timing by the learner will result in his receiving almost all of the possible reinforcers without a significant reduction in the problem behavior. In one such case (LaVigna & Donnellan, 1976), a young man in an institutional setting was reinforced once per week for the non-occurrence of destructive behaviors. Immediately after receiving the reinforcer, he would engage in several destructive acts and, as the procedure included a resetting of the timer, he was still able to receive his reinforcement at the end of the following interval.

While research on this phenomenon is virtually nonexistent, as mentioned earlier, it appears to occur particularly in DRO schedules where the interval is reset immediately following a response. Fixed or variable interval DRO procedures based on a priori schedules may, therefore, provide an interesting solution to this problem. In any case, this is an important and interesting question to investigate empirically.

Another solution to the problem of response after reinforcement may be the differential reinforcement of other behavior with a progressively increased schedule of reinforcement (DROP) for each

consecutive interval in which the target behavior does not occur (LaVigna, 1978). One unit of reinforcement could be presented after the first interval of no target behaviors, two units after the second consecutive interval of no target behaviors, and so on, up to the point, for example, where the eighth consecutive interval of no target behaviors would be consequated with eight units of reinforcement. The eight units of reinforcement would again be delivered for each subsequent consecutive interval free of the target response. If the target response occurred, reinforcement would not be delivered and the timer would be reset. The next interval for which reinforcement is earned, reinforcement magnitude would be recycled back to the one-unit level and increased accordingly. Such progressive schedules eliminate the possibility of the learner maintaining the optimum density of reinforcement without sharply decreasing the frequency of responding and may, therefore, avoid the discriminative properties of reinforcement delivery for target responding.

While DROP procedures have not been widely reported in the literature, we use them quite regularly in our respective professional practices, often for the purpose of eliminating very serious behavior problems. One such application involved a young man whose destructive behavior was the primary reason he was in a state institution (LaVigna & Donnellan, 1976). Initially, he was given 50 tokens on a DRO schedule for one week of no destructive responses. Unfortunately, however, following reinforcement, he would typically engage in the problem behavior. The procedure was changed to DROP schedule in which he received 50 tokens for one week of no destructive responses, 100 tokens for the second consecutive week, 150 tokens for the third and 200 for every consecutive week thereafter. Any occurrence of destructive behavior recycled the reinforcement schedule back to the 50 token level. As can be seen in Figure 6.1, this progressive schedule resulted in almost immediate and total control over this behavior, which had an initial baseline rate of one destructive behavior per day. At a minimum, DROP procedures represent an interesting topic for future research in the further development of our non-aversive technology.

IV. Suggestions for Implementation

A. Selection of Target Behaviors

When a learner has a large number of inappropriate responses in his repertoire, one suggestion is to choose the target behaviors for

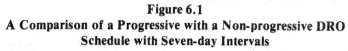

Figure 6.1
A Comparison of a Progressive with a Non-progressive DRO Schedule with Seven-day Intervals

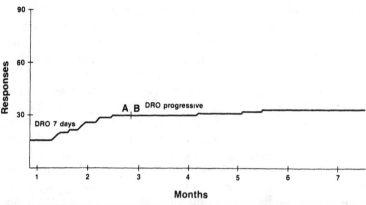

the DRO schedule which represent the priority behavior problems for that learner. Thus, if behaviors include cursing and property destruction, we would probably choose window-breaking, with full recognition that we would not simultaneously be reducing cursing. We could further specify that at the end of an interval of no destruction, the reinforcer will not be delivered until at least five minutes had passed with no cursing. This "limited hold" function would serve to avoid the possibility of inadvertently reinforcing another inappropriate behavior. A third possibility involves including a number of problems within a single definition of a response class for purposes of a DRO schedule. For example, if a learner's problem behavior includes head-banging, window-breaking and clothes-tearing, these could be included in a single DRO response class. Thus, the specified interval would have to go by without any of these behaviors occurring in order for the criterion for reinforcement delivery to be met. This approach makes particular sense when the separate behaviors serve a single function for the learner, such as to obtain attention or to avoid a task (see Chapter III on Functional Analysis). It makes less sense, although it still may work, when the separate behaviors serve separate functions. That is, one would be less inclined to combine self-injurious behavior maintained by contingent adult attention and stereotypic behavior maintained by sensory feedback into a single response class for a DRO intervention. When combining multiple behaviors into a single response class is not possible, however, the priority behavior problem should ordinarily be selected first.

B. Selection of Time Interval

The selection of an appropriate time interval is one of the keys to successful behavior reduction using a DRO strategy. The interval selected should be based on the interresponse time (IRT) (Catania, 1968) under baseline conditions. The IRT is the average length of time between responses. If a response occurs 30 times in a five hour period, the average length of time between responses, (i.e., the IRT) is ten minutes. If the DRO interval selected is too long, the learner will not come in contact with the contingency for reinforcement and therefore will not come under its control. For example, if the IRT of a problem behavior is an hour, a DRO schedule based on a two-hour interval is not likely to be effective as the chances are that an occasion for reinforcement is not likely to occur. Similarly, a DRO schedule is not likely to be effective if the specified time interval is too small, as the occurrence of a target response would not significantly impact the overall density of reinforcement. Again, if the IRT of a problem behavior were to be an hour, a DRO schedule based on a one-minute interval is not likely to be effective, as the occurrence of a target response could still result in the delivery of reinforcement 59 out of 60 times. This is only negligibly less than the 60 out of 60 times that would occur if the behavior were totally eliminated.

A sensible guideline calls for the selection of an interval equal to one-half the inter-response time during baseline conditions. If, for example, the IRT is one hour, i.e., the response occurs an average of once an hour during baseline, the initial DRO interval might be one-half hour. This assures that the learner will come in contact with the contingency for reinforcement 50% of the time, assuming baseline rates continue. If we have selected an effective reinforcer, we should be able to increase the proportion of intervals that are response free from 50% up to a level approaching 100%. If 100% of the intervals are free of target behavior, we have obviously eliminated that behavior.

C. Selection of DRO Variation

Unfortunately, there are no empirically established guidelines for selecting one DRO variation over another. We simply do not know much about the differences in their functional properties, or how these properties differentially affect the rapidity of behavioral reduction, generalization, resistance to recovery and reestablishment, side effects or other important dependent variables. Practi-

tioners typically start off with a fixed interval DRO with either an a priori interval schedule or by resetting the interval timer every time a target behavior occurs. Our experience is that practitioners will often move to a variable interval DRO as a step toward fading out the intervention on the assumption that it will facilitate generalization of treatment gains across time. This is analogous to moving from a CRF to a straight variable interval schedule. However, whether behavior reduction is more permanent after a variable DRO than it is after a fixed interval DRO has yet to be investigated empirically.

Our choice is to start with a fixed interval, a priori DRO schedule. In our experience, this usually avoids establishing the reinforcement delivery as a discriminative stimulus for the target behavior. If necessary, it is also possible to move to a "DROP" variation quite easily. Others prefer an escalating DRO because of findings that suggest that behavior may thus be brought under more rapid control (Homer & Peterson, 1980). As there are no guidelines to suggest how large the escalation should be, this decision is left to clinical judgment.

D. Selection of Reinforcers

Ideally, the reinforcer in a DRO procedure should be the one identified in the functional analysis as maintaining the target behavior. For example, if a learner exhibits temper tantrums to get attention, attention should be used differentially to reinforce specified intervals of time which occur tantrum free. However, it is not always possible to identify or, if identification is achieved, to control the reinforcer maintaining the undesired behavior. Unlike extinction, DRO as a reductive strategy does not require us to do so (Rachlin & Baum, 1972; Zeiler, 1976). We must simply identify a reinforcer that is sufficiently powerful to offset the reinforcer maintaining the behavior we wish to eliminate.

In determining what and how much to use as a reinforcer, certain guidelines should be kept in mind. Whenever possible, the reinforcer selected should be available only through criterion performance under the DRO schedule. If the reinforcer is available to the person in some other way, the effectiveness of the DRO schedule may be undermined. Further, the density of reinforcement under optimum DRO performance should be somewhat less than what the learner would ordinarily seek for himself if he were left on his own and given free access.

A single example will illustrate both of these points. Suppose

we wish to use as a reinforcer the opportunity to watch the living room TV for one-half hour for every four-hour interval that passes free of a temper tantrum during a 16-hour day. If the person has free access to a bedroom TV, this schedule is not likely to be as effective as possible. Also, if he ordinarily watches TV only for an hour a day, this schedule, which offers the opportunity to watch for two hours a day, provides only a partial incentive for him to decrease temper tantrums. To be most effective, a schedule of reinforcement must keep him wanting a little more, even under optimum performance (see Footnote 1).

E. Fading Out

While research findings suggest that behavior reduction is resistant to recovery and/or reestablishment after the sudden termination of a DRO intervention, we favor a more gradual fading out of the procedure once the rate of behavior has reached an acceptable level. This can be accomplished by systematically escalating the DRO interval and/or by switching over to a variable interval schedule if the initial intervention did not already incorporate these features.

If, on the other hand, the behavior has been reduced but not to an acceptable level, we have found that switching to a DROP variation often contributes additional and sufficient effectiveness to the intervention. DROP schedules require the use of reinforcers that can be presented in progressively increasing units. These may be 1, 2, or 3, or however many exchangeable tokens, ounces of beverage, slices of pizza, minutes of one-to-one time with staff, hours of TV, etc. In deciding the rate of progression and maximum values it is best to anchor the upper end first and work backwards. The upper level should still represent a little less than that learner would self-acquire and be reasonable in its density. If exchangeable tokens are to be used, the economy of exchange rates should be based on the assumption that the learner will be earning at maximum levels. Care at this level will assure the greatest potentiation of the available consequences as positive reinforcers.

F. Positive Programming

There is another consideration when the learner does not have a repertoire of functional skills. Even if effective, DRO alone in such a situation would not help increase the learner's functional behavior. Rather, it is necessary to design a positive program (Chapter IV) to develop the person's ability to behave in appropriate and ac-

ceptable ways which are functional in obtaining significant and meaningful payoffs (Leitenberg, et al., 1977). Without such a constructive context, DRO would be subject to the charge of creating "dead man" behavior and on this dimension at least would be no better than punishment. This, of course, is not a major consideration in dealing with a learner who has a demostrated repertoire of functional skills able to fill the void left by the eliminated behavior problem. Still, we caution against unwarranted assumptions (Donnellan, 1984). In one study where behavior labelled as sibling rivalry was reduced with a DRO procedure, the brothers simply stopped playing together (Leitenberg et al., 1977). In this case, it was necessary to teach them appropriate play skills, as well as to attempt to reduce inappropriate responses.

G. Target Behavior Occurrence

One question always comes up when implementing a non-aversive procedure: "What do we do when the target behavior occurs?". There are a number of options when implementing a DRO strategy. The target response could be ignored, and, if attention was at all part of the positive reinforcement maintaining the response, this should facilitate the effectiveness of the DRO procedure by adding an element of extinction to the intervention package. If the behavior is not one that can be ignored, you might try telling the learner "No!". This may technically be considered an aversive consequence, but if done in a firm but matter-of-fact way as feedback, it is certainly innocuous and socially acceptable; moreover, it has been reported to be quite successful when used with a DRO schedule (Repp & Deitz, 1974). For severely dangerous and/or destructive behaviors, it may be necessary to employ an emergency intervention procedure. For more on the topic of target behavior occurrence, see the footnotes and comments in Chapters I and V.

V. Research Ideas

The widespread applicability of DRO to the reduction of severe and not so severe behavior problems is amply documented by at least two separatate reviews of the literature (Homer & Peterson, 1980; Poling & Ryan, 1982). These reviews tend to emphasize the importance of comparative studies, in order to determine which is "better," DRO or procedure X. We believe this emphasis is prema-

ture. First, truly comparative studies seem difficult, if not impossible, until we can find a way of equating the degree of reinforcement in a DRO schedule to, for example, the degree of punishment used in an aversive procedure (Benasi, 1976). Second, we need to know more about the conditions under which DRO can be used effectively and how to maximize its effectiveness under those conditions. In this spirit, we offer the following research ideas, which represent only a few of the important questions that remain to be answered about DRO as a reductive strategy for human behavior problems.

A. What are the functional properties of DRO schedules implemented under clearly discriminable stimulus conditions versus those implemented under poorly discriminable conditions? In particular, does increased discriminability detract from the resistance to recovery which has been associated with DRO schedules?

B. Does the finding about the lack of behavioral contrast in animal studies also hold for applied studies?

C. What are the differences in the functional properties of the variations of DRO as they affect rate of reduction, generalization and side effects? Specifically, what is the functional difference between fixed and variable interval DRO schedules?

D. What are the differences in the functional properties of DRO schedules utilizing the reinforcer identified as maintaining the undesired behavior, and those using an unrelated reinforcer?

E. What is the optimum method of escalating DRO schedules?

F. Under what conditions can DRO schedules of reinforcement be applied to the solution of severe but low frequency behavior problems?

G. Under what conditions can DRO schedules be used most effectively with people who are mentally and linguistically impaired?

H. What, if any, side effects are associated with DRO schedules?

In summary, it appears that DRO Procedures have the potential for successful application in a wide variety of settings and situations. Given the non-constructional nature of DRO, it should, of course, be used only in a solid context of positive programming. Within such a context, it can be one of our most powerful non-aversive behavioral strategies.

Footnotes

1. While we are making this point now within the context of our discussion concerning DRO, it is applicable to any intervention using a schedule of reinforcement. That is, the total amount of reinforcement available, assuming maximum performance under a specified

schedule of reinforcement, should be somewhat less than (probably no more than 80% of) what the learner would seek given free access to that reinforcer. Research has indicated that arranging for deprivation in this way maximizes the effectiveness of the intervention (Konarski, Johnson, Crowell, & Whitman, 1980). In fact, in kind of a twist on the Premack Principle (Premack, 1959), Konarski et al. have shown that it is even possible to reinforce and increase high probability behavior with the contingent opportunity to engage in low probability (but not absent) behavior. This is possible as long as the opportunity to engage in the low probability response is less than the learner sought, in relation to the high probability response, under baseline conditions.

DIFFERENTIAL REINFORCEMENT OF LOW RATES OF RESPONDING (DRL)

I. Introduction

A most promising strategy for the non-aversive management of behavior problems in applied settings is the Differential Reinforcement of Low Rates of Responding (DRL). DRL schedules of reinforcement were first described by Skinner (1938) in a discussion of temporal discrimination.

A. DRL-IRT

The classical definition of the procedure Skinner described is that reinforcement is delivered as a consequence of a target response but only if that response occurs after an interresponse time (IRT) of some specified amount; i.e., only if a specified interval of time has elapsed since the last response. We term this procedure DRL-IRT. If one specifies an IRT which is greater than the average IRT during baseline conditions, a DRL schedule will increase the average IRT and, as a consequence, lower the overall rate of the behavior. One example of this procedure is the case in which a problem behavior occurs approximately six times an hour over a five-hour period for an average baseline IRT of ten minutes. The baseline data might also disclose that the IRTs ranged from three minutes to 20 minutes. If we establish a DRL schedule in which reinforcement is delivered after every target response following an IRT of ten minutes or more, this will result in an increase in frequency of long IRTs (IRT >10)

while decreasing responses following short IRTs (IRT<10). If we are successful in raising the average IRT to some level over ten, we will have reduced the overall rate of the target response. An average IRT of 15 minutes would mean an average of four responses an hour for a one-third reduction in the rate of response compared with baseline conditions in this case.

An overwhelming number of studies investigating the functional characteristic of DRL schedules applies them in the manner described above using animals as subjects (Kramer & Rilling, 1970). Ironically, although the schedule was first conceptualized within the context of temporal discrimination, it appears that temporal discrimination is not necessary for behavior to come under the control of a DRL-IRT schedule. A variety of investigations suggests that, instead, certain stereotyped responses are developed to fit the IRT and this ritualistic behavior acts as a mediating response (e.g., Kapostins, 1963; Latries, Weiss, Clark & Reynolds, 1965; Segal-Rechtschaffen & Holloway, 1963; Wilson & Keller, 1953). In fact, in one of the few human experimental studies of DRL-IRT, involving a key pressing response (Bruner & Revusky, 1961), the subjects reported their conviction that reinforcement could be obtained only by a specific pattern of responses on at least one of the other keys in order to set up the reinforced key. No subject in this study expressed an opinion that reinforcement depended in any way upon the passage of time.

The body of DRL research is considerable. In fact, more research has been published in the Journal of Experimental Analysis of Behavior on DRL schedules than on Variable Ratio (VR) schedules (Kramer & Rilling, 1970). It is difficult, though, to draw useful information from this literature for our purposes of furthering the development of alternatives to punishment in behavior management programs in applied settings. The reasons for this are threefold.

1. Most of the experimental work designed to identify the functional properties of DRL schedules has been carried out with animal subjects (Kramer & Rilling, 1970). Relatively little experimental work has been done with humans in examining the extent to which findings with animal subjects generalize to human subjects.

2. Behavior under the control of a DRL schedule appears very complex and this may account for many of the contradictions reported in the literature.

3. Research with humans has adopted a different paradigm for applying DRL schedules to behavior problems in applied settings. We refer to this applied approach with the more general designation of DRL.

B. DRL

This alternative paradigm for doing DRL research with humans was first introduced by Dietz and Repp in 1973 and involves a more accurate reflection of the procedural definition. Their definition involves determining the average number of responses per specified interval of time and delivering contingent reinforcement at the end of any interval in which frequency is at or below baseline rate. Accordingly, it literally means the differential reinforcement of low rates of responding. Using our previous example, rather than reinforce responses that were preceded by sufficiently long IRTs, we would deliver reinforcement for each interval (e.g., every hour on the hour) if responses during that interval occur at a low rate — say six or fewer for the hour. Kramer and Rilling (1970) defined this DRL contingency rule as "the emission of 'n' or less responses within a certain elapsed time interval." It is this interpretation of DRL which is more reflected in the applied literature.

Although the number of applied investigations of DRL is small, as the following studies indicate, it is a growing area of research showing the applicability of DRL to a wide variety of problems in human behavior.

As indicated earlier, Dietz and Repp (1973, 1974) have done much of the seminal work utilizing this procedure. Prior to their studies, however, Bolstad and Johnston (1972) used a series of DRL schedules to modify such classroom behavior problems as "talking out of turn," "out-of-seat behavior," and aggression. This study used yet another variation on the procedure in that the students were differentially reinforced as a function of response rate; e.g., eight points for less than five disruptions, four for six to ten, none for more than ten. This kind of procedure was demonstrated to be effective, although the later work with DRL did not follow up on the Bolstad and Johnson variation.

Dietz and Repp (1973, 1974) conducted a variety of experiments utilizing DRL schedules in both regular and special education classrooms. In a series of three studies with regular fifth graders, they used a DRL schedule to reduce the "talking out" behavior of an 11-year-old boy. The average rate of his responding fell from 4.45 per 45-minute session to 1.83 per 45-minute session as a function of the delivery of non-exchangeable gold stars contingent upon two or fewer responses per session. During the reversal phase, the rate went to 7.60 per session and dropped again to a 1.20 per session average when the stars were reinstated.

Using a similar contingency, Dietz and Repp (1974) reduced the "out of seat" behavior of a sixth-grade girl in a regular education class. Reinforcement was contingent on the occurrence of two or fewer responses in the 45-minute session, the behavior went from an average rate of 6.10 during baseline, to 0.16 during treatment, to 6.0 during the reversal and down again to 0.40 during reinstatement.

The third study in the series reduced the same behaviors in a fifth-grade boy. Gold stars were made contingent on both low rates of out-of-seat behavior and talk-outs. Out of seat responses fell from a rate of 7.50 per session to 1.14 and talk-outs were reduced·in rate from 4.66 to 1.14. In their discussion of these studies, Dietz and Repp (1973) indicated that the students were told only that they were receiving these conditioned reinforcers because they did "fewer than X responses." Furthermore, they commented that the conditioned reinforcers were sufficient to maintain the lowered rates of behaviors without resorting to more elaborate token or other exchange programs. The authors suggested that research is needed regarding the differential effects of providing feedback on rate.

In a particularly interesting study, Dietz and Repp (1973) utilized DRL schedules to reduce group verbal behavior. The problem was "subject change," i.e., changing the topic from an academic subject to another, usually social, topic. The experiment had six phases. Phases one and six represented baseline conditions; during the other phases the DRL criteria for reinforcement were progressively reduced from six to zero subject changes during the 50-minute class. The conditions were maintained for the first four days of the week and the contingent reinforcer for the group was free time on Friday. As in the previously reported studies, the experimenters explained the contingencies to the class but did not inform the students of their accumulated responses. The average number, range and rate of responding fell to criterion level during each of the phases, including phase five, in which the procedure actually became a DRO schedule. During reversal, rate of subject change was up. Decreasing the DRL limits was shown to have an orderly effect on reducing response rates.

In addition to their work with normal elementary and high school students, Deitz and Repp (1973) developed a series of experiments with children diagnosed as mentally retarded. Again, both individual and group contingencies were employed. In one study, talk-outs were targeted as the response to be reduced. The subject was an 11-year-old who was considered mentally retarded. His talk-out behaviors included talking, singing, humming to himself, and making

statements not related to the ongoing class discussion. The average rate of these behaviors in the pre-treatment phase was 5.7 for a 50-minute session. During treatment the student was instructed that he would be rewarded with five minutes of playtime at the end of the day if he engaged in fewer than three talk-outs during one session. At the end of each session he was also informed whether or not he met the requirement. The results indicated that the DRL contingency was effective in reducing his rate of talk-outs to 0.03 per session. At no time during the treatment did the target response exceed the specified requirement. The reduction of the behavior occurred immediately, the student was able to earn the free time each day, and the reduced levels of talk-outs were maintained during treatment.

Dietz and Repp (1973) then applied the DRL contingencies to deal with talk-outs in a group of students labelled trainable mentally retarded and described by their teacher as extremely disruptive. During baseline, the group rate for talk-outs was 32.7 for the 50-minute class session. This was reduced to a rate of 3.13 during treatment and went up to 27.16 during reversal. During treatment the students were told that they would each receive two pieces of candy if there were five or fewer talk-outs during the session. At the end of each session they were told whether the requirement had been met but were not given a moment by moment account of the accumulated responses. Overall, the DRL contingency reduced the variability as well as the frequency of responding by a factor almost equal to 10.

The Dietz and Repp (1973, 1974) studies clearly indicate that DRL is an effective management tool for both individual and group behavior. In each case they were able to identify powerful reinforcers, such as free time. Some would argue against the loss of such time for instructional purposes. However, Dietz and Repp reported the teacher's opinion that four days of instructing students who were not disruptive was better than five days of having to teach and deal with disruption as well. They did not, however, report any empirical evidence to support her opinion.

II. Advantages

There are several important advantages that DRL strategies can contribute to reducing human behavior problems in applied settings. These include the reduction of high rate behavior, flexible interval size, staff acceptance, reinforcement frequency, tangible feedback, speed of effects, potential for group contingencies, non-

specific reinforcement, and, in combination with other procedures, potential for completely eliminating a response.

A. High Rate Reduction

DRL can be used successfully to reduce high rate behaviors. Thus, it may have even greater applicability than DRO and, certainly, more than many aversive strategies. In some case, for example, the behavior may be one which we want to eliminate but the rate is so high that a DRO schedule would be difficult if not altogether unrealistic (see Suggestions for Implementation for a discussion of how DRL can be used to reduce rates to an acceptable level for implementing a DRO schedule.) In many other cases, however, we are dealing with a behavior which is only a problem because it is at an unacceptably high rate. We might, therefore, want to reduce but not eliminate it. For example, we might want to reduce the rate of perseverative speech in a person with a mental disorder but certainly would not want to eliminate speech entirely. Likewise, we would not want to eliminate "out of seat," "laughing," and a host of other classroom behaviors which are problems only when they are excessive.

B. Flexible Intervals

DRL has the additional advantage of allowing flexibility in establishing the reinforcement interval. The size of the interval with DRO schedules is (as discussed in Chapter VI) a function of the average IRT under baseline conditions. Using a DRL strategy, however, we can set the interval size at virtually any length fitting the flow of events in the natural setting. This, for instance, could be a 20-minute interval coinciding with a one-to-one language session, an hour coinciding with the length of an entire math class, or the entire morning or afternoon to adapt to a job site schedule. In a residential setting, the interval could be set from wake-up to the time the learner leaves for the day's activity, e.g., from 6 A.M. to 8 A.M., and then from the time the learner arrives home to bedtime, e.g., 4 P.M. to 10 P.M. This flexibility is possible because the critical aspect of the procedure is not the size of the interval but the rate of responding.

Rate can be held constant across a range of intervals, making it possible to adopt an interval size most suited to the other requirements of the natural setting. Once a specific rate has been established as a DRL criterion for reinforcement, we can hold it constant by changing the frequency criterion as a function of the interval size.

For example, Table 7.1 shows the different frequency criteria that could be established for various interval sizes holding the rate criterion at a constant of six responses in 60 minutes, compared with those corresponding to a rate criterion of three responses in 60 minutes.

Table 7.1
Changing DRL Criteria As a
Function of Interval Size

DRL Rate Criterion for Reinforcement

F6/60 Min.		F3/60 Min.	
Frequency Criterion	Interval Size	Frequency Criterion	Interval Size
2	20 min.	1	20 min.
3	30 min.	1.5 (<2)	30 min.
6	1 hr.	3	1 hr.
12	2 hrs.	6	2 hrs.
24	4 hrs.	12	4 hrs.
48	8 hrs.	24	8 hrs.

C. Reinforcement Frequency

This flexibility is an advantage because it allows the DRL interval to be set at a length such that reinforcement delivery need not interfere with or interrupt the flow of events occurring in the natural settings. In this regard, it is less intrusive (Donnellan, Mesaros, & Anderson, 1984). As noted, it may also have the advantage of being more manageable than the smaller interval size that might be required in a DRO schedule. Using a DRL strategy, we can establish an interval that is not only more manageable but less likely to result in reinforcer satiation and depotentiation.

D. Tangible Feedback

As noted earlier, Dietz and Repp (1973) suggested the possibility of developing methods to inform learners of the accumulation of target behavior occurrences. This would presumably provide information and feedback, allowing each learner to more effectively meet the criterion of reinforcement. Adding this component to a

DRL schedule may lead to more rapid control over behavior. While research is needed in this area, clinical and classroom experience with learners who are labelled severely/profoundly handicapped suggests that this rapid control does not take place (Donnellan & LaVigna, in press; LaVigna, 1978). More importantly, such feedback mechanisms appear to make DRL schedules more tangible and concrete for those cognitive abilities may make such schedules difficult to understand. Several feedback systems have been utilized with normal and special populations. Dietz and Repp (1973), for example, posted numbered cards on the teacher's desk to indicate how many responses had occurred for a DRL schedule applied in a group contingency. In our own work with severely handicapped populations, we have developed self-monitoring systems whereby the learner moves a counting object (marbles, chips or other items) from one container to another in order to keep track of the number of responses that have occurred since the beginning of the interval. If we start with a number of counting units in the first container equal to the DRL criterion for reinforcement, the learner is more likely to see the relationship of his behavior to the reinforcement contingency. Even for very handicapped learners, these concrete systems help to make the following kinds of connections:

1. If I do \underline{X}, I move an item from Container A to Container B.

2. If there are any items left in Container A when the bell rings, I receive something good.

3. If I don't do \underline{X}, there will be items left in Container A when the bell rings.

4. If I don't do \underline{X}, I will be reinforced!

The intent of such procedures is to maximize the informational feedback to the learner to bring about a more rapid control of the DRL contingency over the target behavior.

E. Speed of Effects

Another advantage of DRL schedules is that they can lead to rapid control. While the necessary conditions for rapid control have not been identified explicitly, it is important to realize that the utilization of a DRL strategy does not necessarily mean a protracted period before control is established. Once the contingency rule for reinforcement is understood, responding meets and often exceeds the DRL criterion (Dietz & Repp, 1973; Donnellan and LaVigna, in press; LaVigna, 1978). A number of variables need to be investigated for the contribution they can make to the rapidity of control. These are discussed in this chapter's section on research ideas.

F. The Potential for Group Contingencies

As noted above, the work of Dietz and Repp (1973) has demonstrated that with certain populations DRL contingencies can be applied even to group behavior. The advantage of this is obvious in that one intervention may serve to modify everyone's behavior in a classroom or other group setting. This provides increased ease of management and the most efficient use of staff time. The minimum requirement, of course, would be the identification and definition of a behavior problem shared by a significant number of learners and the identification of either a reinforcer comparably effective for all the members of the group or a generalized pay-off (such as tokens) which could be exchanged for more individualized reinforcers.

G. Non-specific Reinforcement

Finally, DRL shares with DRO the advantage that, while desirable (Rotholz & Luce, unpublished), one need not necessarily identify the reinforcer maintaining the undesired behavior provided that the reinforcer used in the DRL schedule can effectively compete. That is, if the consequence for engaging in a behavior at a decreased rate is more powerful than the consequence for maintaining the behavior at higher rates, the behaviors should be weakened and begin to occur less often.

In summary, there are a number of advantages associated with DRL as a non-aversive strategy for reducing behavior problems in applied settings:

1. DRL can be useful in dealing with a wide variety of behaviors which are problems only as they occur at high rates.

2. Relative to DRO, there is more flexibility in setting the size of the reinforcement interval. This factor makes it possible to integrate the intervention with less intrusiveness and interruption in the natural flow of activities and events in the natural setting.

3. On-line staff report that they find DRL an effective and manageable intervention strategy to use in applied settings, such as the classroom (Deitz & Repp, 1973, 1974).

4. DRL schedules have a lower density of reinforcement delivery than DRO strategies, making it easier to avoid the problems associated with satiation.

5. DRL schedules lend themselves to concrete monitoring systems using innocuous, non-aversive consequences and may accordingly enhance the establishment of behavior control through the informational feedback which can be provided to the learner.

6. Under certain condition, DRL can lead to rapid control over serious behavior problems.

7. DRL contingencies can be applied to the control of group behavior.

8. It is not necessary to identify and control the reinforcer maintaining the undesired behavior in order to reduce the frequency of the undesired behavior.

9. DRL schedules in themselves are designed to decrease and not eliminate a response; however, as control is established and the criterion for reinforcement is lowered, it may be possible to switch to a DRO or other strategy in an effort to totally eliminate the response.

III. Cautions

A number of cautions should be cited in the use of DRL schedules to reduce behavior problems. In turn, we will discuss its non-constructive nature, our concern about social validity, and the potential for an aversive component. (See, also, the "Cautions" section of Chapter VI for a discussion on inadvertent reinforcement.)

A. Non-constructive

DRL shares with DRO the problem of not necessarily teaching more appropriate behavior. In fact, some experimental studies with both animals and humans have found that ritualistic, superstitious behaviors may be developed to mediate the IRT (e.g., Kapostins, 1963; Latries, et al., 1965; Segal-Rechtschaffen & Holloway, 1963; Wilson & Keller, 1953). That is, rather than the discrimination of time, a classic DRL schedule appears to develop and inadvertently reinforce a chain of superstitious behavior that precedes the target response and through this mediation increases the IRT sufficiently to satisfy the criterion for reinforcement. This phenomenon has not been as clearly demonstrated for the form of DRL schedules tending to be used in applied settings (the form where low rates are reinforced rather than long IRTs). Nevertheless, it is important to use DRL strategies only in the context of an instructional program designed to teach appropriate, functional behaviors. Such a context will maximize the possibility of developing desirable responses as mediators to satisfy the DRL criterion of reinforcement.

Two contrasting examples may aid in the understanding of this point. On a barren state hospital ward, a DRL 3/1 hour schedule would provide for delivery of a reinforcer for each hour that passes with fewer than three target response emissions. To satisfy the criterion for reinforcement, it may be that the learner will develop a set of ritualistic responses in order to mediate the time and reduce the rate of target response emission. On an institutional ward, this alternative is likely to be undesirable because:

1. The learner lacks the opportunity to engage in many desirable responses in such an environment;

2. There are few things she needs to do and typically she will receive little instruction to help expand her repertoire of functional behavior (Biklen, 1979); and

3. The fewer desirable responses in the learner's repertoire, the more likely that undesirable mediating responses will occur.

Conversely, in a non-institutional, community based, heterogeneous, residential, educational, recreational or vocational setting, there is potentially greater opportunity to engage in appropriate behaviors. In such settings, there are more chances to carry out a DRL strategy within the context of a larger program designed to teach the learner greater skills and competencies. Many of these can then play the role of mediating the decrease of DRL behavior to meet the criterion for reinforcement.

B. Social Validity

A second potential problem in using DRL schedules concerns social validity (Kazdin, 1977a). Although our experience and that of others (e.g., Deitz & Repp, 1973, 1974) is that DRL is an acceptable strategy to most persons, some may be bothered by the requirement to deliver reinforcement in the presence of target behavior occurrence. It was partially for reasons of social validity that most applied studies reinforced low rates rather than long IRTs since the latter actually required the delivery of reinforcement as a consequence to every target behavior that occurred after a long IRT. Reinforcing the emission of responses within a certain elapsed time interval appears to be much more acceptable to people working in applied settings.

In addition, it is good to remember that people often need an explanation before they are willing to utilize an intervention strategy that involves the delivery of reinforcement while an undesirable behavior is still occurring. It may be helpful to focus on the ultimate goal of elimination and to characterize the interim DRL criteria as

necessary steps along the way. Our own experience is that DRL also increases in its social validity with successful use.

C. Potential for Aversive Component

The final caution is that the information feedback mechanism used in conjunction with the DRL schedule may bring a mildly aversive quality to the intervention. While this is also an area for future research, in application a monitoring system designed to keep a learner informed of her responses should endeavor to minimize the aversive potential. Recommendations for doing so are discussed below.

IV. Suggestions for Implementation

Our suggestions for implementation include the consideration of response rate in selecting DRL as an intervention strategy, learner ability, interval size and reinforcement criteria, changing criteria and reinforcement magnitude.

A. Response Rate

While there are no hard and fast rules for adopting one non-aversive strategy over another, at least two considerations could make DRL a treatment of choice in a particular situation. The first is the baseline frequency of the target behavior. All other things being equal, the lower the baseline frequency, the more impractical DRL becomes. Conversely, the higher the baseline rate, the more attractive DRL may be as an intervention. If baseline frequencies are so high as to make a DRO schedule impractical or unacceptably intrusive in the natural setting, DRL may be the most viable alternative.

B. Learner Ability and Tangible Monitoring Systems

The second consideration is the functioning level of the learner. The less cognitively able the learner, the more important it may be to make the intervention as concrete and tangible as possible. We have already discussed concrete self-monitoring systems that can be devised to keep the learner informed of the accumulated responses under DRL performance. We have used and observed a number of devices for this purpose, including:

1. Moving tickets from one pocket to another.

2. Moving tickets from one envelope to another, with the envelope posted on the wall.

3. Moving keys from one ring to another.

4. Turning pictures to the wall.

5. Taking down reproduced pictures of the reinforcer from the wall.

6. Moving blocks from a round plastic container to a square, tin metal container (e.g., for a person who is blind).

While this kind of consequential feedback may technically fit the definition of punishment, keeping it as innocuous as possible allows us to minimize aversiveness while maximizing the informational properties. By providing for an innocuous consequence we also provide information to the learner as well as address staff's understandable need to have something to do when the target response occurs.

Our experience persuades us that non-aversive informational systems *are* possible. In fact, it is not uncommon for learners to take advantage of the information in order to engage in the response as many times as possible while still meeting the DRL criterion for reinforcement. When this happens, two conclusions are suggested:

1. The informational feedback itself is not aversive since it is not avoided up to the criterion point.

2. The differential characteristic of the contingency rule for reinforcement is understood and the reinforcer that has been made available is sufficiently strong to lead to correspondingly differential responding and the satisfaction of that rule.

When a learner begins to perform in this way, the behavior is under perfect control of the DRL schedule. Rather than think the learner has found the loophole, we must realize that we can now control the behavior by changing the criterion of reinforcement. As the criterion for reinforcement is lowered, the frequency of the responses should decrease. This strategy provides a natural path for the fading out of the DRL schedule. If the goal is total elimination, it leads to the eventual switchover to a DRO schedule or some other procedure. When a tangible monitoring system is used, we urge consideration of the following to reduce the potential for creating an aversive component:

1. The practitioner's tone and manner should be as matter of fact and supportive as possible. If the person needs a verbal or non-verbal reminder to move one of the counting items when a target response occurs, it should be given calmly and non-aversively. If the criterion for reinforcement has not been met at the end of the session, the teacher should again be non-aversive and as supportive as

possible. She might say, for example, "Uh-oh, you didn't make it this time. Let's try again," while filling up the beginning container once more.

2. The learner should be the one to move the items. By keeping them under the learner's control, we not only increase the informational value of the technique, but may also minimize its aversive potential.

3. The learner should switch the counting items from one container, envelope, or place to another rather than yield the items to the teacher. This enhances the learner's control, decreases the topographic similarity to a response cost procedure, and accordingly minimizes the aversive potential.

4. Reinforcement should not be differentially available as a function of the number of items left in the original container. If there were a one-to-one relationship between the items and the reinforcers, the former could take on generalized reinforcing properties (as tokens do in a token economy). This could convert what was intended as an informational feedback mechanism into an aversive, response cost mechanism (Weiner, 1964, 1969). The items should merely be a way for the learner to keep track of her accumulated responses in relationship to the DRL criterion for reinforcement. One marker remaining earns the same reinforcer as ten. That criterion should be met with a yes or no, not differentially met based on the number of responses made (see Footnote 1).

5. The practitioner should not attempt to interrupt the target response with a requirement to engage in the self-monitoring response. The self-monitoring response should be required only after the conclusion of the target behavior. This may mean that the target behavior must be redefined. For example, if we are dealing with self-injurious behavior involving blows to the head, we may need to define an event as an entire episode with one or more responses followed by at least 30 seconds without a blow. Attempting to interrupt an episode with a self-monitoring response, such as moving a marble from one container to another, may actually escalate the head blows or elicit resistance and possible aggression. Response interruption should, therefore, be avoided.

C. Interval Size and Reinforcement Criterion

Another issue in implementation involves the size of the DRL interval. We recommend that, where possible, the DRL interval correspond to the time frame of some natural event. This could be an activity, instructional session, time in a particular location, or the

like. The critical requirement for effectiveness is not the size of the interval but the criterion for reinforcement. Considerable research is needed in this area. Based on our combined clinical and classroom experience, however, we recommend that the baseline rate of the behavior be used as the initial criterion for reinforcement. The reader should refer to Table 1 to see how this works. At baseline levels, we can expect the learner to come into contact with the reinforcement contingency approximately 50% of the time. For example, if a response occurs an average of six times an hour and we established six or fewer responses as the criterion for reinforcement for each hourly interval, we can expect the learner to meet the criterion about 50% of the time. That is, based on baseline frequencies, approximately half the intervals would have an emission of six or fewer responses and approximately half would have more than six.

D. Changing Criteria

If we have identified an effective reinforcer and protected against the possibility of satiation, we will increase the number of intervals having six or fewer intervals and accordingly lower the overall frequency of the behavior. We recommend lowering the criterion for reinforcement only after a new steady state is reached. For example, if we start with a response that occurs an average of six times an hour during baseline and if we establish a DRL criterion of six or fewer for each hourly interval, the behavior should decrease to the point where the learner is consistently meeting the criterion for reinforcement. At this point, we should recalculate the new rate of the behavior and set a new criterion at this level. We can continue to do this until the behavior is either brought down to an acceptable level or, when we are interested in eliminating the behavior totally, until we can conveniently switch to a DRO schedule or another procedure.

Another suggestion for setting and changing DRL criteria is that some thought be given to whether the behavior under baseline condtions occurs at varying rates in different places or situations. When this is the case, you may want to consider correspondingly different criteria. For example, if you are providing consultation for a problem behavior that occurs both at home and at work and you are able to determine that the rate is ten times an hour in the former setting and six times in the latter, we suggest setting the criteria differently in each setting in which a DRL schedule is adopted as an intervention strategy. In this case, ten or fewer responses an hour would be the criterion for reinforcement in the home setting.

E. Reinforcement Magnitude

A final suggestion has to do with the selection and magnitude of the reinforcer used in a DRL intervention. As discussed in the chapter on DRO (Chapter VI), in order to protect against the possibility of satiation it is important to utilize the reinforcer to such an extent that even if the learner met every criterion, she would still have somewhat less of the reinforcer than she would seek given free access. It is not enough simply to use what the person likes. As suggested by the work of Konarski and his colleagues (Konarski, et al., 1980), it is necessary that the contingency rule for reinforcement arrange for a certain level of deprivation.

While this principle has already been discussed in Chapters V and VI, we believe that this area of consideration is so vital to non-aversive behavior management that another example can contribute additional emphasis and understanding. In fact, if this concept is fully utilized, it might actually increase the variety of reinforcers we can effectively use in our non-aversive strategies.

Assume that a learner engages in an aggressive act an average of 20 times in a ten-hour day, and we decide to adopt a DRL strategy to bring it under control. Further assume that we plan to use a two and one-half hour interval in order that our initial criterion for reinforcement will be five or fewer responses. Now we must determine a payoff if the criterion is met. A reinforcement survey may disclose that at this time the learner likes to look at catalogues for a cumulative total of one hour a day and to change clothes six times a day. Both of these opportunities have potential as effective reinforcers in our DRL schedule. If we are not careful, however, they could both be used ineffectively as well. Following are examples of possible contingent consequences for meeting the criterion of five or fewer responses for every two and one-half hour interval. The opportunity for:

1. Ten minutes of looking at catalogues.
2. 20 minutes of looking at catalogues.
3. Five minutes of looking at catalogues.
4. 30 minutes of looking at catalogues.
5. Changing clothes once.
6. Changing clothes twice.
7. Changing clothes three times.
8. Changing clothes four times.

In fact, only payoffs 1, 3, and 5 are likely to be effective since payoffs 2, 4, 6, 7, and 8 would provide the learner with more oppor-

tunity than she sought under baseline conditions. For example, if the criterion was met every time and payoff 2 was utilized, the learner would earn the opportunity to look at catalogues for a total of 80 minutes. As this is 20 minutes more than she would ordinarily engage in this behavior, this arrangement is not as likely to be as effective as payoffs 1 or 3 which, even under maximum earnings, still provide less of an opportunity to look at catalogues than she sought under baseline conditions.

V. Research Ideas

One critical need in the area of research is examination of the effectiveness of DRL schedules of reinforcement as a function of reinforcement magnitude and deprivational relationships in the contingency rule. For example, would the contingencies described in the two preceding paragraphs have a differential effect on rapidity of target behavior reduction? Until questions such as these are answered, we must regard as premature the validity of studies attempting to compare the effectiveness of DRL with other aversive and non-aversive strategies. Other research questions that should be addressed include the following:

1. With which behavior problems are DRL strategies effective?
2. With which populations may DRL strategies be effective?
3. What is the role played by the following variables in effectiveness, rapidity of control, resistance to recovery under the original set of conditions, response generalization, and the generalization of treatment gains to extra-treatment settings?

a. Verbal instructions to the learner explaining the DRL contingency rules for reinforcement.

b. Tangible, self-monitoring systems and other information feedback mechanisms for informing the learner of her accumulated responses in relationship to the DRL criterion.

c. Reinforcment magnitude and deprivational relationships built into the contingency rule for reinforcement.

d. Interval size.

e. Different rules for changing criteria, e.g., steady state rules versus consecutive intervals in a row where the criterion for reinforcement has been met.

f. Different rules for establishing criteria, e.g., criteria set at 100 %, 75 %, or 25 % of baseline levels.

g. Opportunities for and instruction in desirable collateral behavior.

h. The learner's cooperation and self-adoption of the goals of treatment as might be measured by the extent to which escape from the DRL condition is sought when the opportunity is provided.

4. The social validity of DRL strategies for staff, consumers, consumer representatives, funding agencies, administrative bodies, and the general public when compared with other non-aversive as well as with aversive strategies.

Footnote

1. Despite these safeguards, a tangible monitoring system may take on some of the aversive properties of a response cost system. If the learner should display the negative side effects associated with aversive intervention procedures, we recommend discontinuation of the tangible feedback component.

CHAPTER VIII

STIMULUS CONTROL

I. Introduction

The concept of stimulus control is basic to the operant paradigm. It is defined as the discriminative control of behavior, i.e., certain stimuli set the occasion for certain behavior (Catania, 1968). Everyday examples of this abound. When we are lost, another person sets the occasion for asking directions. A report of snow sets the occasion for a ski trip to the mountains. A particular time on a certain day sets the occasion to turn the TV on for a favorite show. In these examples, another person, a report of snow, and a particular time on a particular day have discriminative control over the behaviors of asking for directions, taking a ski trip to the mountain, and turning on the TV, respectively. That is, these behaviors are likely to occur in the presence of these discriminative stimuli (S^Ds) and are not likely to in their absence.

In what way do stimuli establish control over those behaviors and set the occasion for their occurrence? In the past, they have been reinforced in the presence of those stimuli and extinguished in their absence. Asking directions of another person is likely to be reinforced with information capable of getting you to your destination. Asking questions when there is nobody to answer will obviously not result in fruitful information. Likewise, going to the mountains or turning on the TV are not likely to result in reinforcement unless they occur under the appropriate stimulus conditions. The stimulus indicates the reinforcer is available if a particular response

occurs and thus sets the occasion for that response. The absence of relevant S^Ds indicates that the reinforcer is not available. The absence of the S^D is referred to as the S^\triangle (pronounced Ess Delta) condition (Catania, 1968). Through the process of differential reinforcement, a given behavior is reinforced and accordingly strengthened under the S^D condition. That same behavior is extinguished and accordingly weakened under the S^\triangle condition. Stimulus control is established to the extent that future occurrences of a given behavior aggregate under the S^D condition and tend not to occur under the S^\triangle condition (Woods, 1980).

A related concept is "inhibitory stimulus control" (Rollings & Baumeister, 1981). In the case of inhibitory stimulus control, the S^D indicates that punishment is available if a particular response occurs. Hence, the S^D becomes discriminative or sets the occasion for not responding. For example, a red traffic light is discriminative for not driving forward, the interior of a church is discriminative for not laughing out loud, and a crowded elevator is discriminative for not taking off one's clothes. If these behaviors were to occur under these stimulus conditions, they would most likely be punished. Most of us, however, are under inhibitory stimulus control and would not engage in these behaviors in the presence of these S^Ds.

The process for establishing inhibitory stimulus control is clear. We simply arrange for a response to be punished in the presence of a specified stimulus. Eventually, that stimulus will become discriminative for not engaging in that response and the response will tend to occur only in the absence of the operative S^D. Historically, inhibitory stimulus control has been viewed as a disadvantage in the use of punishment. For example, in one earlier study, the undesired behavior of a child with autism was punished with contingent electrical stimulation (Lovaas, Schaeffer & Simmons, 1965). The person who applied the punishment in this investigation began to take on discriminative properties and while the response did decrease in his presence, it continued to occur when he was absent. The person's presence had taken on discriminative properties, therefore, and set the occasion for non-responding. This was viewed as a disadvantage, since in order to maintain the effects of punishment, the stimuli associated with punishment would always have to be present.

While inhibitory stimulus control was seen in the past as a disadvantage in the use of punishment, present studies have sought to use it to advantage in an effort to establish limited control over a behavior problem that need not be totally eliminated, such as in cases of stereotypic responding. For example, Rollings & Baumeister (1981) established inhibitory stimulus control over the stereotypic

responding of two adults considered to be profoundly retarded. Their stereotypic responding included "head-nodding" and "body-rocking." After a baseline period, a discrimination training phase was initiated. During this phase, the behaviors were punished if they occurred when light "A" was on and not punished if they occurred when light "B" was on. Punishment in this study consisted of a one-minute application of the over-correction procedures developed by Foxx an Azrin (1973). After the discrimination training phase, lights "A" and "B" continued to be presented. All consequences were discontinued, however, to see if inhibitory stimulus control had been established. It was. Stereotypic responding was reduced when the light associated with punishment was on, in sharp contrast to the rates of stereotypic responding which occurred in the presence of the light not associated with punishment.

In a second study investigating inhibitory stimulus control, the S^D employed was a beach hat worn by the learner (Woods, 1980). After discrimination training in which ear-rubbing, ritualistic staring and self-stimulatory verbalizations were contingently, albeit mildly, punished with response prevention, a test for inhibitory stimulus control was initiated. Although the consequences had been discontinued, the beach hat continued to have discriminative control over the non-engagement of target behavior. When it was removed, target responding recurred. Over time, the presence of the beach hat in the same room was sufficient to maintain control over the behavior. Woods' study represents a very practical and creative application of inhibitory stimulus control in its use of an S^D that is portable and not likely to attract negative attention in the community.

As the establishment of inhibitory stimulus control utilizes aversive stimuli, we will, in keeping with the spirit of this book, turn our attention to stimulus control as it can be established strictly with the use of reinforcing stimuli. We would like to make several introductory points in our discussion concerning the application of stimulus control strategies to the reduction and control of human behavior problems. The first important point is that the object of behavior management is not always to eliminate a response from a learner's repertoire but rather to bring it under the discriminative control of a more limited set of stimulus conditions. Undesired behavior targeted for intervention is sometimes labeled as a "behavioral excess." These behaviors are rarely excessive in the absolute sense. They are excessive only in that they occur under an inappropriate set of stimulus conditions (see Chapter I, Ethical Considerations).

Sex represents one category of behavior for which the conditions strongly determine acceptability. We could generate a long catalogue of sexual behavior that many, perhaps most, of us would

consider acceptable, but only under a limited, and in fact rather narrow, set of conditions. Heterosexual intercourse of a married couple is a good case in point. As a behavior engaged in within the privacy of their bedroom, for example, it would be considered as acceptable by most. If a couple were to engage in intercourse in public, however, such as on a bus, a crowded beach, or in the living room in the presence of children, their behavior would likely be labeled undesirable by most of us. Similarly, when our severely disturbed or handicapped learners engage in public masturbation, that behavior is very likely to become a target for our behavior management programs. The real issue, however, is not the elimination of this behavior or necessarily even its absolute reduction. The real task is to bring it under more acceptable stimulus control: that is, we want it to occur in private rather than in public!

As an example, one pre-school teacher we know was bothered by the public masturbation of a normal five-year-old girl in her class. Not only was it disturbing to the staff, but a modeling effect was occurring and the other children were also starting to masturbate publicly at an increasing and alarming rate. Rather than punish this behavior, however, the teacher decided to use a stimulus control strategy. The child was instructed to and differentially reinforced for masturbating privately in the bathroom. As a result, public masturbation was eliminated (LaVigna & Donnellan, 1976).

It is interesting to note that in this case, private masturbation also decreased. This may have resulted from what we refer to as the "scrambled egg phenomenon" and the effect of "separating the white from the yolk." As long as different behaviors continue to occur under the same stimulus conditions, it seems the reinforcers naturally available for one of the behaviors may also act to inadvertently strengthen the other behaviors as well. In this scrambled egg condition, as long as masturbation occurred in the classroom, where positive reinforcement, such as teacher attention, was available for academic and other appropriate classroom behavior, those reinforcers could inadvertently have acted to strengthen the undesired public masturbation as well. If this was so, then by separating the white from the yolk (i.e., by having masturbation occur only under specified and unscrambled stimulus conditions), the only reinforcers available were those inherently available for masturbation. These latter reinforcers may not have been sufficient to maintain the behavior at its prior strength and may explain the observed decrease in private masturbation.

There are two major points involved in the above example. First, the absolute frequency of a response may not be the critical issue in a behavior management program; rather, the issue may be to

bring it under more acceptable stimulus control. Second, by limiting the stimulus conditions under which a behavior occurs, we may control the inadvertent reinforcement which has been maintaining a response at an unnecessarily high rate. To the extent we remove inadvertent reinforcers and to the extent a behavior is maintained only by those reinforcers which are inherently contingent upon its occurrence, it may maintain itself at a lower rate.

Stimulus control procedures may also be used, however, in a direct effort to reduce frequencies and to eliminate or prevent a behavior. The strategy is one of establishing firm discriminative control over the behavior in question and then gradually reducing and eventually discontinuing the presentation of the S^Ds which set the occasion for the response. One of our favorite examples of an application of this strategy involved a performing porpoise (Pryor, 1977). The trainers had become concerned about a response the porpoise was exhibiting because of its potential for self-injury. With predictable frequency, the porpoise would jump out of its pool onto the poolside platform and flip around. The trainers worried that in the process it would break a flipper or otherwise injure itself. While they considered a punishment procedure, they rejected it as a strategy because they were convinced that application of an aversive stimulus would cause the animal to begin to avoid them. This would obviously hinder their training efforts and the public performance of their marine life entertainment act.

Consequently, they adopted a stimulus control strategy to eliminate this response. The first phase of their effort involved the differential reinforcement of the target response if it occurred within a brief, specified time after a bell was rung. As a result of this differential reinforcement, the bell began to take on discriminative qualities. More and more of the porpoise's self-injurious behavior began to aggregate within the specified time after each ring of the bell. Eventually, stimulus control was firmly established; i.e., the bell became discriminative for the target behavior and set the occasion for its occurrence. In the absence of the bell, the response did not occur. While stimulus control had been established, at this point there had been no reduction in the overall frequency of the target behavior. They now, however, began to reduce the frequency with which they presented the bell. As the frequency of presentation of the S^D was diminished, so was the frequency of the behavior. In this way, the porpoise's self-injurious behavior was gradually eliminated.

While this case involved an animal subject, we believe it presents a clear model for applying stimulus control strategies to problems involving human behavior. Such strategies can be applied

both in a situation where the behavior needs to be reduced and/or eliminated and in one where the point is not so much to reduce the overall frequency of the response as to bring it under the control of a different set of discriminative stimuli. Stimulus control has been underutilized as a viable strategy in behavior management programs, and has not received the attention it deserves from both researchers and clinicians. Nevertheless, research studies which have been carried out add substance to its promise as another alternative to punishment in reducing behavior problems.

One of the first studies was offered by Azrin and Powell (1968) in an attempt to reduce cigarette smoking in normal adults. A specially designed cigarette box was provided to each participant in the study. When a buzzer imbedded in the box went off, it indicated that the locking mechanism would be released for the next several seconds, "setting the occasion" to reach in one's pocket for the box, remove a cigarette and enjoy a smoke. Obviously, attempting to do so in the absence of the buzzer would be met with extinction, since the box would be locked and unopenable. Stimulus control over smoking was thus established, with the buzzer becoming the S^D for this target response. The interval between buzzes was gradually increased and smoking correspondingly decreased. The establishment of stimulus control and the gradual fading out of the S^D on the dimension of time was successful in reducing the study participants' undesired response of cigarette smoking.

In another example (Ferster, Nurnberger, & Levitt, 1962), the target behavior was eating by overweight people. Eating as a problem behavior provides the archetypical example of a response that should not be eliminated. The goal of behavior management here is not to eliminate the response but to bring it under more narrow stimulus control. The investigators instructed the subject to eat only under very narrowly defined stimulus conditions; e.g., on a purple table cloth. Eventually, all of the stimuli which had primarily set the occasion for eating lost their discriminative quality and the subject's overall frequency of eating was sufficiently reduced for him to lose the required weight.

In a similar way, Goldiamond (1965) worked with a couple experiencing marital discord. In one of the first reported cases extending the principles of applied behavior analysis to self-control, the husband was taught to bring his "sulking" behavior under the stimulus control of a "special sulking stool" which was kept in the garage. Sulking, which was previously occurring up to one and one-half hours a day, was eventually eliminated entirely. One can only speculate that sulking in isolation does not inherently provide suffi-

ciently reinforcing consequences to maintain itself apart from the extrinsic reinforcers which are available when it occurs in a social context.

As these earlier applications of stimulus control procedures to human behavior problems involved people who were not cognitively handicapped, a question may be raised as to whether this procedure can be as effective with more cognitively impaired learners. This is of particular concern where instructional control in the form of verbal directions cannot be understood and, therefore, cannot provide the learner with the verbal information concerning the new contingencies of reinforcement. Is verbal understanding of the contingency rules necessary in order for behavior to come under the discriminative control of stimulus variables in the environment? Fortunately not.

A host of discrimination training studies have demonstrated conclusively the effectiveness of certain procedures in establishing stimulus control over behavior, even when the populations involved were severely and profoundly handicapped and even when discrimination of the relevant stimulus was very difficult (Sidman & Stoddard, 1967; Moore & Goldiamond, 1964). Further, Spradlin, Cotter, and Braxley (1973), among others, have demonstrated that such stimulus control can be transferred from one stimulus class to another, as did Schreibman (1975) in her work with children with autism.

These and other studies take advantage of the fading techniques developed by Terrace (1963a, 1963b) which can be effective in transferring stimulus control without error. They can also be effective in establishing stimuli discriminative for certain behavior where the more straightforward procedure of differential reinforcement may fail.

While demonstrations of the technology available for the development and transfer of stimulus control for teaching new skills abound, this technology has only rarely been applied to behavior problems in the way that we are suggesting. In one experimental investigation (O'Neil, 1978), an attempt was made to bring the self-stimulatory verbalizations of a nine-year-old with autism under the discriminative control of a red light. Instructional lessons in a one-on-one teaching cubicle were divided into sequential but alternative five-minute sessions. For half of the sessions, the room was lit with a red light and self-stimulatory responses were positively reinforced with pieces of candy and social praise. When the red light was off during the alternate sessions, the student was reminded to wait for the red light. During baseline, before training, self-stimulatory behavior occurred during approximately 70% of the observation inter-

vals. After training, self-stimulatory behavior had increased under the "red light" condition to the extent that it was essentially occurring during 100% of the observation intervals. In the absence of the discriminative stimulus, however, it was occurring during approximately 15% of the observation intervals. This differential effect held during a post experimental probe, when the red light was kept off twice as long as it was kept on. The target behavior continued to occur during approximately 15% of the observation intervals under the former condition and up to 100% of the observation intervals under the latter.

A stimulus control strategy was also employed for two students in a classroom study (Donnellan & LaVigna, in press). One was a 14-year-old boy who contracted herpes encephalitis at age 12, requiring brain surgery that left him multiply handicapped. The target behavior consisted of inappropriate verbalizations. This behavior included "knock-knock" jokes, questions about the listener's family, statements about the student's family, multiplication facts and rhyming words. For example, in response to the teacher's morning greeting, "Hi, how are you?" the student might respond, "Guess what 9 × 9 is?" These phrases were repeatedly verbalized under inappropriate stimulus conditions by the student throughout the day and made up the majority of his conversation with peers and staff. Baseline measures over a four-day period indicated an average daily frequency of 63 occurrences.

The stimulus control procedure involved having the teacher designate an area in the room where two chairs were placed for the student and another person to sit. At the end of each work session of approximately 45 minutes, the student was told that it was time for "red sign talk" or "inappropriate conversation" and a timer was set for five minutes. A piece of red construction paper with the words "inappropriate conversation" written on it was placed on the walls by the chairs. During this time the student was free to say anything he wanted. At the end of the five minutes, he was told that "red sign" or "inappropriate conversation" time was over. The red sign was taken off the wall and the student would continue to the next activity. If the behavior occurred when it was not "red sign" time, the student was reminded that what he had said was inappropriate conversation and to wait for "red sign" time. From a baseline average of 63 per day, the frequency was reduced to an average of 11 incidents a day during the 30 weeks of the program.

A second student in this class was a 17-year-old girl with a diagnosis of autism. The target behavior in this case was labeled as "nonsense talk." It was echolalic and self-stimulatory in nature and made up of single words and short phrases which typically were not

related to the present situation or environment. For example, when asked to give a dime as a money identification task, she might respond with "Johanna, quack, quack, Johanna, quack, quack, isn't that right?" In most instances, this behavior was accompanied by stereotypic laughing and grinning and would vary in volume from whispering to screaming. The most disturbing aspect of this behavior was its loud and vulgar nature, which prevented the student from engaging in positive and successful social interaction. In addition, the school system was beginning to take the necessary steps to have her expelled from public school because of the disruptiveness of her behavior. Because of the urgency created by this problem, no baseline data were accumulated.

Thirteen previous attempts to control this behavior were unsuccessful. The procedure which finally proved successful was based on the stimulus control procedure reported by Sailor, Guess, Rutherford, and Baer (1968), in which temper tantrums were brought under the discriminative control of certain study material. In the present study, the student began each school day in a large classroom with her classmates. She worked on tasks which she was thought to prefer. Tokens were earned for task completion and appropriate behavior. Twice a day, a token exchange period was scheduled in the classroom, giving the students the opportunity to exchange their tokens for the individualized, back-up reinforcers. This setting was designated as the S^Δ condition for nonsense talk. Hence, she remained there as long as no nonsense talk occurred. A timer was set for each five-minute period. At the end of each five minutes, the student was instructed to record an "O" on a data sheet indicating that no nonsense talk had occurred. She earned one exchangeable token for each "O" recorded and was further reinforced with social praise for having exhibited adult behavior.

When the student engaged in nonsense talk, she was matter-of-factly escorted into a smaller room adjoining the classroom. Because of the disruptiveness of her behavior, this is where she did most of her school work prior to intervention. Once intervention was initiated, it was explained whenever she was escorted into the room that this was where nonsense talk was supposed to occur. There she was given one-to-one instruction on academic tasks already a part of her regular curriculum but thought to be less preferred than tasks she performed in the regular classroom. In the small room, she received social praise for task completion and accuracy but no token reinforcement. The intent was to create an easily discriminable difference in the stimuli and reinforcement densities between the two rooms. The minimum amount of time the student stayed in the small room with the teacher was three minutes. After

the three minutes elapsed, she could return to the regular classroom as long as the nonsense talk was stopped. In the beginning the student spent as little as 3% of the time in the large classroom. By the end of the intervention, she was frequently spending 100% of her time in that environment. Her behavior improved so noticeably that the school system terminated its expulsion procedures.

This case illustrates that if one does not want to rely on the scrambled egg phenomenon, it is possible to enhance the S^Δ condition in contrast to the S^D condition by having an overall higher density of reinforcement (for non-target behavior) available under S^Δ. As demonstrated in this case, such differential densities differentially reinforce the learner for choosing to spend more time under the S^Δ condition and less time under the S^D condition which sets the occasion for undesired responding.

This limited review of the literature illustrates a variety of ways in which stimulus control strategies can be applied to the control of behavior problems. We believe it represents one of the most overlooked, understudied and underutilized strategies available to us today. Its potential is not only substantiated by the available literature but also by the anecdotes and common sense stories with which we are all familiar. For example, in a recent round table discussion, parents of children with autism were asked how they went about dealing with stereotypic behavior in the home environment. Many of them expressed their opinion that self-stimulation should be allowed within limits, i.e., under specified stimulus conditions. Accordingly, they allowed their children to engage in self-stimulation but only in their room, on a special chair, or at other special places in the house. Their children then have the choice of engaging in stereotypic behavior or in activities which are allowed, i.e., reinforced, in other areas of the house. They can choose the white or the yolk of the egg. The practice of "allowing" them, i.e., reinforcing them, for engaging in this behavior under the specified conditions takes the battle out of dealing with this problem. We interpret this to mean that it thus takes the aversiveness out of dealing with this problem for both the child and the parent.

II. Advantages

A. Positive Approach

One of the major advantages of stimulus control strategies is its very positive orientation. The message conveyed using this approach

is that the learner is "okay" and so is the behavior, as long as it occurs under the specified stimulus conditions. This attitude is particularly welcomed by those who are concerned with how a person's self-perception, self-concept, and self-esteem are affected by the direct and indirect messages our interventions communicate. It is the difference between saying "Masturbation is wrong and you are bad to do it," and "Masturbation is okay behavior but it is better to do it in private." The former message invalidates the learner and his or her natural tendencies. The latter validates the learner and the behavior and contributes to what we would label self-esteem—the sense of efficacy and self-worth.

B. Control Without Elimination

Many behaviors do not need to be totally eliminated from a learner's repertoire. As we have described above, a solution can often be found simply in establishing a narrow set of conditions under which the behavior will occur. As noted by the parents mentioned earlier, stereopathy or self-stimulatory behavior provides a prime example of a response which falls into this category. It may be true that certain stereotypic behavior can interfere with learning (Koegel & Covert, 1972). It is a long step from that finding, however, to the position that all stereotypic responding must be eliminated. In fact, we all engage in stereotypic behavior. We tap our feet when sitting still, finger our beards or hair, play with coins in our pockets, or otherwise manipulate our proverbial "worry beads." Should we expect any other learner to be devoid of all stereotypic behavior? We do not believe so. We believe that it should merely be brought under sufficient control so that it neither interferes with learning, nor attracts undue negative attention when exhibited in the community. Many behaviors fall into this category of not needing to be totally eliminated. In these cases, stimulus control provides a useful model for dealing with the problem.

C. The Development of Conditioned Reinforcers

Stimuli which become discriminative for certain behavior and set the occasion for their occurrence become conditioned reinforcers and can be used contingently to strengthen other behavior. If a red light sets the occasion for nonsense talk, if a sweatshirt sets the occasion for stereotypic humming, if a chair becomes discriminative for body rocking or if a bedroom becomes discriminative for masturbation, then the opportunity for access to these stimuli can be used as positive reinforcement in a variety of programs. This is a major ad-

vantage particularly when we are working with a learner for whom it is difficult to identify effective reinforcers. In such situations, the creation of conditioned reinforcers may become crucial for effective programming. Contingent access to S^Ds such as the red light, sweatshirt, chair and bedroom as described above can be used to positively reinforce task completion, accuracy and rate in a positive program to increase a learner's skills and competencies. It could also be used to reinforce other behavior or low rates of responding, for example, in behavior management programs to reduce more serious undesired behavior such as aggression, property destruction, and self-injury.

D. Facilitation of Generalization

One of the strategies for generalizing treatment gains across settings is to utilize a "training stimulus," and to introduce that stimulus into those subsequent settings in which one hopes generalization will occur (Marholin & Touchette, 1979). The strategy of stimulus control explicitly links control over a behavior problem to an explicit and clearly identified extrinsic stimulus. Although the possibility invites controlled study, a likely advantage of stimulus control is that once it has been established in one setting, it may be easier to establish control in other settings. This is particularly true if the S^D is portable. For example, if stereotypic body rocking has been brought under the discriminative control of a bracelet in the classroom setting, the establishment of control at home may be achieved by the systematic introduction of the S^D in that setting as well.

E. Unscrambling the Egg

As we have already described, one of the major advantages of establishing stimulus control over an undesired behavior is the potential it provides for preventing the occurrence of unnecessasry reinforcement. If a behavior occurs under a wide variety of stimulus conditions, it may be incidentally and inadvertently reinforced simply because of its proximity to stimuli and events which are present but independent of the target behavior. By establishing a stimulus which is discriminative for the target behavior and by isolating it from stimuli which are discriminative for other behaviors, the target behavior will be reinforced only by its own consequences and not by the consequences of other behaviors which may occur. Given this effect, the behavior brought under this narrow stimulus control may also reduce in its overall frequency as well.

F. Unobtrusive Intervention

The issue of social validation addresses both the goals and the methods of behavior management. Even a positive procedure can be obtrusive and attract negative attention from the community. With reasonably careful planning, the stimulus control of a behavior can be unobtrusive and attract very little negative attention. This is particularly true if the S^D is an age appropriate item or piece of clothing.

III. Cautions

A. Contraindications

The major caution with stimulus control procedures is that they ordinarily should not be applied in the management of aggressive, self-injurious or destructive behavior. The reasons for this should be obvious. For stimulus control to be established, it is necesssary for the behavior to be reinforced under the specified stimulus conditions. To reinforce aggressive, self-injurious or destructive behaviors under a set of stimulus conditions will strengthen those behaviors accordingly, increasing the likelihood of someone being hurt or property destroyed. Ideally, stimulus control strategies should be employed primarily in cases where it is not necessary to eliminate the behavior but merely to bring it under the control of more limited stimulus conditions. If the behavior does require some absolute reduction in frequency, it should be a response that can be tolerated at relatively high rates, without danger to people or property, until discriminative control has been established and the availability of the S^D can be reduced.

There is a special case, however, when a stimulus control strategy may be responsibly employed to reduce and eliminate a serious problem, such as self-injury or assaultive behavior. This may occur when the functional analysis (see Chapter III) results in the clear identification of those stimulus conditions under which the target behavior does not occur. By scheduling consecutive S^Δ conditions, we may be able to eliminate the behavior. This may provide time for positive programming and other strategies to permanently remove the response under broader, more natural stimulus conditions.

This approach was creatively applied in a case reported by Touchette (1983). Although the learner had a history of extremely severe self-injurious behavior, careful analysis disclosed that there

were very specific stimulus conditions under which self-injury would not occur, e.g., meal times and in the absence of task demands. By extending and scheduling these S^Δ conditions consecutively, it was possible to sharply reduce the undesired behavior. This provided the opportunity for positive programming, which not only involved teaching a more functional repertoire but also gradually desensitized (Wolpe, 1958) him to those stimuli which previously were discriminative for self-injury.

B. Limited Research Findings

A second caution involves the limited number of controlled investigations into the application of stimulus control strategies in behavior management programs. As promising as this procedure may be, it has not received much attention by researchers in the field. Our recommendations for using this procedure are based on the limited number of studies which have been carried out, our own classroom and clinical experience and the large number of anecdotal reports we have received from other professionals and from parents of handicapped and behaviorally disordered children. Given the small empirical basis for this strategy, it should be used with caution. Continued research will contribute to the empirical understanding of this procedure and how it can be applied across a wide range of behavior problems for a variety of populations.

IV. Suggestions for Implementation

A. Target Behavior

As already indicated, under ordinary circumstances stimulus control should be applied only to less dangerous behavior problems, i.e., problems other than aggression, self-injury or property destruction. Stereotypic motor responses, undesired verbalizations, and sexual behavior represent at least three categories of responses which lend themselves quite well to stimulus control interventions. In considering stimulus control as a behavior management strategy for a particular response, you should already have your ultimate goal in mind. If your goal is to bring the behavior under more limited stimulus conditions to reduce its absolute frequency and, if possible, to eliminate it, there are important implications for your eventual identification and specification of the S^D.

B. Selecting a Reinforcer

Some reinforcers are intrinsic to a response and some are extrinsic. For example, masturbation can be positively reinforced both by the result of orgasm and by the social attention and reaction it attracts. To the extent that a response is being maintained by extrinsic reinforcers, it may be necessary to use those extrinsic reinforcers differentially in your efforts to bring a behavior under stimulus control. Once stimulus control is established, however, shifting of the extrinsic reinforcers to more appropriate behavior under the S^Δ condition will then leave the maintenance of the target behavior to the effectiveness of the intrinsic reinforcers. As we have discussed, this is often not strong enough to maintain the behavior at its previous strength.

C. Selecting an S^D

For most purposes one should select an S^D to which access can be controlled. One result of this would be to avoid accidental or unplanned presentations of the S^D which would set the occasion for undesired responding. Another is that with controlled access, the S^D can be utilized as a conditioned reinforcer to strengthen desired behaviors or weaken undesired behaviors through, for example, a DRO or a DRL strategy.

One of the things we may ascertain as a result of a behavioral assessment is that the behavior is already under stimulus control and access to the operative S^D can already be manipulated. For example, in working with victims of Prader-Willi Syndrome, an S^D for excessive eating is often unmonitored access to food. One way to reduce excessive eating is to reduce access to the S^D, that is, reduce the learner's opportunities for unmonitored access to food. In a group home setting this could mean: 1) built-in, locked refrigerator with staff having the only keys; 2) locked outdoor trash cans, with as much food/garbage as possible going down the disposal; 3) a locked pantry; 4) a locked freezer, and 5) an intruder alarm to warn of nighttime foraging. Changing antecedents to reduce the frequency of behavior is a strategy which can be employed once stimulus control has been established or identified and if access to the S^D can be controlled.

V. Research Ideas

Additional applied research is needed to demonstrate the effectiveness of stimulus control procedures in behavior management programs across the range of behavior problems and learner populations. In addition, in this context, we consider the following questions to be important.

A. In what ways can the use of stimulus control facilitate efforts to generalize treatment gains across settings?

B. What are the effects of other non-aversive reductive procedures during the S^Δ condition on the development of stimulus control?

C. Can inhibitory stimulus control be established using reductive strategies such as DRO or DROP during the S^D condition.

D. Under what conditions can stimulus control be established over behavior problems?

E. What are the effects of stimulus control on collateral behaviors?

CHAPTER IX

INSTRUCTIONAL CONTROL

I. Introduction

We have defined stimulus control as the aggregation of a behavior's occurrence in the presence of or following the presentation of a specified stimulus. Instructional control is an instance of stimulus control. Specifically, instructional control exists when a response occurs in the presence of or following the presentation of a command, direction or request. These can be verbal, written, signed, pictorial or gestural (see Footnote 1). For simplicity's sake, we will refer to them all as verbal. Thus, instructional control is an example of stimulus control when the stimulus is verbal.

Learners who do or refrain from doing things when so requested are under instructional control. Following directions is widely recognized as an important prerequisite to learning and cognitive development. Engelmann and Colvin (1983) consider it the least negotiable of the learning characteristics necessary for teachers to be effective. If a student does not follow directions, the teacher has no feedback on the basis of which to pursue instructional objectives. When the learner is non-compliant, it may mean that she does not know how to produce the response. That is, the motor response may not be in the learner's repertoire. On the other hand, the learner may be able to produce the response but simply does not understand the teacher's directions. A third possibility is that the learner may be able to produce the response and may understand the directions, but is non-compliant. Generalized instructional control is needed for the teacher to receive the necessary feedback for her instructional ef-

forts. Generalized instructional control is established when the learner is given a novel command that she understands, the response is in her repertoire, and she complies within the reasonable length of time necessary to process the verbal instruction.

Luria (1961) has suggested that with young children, one or two years old, the development of verbal control over motor behavior may not necessarily correspond to the child's ability to verbally label objects and actions. In his view, it is a critical skill and one that should be taught if it does not already exist in the learner's repertoire. As he says:

> . . . instruction following is an important pragmatic skill in language use and one that is not necessarily equivalent to simply summing together a child's nominative comprehension skills. It seems to be a skill that would need to be approached directly with language-deficient children.

As instructional control is a specific example of stimulus control, the strategy for establishing instructional control is similar. This involves the differential reinforcement of the response when it occurs following the presentation of the verbal request or direction. Reinforcement is not delivered if the response occurs in the absence of the instructional stimulus and would, therefore, be reduced through the process of extinction. For example, Kazdin and Erickson (1975) used differential reinforcement to establish instructional control over the appropriate responses to commands from a group of children who were considered to be severely retarded. Examples of the instructional stimuli used were "Sit down," "Catch the ball," and "Roll it to me." Positive reinforcement in the form of food and noise were differentially delivered during training each time a child correctly followed an instruction. Initially it was necessary to guide the correct responding of the child. Eventually, however, guidance was no longer necessary and the behavior came under the control of the instructional stimuli. Others have reported similar strategies to establish instructional control over a variety of behaviors for a variety of populations presenting language delays, retardation, and other developmental disabilities (e.g., Donnellan-Walsh, Gossage, LaVigna, Schuler & Traphagen, 1976; Striefel, Bryan, & Aikens, 1974; Striefel & Wetherby, 1973; Whitman, Zakaros & Chardos, 1971).

For purposes of clarification, it might be better to conceptually separate the procedure of differentially reinforcing the correct response and the procedure of guiding or prompting a correct response. Our assessment of the learner may disclose, for example,

that Johnny correctly complies with the instructional stimulus, "Come here," 20% of the time on the average. When a correct response follows an instructional stimulus at least some of the time, differential reinforcement alone may be used to establish instructional control. If the learner never complies correctly, however, we would have no opportunity to deliver the reinforcer and would therefore be unable to use differential reinforcement alone to establish instructional control. In such a case, it is necessary first to prompt the correct response after the instructional stimulus is presented in order to deliver the positive reinforcer (see Footnote 2). Instructional control is thus eventually established as the prompt is gradually faded out (Donnellan-Walsh et al., 1976). We will have more to say about prompting under the section in this chapter concerning suggestions for implementation. We have found the following sequence of a well-organized trial to be very helpful:

1. Obtain the learner's attention.
2. Present the instructional stimulus.
3. Prompt a correct response.
4. Deliver positive reinforcement following the occurrence of the correct response.
5. Wait a sufficient length of time before presenting the next instructional stimulus so that the learner can discriminate each trial as a discrete event unconnected to the trials that precede and follow it.
6. Fade the prompt gradually over subsequent trials.

Of course, our assessment may disclose that the learner is already under instructional control. This could set the stage for using instructional control as a strategy for controlling undesired behavior.

A number of studies have demonstrated specifically that instructional control can be applied as a strategy for the control of undesired behavior in a variety of applied settings. In one approach, instructional control is recommended for a finite set of commands over specific alternative responses incompatible with the behaviors targeted for reduction. For example, Donnellan-Walsh et al. (1976) suggested teaching children with autism compliance to basic commands such as "Sit down," "Look at me," and "Hands down" in order to reduce their "out of seat," "unattentive" and "stereotypic" behavior which is disruptive to the classroom and which renders the students inaccessible to the instructional process (Koegel & Covert, 1972). Not only can limited (as opposed to generalized) instructional control such as this be used in the classroom but, if extended to other settings, it can contribute to the control of behavior

problems outside the classroom. We are sure that any number of teachers of severely handicapped and other learners with behavior problems wish that their students would respond to a simple request to put their hands down when they are engaging in stereotypic arm flapping. This would be even more likely in cases of serious aggression or self-hitting during instructional time in the community.

Butman (1979) followed the same strategy when he attempted to reduce the self-injurious behavior of six children, ages eight to 13, all of whom had diagnoses of severe or profound mental retardation. Instructional control was demonstrated to be an effective means of controlling self-injurious behavior. Butman concluded that for some, instructional control holds considerable promise in the treatment of self-injurious behavior.

Russo, Cataldo, and Cushing (1981) recently published a study with interesting ramifications in terms of the application of instructional control strategies to the reduction of behavior problems. Three children served as subjects in the study. In addition to exhibiting non-compliance with adult requests, their behavior problems included tantrums, biting, kicking, head-banging, hand-biting, scratching, hair-pulling and thumb-sucking. With the exception of non-compliance, these behavior problems were not directly treated but were continuously measured throughout the study. Compliance was defined as a correct response to an adult request within a specified time limit and was trained using differential reinforcement. Sometimes prompt-fading procedures were added as a component, as well. The study showed that compliance increased as a function of the training procedures employed and the behavior problems which were being measured (but not directly treated) diminished as compliance increased.

In their discussion, Russo et al. address the concept of behavioral or response covariation (Wahler, 1975). This is the notion that certain behaviors vary together and by directly modifying one, one can indirectly modify the other. In some cases, increasing one behavior can result in an increase in others; in the reverse, increasing one behavior can result in a decrease in others. One explanation for this is that regardless of their topography, certain behaviors come to form a functional class because of common controlling variables. In such instances, this group of behaviors may covary directly and/or inversely even though only one of them is being directly acted upon (Sajwaj, Twardosz, & Burke, 1972). Compliance may be inversely related to certain behavior problems, for example, because historically, certain reinforcers may have been available for compliance

only in the absence of those undesired behaviors. Hence, an increase in compliance could result in a decrease in those behaviors with which it has an inverse relationship.

The importance of a treatment approach using behavioral covariation as a strategy is that it may make intervention more efficient. If we can modify multiple behaviors by intervening with only one, the cost/benefit ratio of our efforts can be maximized. This is a particularly relevant consideration for those working with learners who have severely handicapping conditions. For such individuals, numerous behaviors often need treatment. A sequential strategy of treatment in which we change each behavior in turn before we go on to the next is time-consuming, costly, and inefficient compared with a strategy such as that of Russo et al. (1981) which utilized behavioral covariation.

Behavioral covariation as a function of compliance also forms the basis of a seminal book on the topic of generalized instructional control or generalized compliance training (Englemann & Colvin, 1983). Generalized instructional control is a logical extension of the earlier stages of compliance training. Initially, the learner is taught to comply with a limited series of requests or demands. As each new request is introduced, one often finds that it takes fewer trials and/or less prompting for the learner to become "compliant" with that particular "instruction." Eventually, the learner may comply with a novel request without having to be specifically trained to respond to that instruction. When this occurs, generalized instructional control has been established. It is important to note, however, that generalized instructional control in this ultimate sense does not have to be established for the inferred effects of behavioral covariation to occur. Rather, the results indicate that as compliance with each new instruction is established, behaviors that appear to covary with compliance (such as aggression, self-injury, property destruction, and the like) are altered (Butman, 1979; Engelmann & Colvin, 1983; Russo, Cataldo, & Cushing, 1981).

Nevertheless, the notion of generalized instructional control is a powerful one. It means that the learner is under the control of certain rules:

1. Do what you are asked to do.
2. Don't do what you are asked not to do.
3. If you have not been asked to do it, don't.

Obviously, in absolute terms, this level of generalized instructional control carries the connotation of automatons who cannot think for themselves and must be told every little thing. From this perspective, absolute instructional control is not really desirable and needs to be

tempered by some margin for the learner to express personal preferences and to maintain a measure of "self-control" over her own behavior. With these qualifications in mind, establishing generalized instructional control is an important goal for our programming efforts.

As mentioned earlier, Engelmann and Colvin (1983) comment that instructional control is a prerequisite to the instructional process. In their book on generalized compliance training, they outline and describe in detail their program for establishing instructional control. Five major phases are involved:

1. An assessment in order to determine both the nature and the severity of the learner's non-compliance;

2. The initial teaching phase, in which two basic training tasks are introduced and differential consequences are established for limited non-compliance and compliance "sets";

3. Modification of the non-compliance set to permit responses in major as well as minor non-compliance categories;

4. Use of the compliance set as a pre-correction before the learner engages in activities that prompt non-compliance; and

5. The final training phase, when the system is extended to less obvious inappropriate behaviors.

Engelmann and Colvin's (1983) full approach employs some aversive components, primarily in the form of forced responding (Epstein, Dokes, Sajwej, Sorrel, & Rimmer, 1974). Because of this aversive component, they consider their generalized compliance training program to be a fairly intrusive intervention and one which should be protected by all the safeguards one would ordinarily consider, including prior attempts at non-aversive solutions. We concur! Nevertheless, in its initial levels, the system employs physical prompting which, unless there is active resistance on the part of the learner, need never reach the aversive level of forced responding. For this reason, a subset of this approach to establish instructional control is very properly considered as part of the armament of non-aversive technology available for our use.

Although the effects of behavioral covariation often result in the reduction of behavior problems as instructional control is established, behavior problems sometimes remain or exist even when a fair degree of compliance has been established. That is, it is possible for a learner to be under at least limited instructional control and still exhibit behavior problems. When this occurs, instructional control can often be used to deal with those problems or to enhance or contribute to a different strategic approach to their solution. One such case involved an adolescent boy with the problem of autism.

His skills and abilities were high enough that in three of five classes that made up his school day he was integrated with his non-handicapped peers in normal classes. Nevertheless, he exhibited some strange behavior problems that made him "different" from the others and attracted considerable negative attention. Included among these was his penchant for hoarding certain inappropriate material in his school locker. He would not respond to spoken reminders about what could be appropriately stored there. Fortunately, he considered the school orientation booklet his "bible." The solution to this problem was quite simple: merely inserting an addendum concerning locker rules to his personal orientation booklet. If it was in the book as a rule, he followed it.

This example illustrates a point about instructional control that we would like to emphasize. Specifically, individuals with severe learning or language difficulties are often more under the control of the written word than they are under the control of the spoken word. If we cannot achieve compliance with our spoken requests, instructions, demands, and rules, it is sometimes helpful to see whether presentation in a written format will make the difference. This may also explain the effectiveness of a written contingency contract (Homme, Csanyi, Gonzales, & Rechs, 1969) as a medium for communicating to a wide variety of individuals the contingency rules for reinforcement designed to increase desired responding and decrease undesired responding.

In addition to the content and medium used to present the verbal stimulus, instructional control is also a function of other variables. Under the general heading of "demand-giving style," among other things, there is a need for concern about the brevity, clarity, and conciseness of the instruction; the timing of its presentation; the tone of voice with which it is presented; the associated body language, such as proximity, facial expression, body orientation, and the like; and the functionality of what is being asked in relation to the general context of the request. Generally, if one asks another to do something in an unclear, tentative way, using a tone of voice and body language that convey a lack of confidence and a sense of being intimidated, one is not likely to elicit as much compliance as the person who asks in a clear, concise, firm manner, using a tone of voice and body language that convey a sense of confidence and expectation that the request will be satisfied. Demand-giving style is one of the areas we routinely assess in order to understand why a particular set of behavior problems exists. Based on a good assessment, changes in demand-giving style can often contribute to a solution. Such a strategy falls within this category of instructional control.

II. Advantages

There are a number of advantages to instructional control as a strategy to reduce behavior problems in applied settings. At the very least, these include its positive orientation, constructive emphasis, efficiency, social validity, as well as the rapidity with which it can bring problems under control. We will briefly discuss each of these advantages in turn.

A. Positive Orientation

As with the other procedures discussed in this book, instructional control is a positive strategy and does not require the use of an aversive stimulus or of contingent withdrawal of a reinforcing stimulus. This is also true of procedures designed initially to establish instructional control when such procedures are based on differential reinforcement and prompt/prompt fading approaches.

B. Constructive Orientation

In addition to being positive, instructional control has the asset of being constructive. It is constructive in that it teaches the learner a set of responses alternative to and competitive with the undesired behavior which, if carefully selected, are functional in their own right (e.g., Donnellan, 1980b). Further, to the extent that a learner is under instructional control, that control can be used to teach a wide range of other behaviors which are functional as well. The constructive qualities of instructional control go beyond their contribution to the solution of specific behavior problems and include its fundamental contribution to the instructional process at its most basic level. Without assuring the existence of instructional control and the reliable feedback it involves, the teacher is without even the minimum information needed to make instructional decisions (Engelmann & Colvin, 1983).

C. Efficiency

Instructional control has the promise of being a highly efficient intervention strategy. This potential exists on two dimensions, both of which have been referred to already. The first involves behavioral covariation. Compliance, i.e., instructional control, often appears to have a functional but inverse relationship with many behaviors

we would consider to be problematic. In these cases, when we use differential reinforcement and prompt/prompt-fading procedures to increase compliance or to initially establish instructional control, those behaviors with which there is an inverse relationship decrease accordingly (Russo et al., 1981). In this way, a given intervention can accomplish two or more goals for the price of one.

In the second instance, to the extent that generalized instructional control is established, we also are using a particularly efficient intervention. As we teach the learner to comply with instructions, we find that it takes fewer and fewer trials to reach our specified criteria for mastery and that eventually the learner may demonstrate an acceptable level of compliance when presented with a novel instruction. The efficiency here is measured by the decreased training needed over time for the learner to reach a criterion level of performance. This effect of generalized instructional control together with behavioral covariation gives this intervention strategy a real potential advantage of efficiency.

D. Social Validity

Although there have been no systematic studies concerning the social validity of a wide range of intervention procedures, our guess is that instructional control would rate very high in stuch a study. There are a number of reasons why this strategy would be widely accepted by the community at large as a means for the control of behavior problems across the entire range of domestic, vocational, recreational and general community settings. Most significantly, instructional control is a ''natural'' intervention strategy. That is, it is the strategy society uses most prominently to control all of our behavior. Signs, rules, instructions—our culture is a culture of words, and words largely control our behavior. Thus, as an intervention strategy, instructional control has a high degree of social validity. Even in its more artificial forms, such as use of a contingency contract, we believe it would be more readily accepted than some of the artificiality that is introduced even with some of the other positive approaches we have discussed. As continued research in the area of social validity is carried out, we believe that instructional control will emerge as one of the most widely acceptable procedures.

E. Rapidity

Instructional control can contribute to the rapid control of behavior problems. Russo et al. (1981) established almost immediate

control over crying, self-injurious behavior and aggression within only one or two sessions of their differential reinforcement of compliance responses. These kinds of results challenge the notion that only punishment procedures are effective in rapidly eliminating problem behaviors.

III. Cautions

A. Limited Research

There are three major caveats that we regard as important to consider in our discussion of instructional control as a strategy for the management of human behavior problems in applied settings. First, only a limited body of literature has investigated this approach. As we will discuss under the section on research ideas, much more work needs to be done in this area in order for us to determine with certainty the conditions which must be met for instructional control to be a viable approach. We believe that Russo et al. (1981) provide at least one useful starting place for additional research in this area. Engelmann and Colvin (1983) have also contributed a significant effort in this regard. However, what is not clear at this point is the extent to which similar results (as those obtained by Engelmann and Colvin) could be obtained with a generalized compliance training program which did not include the aversive component of forced responding. In terms of the paucity of research on instructional control, it must be stressed again (see Chapter I) that there is an unfortunate tendency to consider the number of studies published concerning a particular procedure as a measure of that procedure's effectiveness. Hence, for example, as more studies have been published concerning overcorrection than instructional control for reducing behavior problems, one might conclude that the former is a more effective procedure. Obviously, this is fallacious thinking. The caution here is that there is a paucity of information. However, that paucity itself tells us nothing about the conditions under which this approach can be viable or how it compares with others in effectiveness.

B. Prompt/fading

The second caveat involves the use of prompting and prompt/fading as a strategy for establishing instructional control. Danger

exists if the prompt being used is a physical one involving "motoring" the learner through the response. If the learner actively resists the prompt and if it is escalated to the point where the learner is physically forced to respond, we have crossed the line and begun to use aversive intervention. Forced responding is an aversive event (Epstein et al., 1973). In recognition of this, Engelmann and Colvin (1983) state the caution themselves:

> ...the first parts of the program may seem harsh to a naive observer, because during parts of the program, compliance is forced, at a high rate...therefore...the parents must be informed about it. The district must agree that the current programs aren't working and that there is a need for it. We must make sure that the child has no medical problems that would make it hazardous to present the program. And we must have a teacher who is trained and facile in the procedures of generalized compliance...

As a non-aversive strategy, we recommend the development of instructional control using differential reinforcement and prompt/prompt-fading without forced responding.

C. Generalization

The third caveat relates to the fact that practitioners sometimes equate instructional control over a behavior with the terminal goal. We are familiar with staff comments such as "I can get him to do it," or "She always behaves when——is in charge." In fact, too limited a notion of instructional control potentially restricts the learner to those situations in which particular staff members or instructional stimuli are located. While this may be necessary at first, it is important to consider the learner's post treatment needs and, to the maximum extent possible, fade to more natural cues (Donnellan, 1980b; 1984).

IV. Suggestions for Implementation

There are number of suggestions for implementation we would like to make which come from our own experience as well as from the work of Engelmann and Colvin (1983). These include basic student assessment, understanding of the distinction between prompts

and correction procedures, timing and selection of the prompt, generalization, selecting behaviors, demand giving styles, and use of written instructions. At the end of this section we will also describe a simple method we have employed in a variety of settings to establish and increase instructional control for many learners who are considered to be severely handicapped.

A. Basic Student Assessment

(See Chapter III, Functional Analysis.) Before embarking on an effort to establish or increase instructional control for any given learner, it is important to have certain kinds of basic information concerning that learner. Among these are: the learner's visual and auditory ability, modality preference, and language comprehension. In addition, you may observe that the learner needs additional time to "process" a verbal request (Engelmann & Colvin, 1983). Any definition of compliance requires us to state some time limit within which the response has to occur in order for us to score it as compliant as opposed to non-compliant. If we have specified a time limit that does not give the learner sufficient time to respond to the instructional stimuli, we will not get an accurate measure of her compliance nor will we be able to effectively intervene and evaluate our intervention efforts. For example, if a learner requires 15 seconds to initiate a response, specifying a criterion of five seconds for response initiations will yield invalid measures of compliance and hence invalid information for intervention planning and evaluation. It is not possible to set a criterion which is equally valid for everyone, since the time necessary to process a verbal stimulus varies considerably from person to person. Further, this is likely to be even a bigger issue the more cognitively or physically handicapped the learner. We therefore suggest that an informal assessment be made and response criteria set for compliance on an individual basis according to the processing time necessary for each person. If the instruction is non-verbal, an assessment must be made within that context.

A second suggestion for this assessment phase is that you have some reasonable sense of what responses are in the learner's repertoire. Instructional control procedures do not involve strategies for teaching new responses; rather, they involve bringing already established behavior under the control of verbal stimuli. For example, we could not teach a person to stand on request if that person were unable to do so because of a physical handicap, nor could we teach her to say her name if she did not know how to speak. Obviously, to

facilitate efforts to establish instructional control one should focus on responses that are within that learner's ability to produce.

A final piece of helpful information is an understanding of which directions the learner will currently follow and the extent to which she will do so. In our work with the population having the problems associated with autism, for example, we often hear that these children are exceedingly non-compliant. However, several studies (e.g., Volkmar & Cohen, 1982) have shown these learners to be highly compliant if they understand what it is they are being asked to do. Moreover, in our experience it is rare to come across anyone who is totally non-compliant. Knowing the extent and conditions under which a learner is compliant offers very useful information about where to start with that individual in a systematic effort to increase instructional control and to approach generalized compliance.

B. Prompts and Correction Procedures

Before embarking on a program to establish instructional control it will be helpful to distinguish between prompts (defined as the assistance provided to the learner after the presentation of the instructional stimulus, to assure a correct response [Donnellan-Walsh, et al., 1976]) and what we refer to as correction procedures. Earlier in this chapter we described the typical design of a discrete trial incorporating a prompt procedure. Where the prompt fits into that sequence should be specifically noted. When the assistance is provided after the presentation of the instructional stimulus but before even the start of an incorrect response, we have arranged a sequence that increases the likelihood that eventually, as the prompt is faded out, the learner will perform the correct response solely upon presentation of the instructional stimulus. If, on the other hand, the assistance is provided after even a partially incorrect response (we refer to this as a correction procedure), we increase the likelihood that the incorrect component will remain part of the sequence that is learned. The diagrams below show two typical trials, one using a prompt and one using such a correction procedure. These diagrams illustrate that even though the positive reinforcement is delivered after a correct response in both situations, in the correction procedure example the incorrect response may become reinforced as well and remain as part of the response chain. Our suggestion for implementation, therefore, is that the prompt be carefully placed in the instructional sequence.

Table 9.1
A Comparison of Two Trials

The Sequence of a Trial Incorporating a Prompt

Instructional stimulus	→	Prompt (gradually faded)	→	Correct response	→	Positive reinforcement

The Sequence of a Trial
Incorporating a Correction Procedure

Instructional stimulus	→	Incorrect response	→	Correction procedure (gradually faded)	→	Correct response	→	Positive reinforcement

C. Timing of the Prompt

There are two reasons we suggest that the prompt be provided to the learner immediately after the delivery of the instructional stimulus. The first is that to the extent a delay occurs we may be inadvertently teaching the learner a long response latency (Catania, 1968) as a part of the response. For example, if we request that a student "put the books on the shelf" and wait five seconds before prompting him with a hand motion, we may find that even if we are able to eventually fade out the prompt, we will be left with a five-second delay in responding. Second, if we provide the prompt too long after the presentation of the instructional stimulus, the learner may never learn the association between it and the prompt and we may never be successful in bringing the learner's behavior under the stimulus control of the instruction. Therefore, to minimize response latency and to maximize the likelihood of establishing instructional control, we suggest providing the prompt immediately after (but not simultaneously with) the instructional stimulus.

D. Type of Prompt

All types of prompts are used in instructional programming. In dealing with the issue of non-compliance, a physical prompt is likely to be necessary. However, the danger exists that the learner will become overreliant on the prompt and that it will not be able to be

121

faded out completely. One suggestion of Engelmann and Colvin (1983) is that to the greatest extent possible, the physical prompt be used to initiate the learner's response, not to direct it. Initially, of course, it would be necessary to physically direct the learner through the response. However, it should be possible to fade out the directional dimensions of the physical prompt before fading out response initiation dimensions. This must be done as quickly as possible in order to minimize the possibility of the learner becoming over-reliant on the prompt.

E. Generalization

Continuing with some suggestions from Engelmann and Colvin (1983), it is important that the instructional control be generalized across a wide range of relevant dimensions. To establish instructional control firmly, it has to be demonstrated, for example:

1. Across a number of settings, such as the work site, playground, home and community and in different places in those settings;

2. Across a number of persons, such as the teachers, aides, ancillary personnel, parents, supervisors, siblings and others;

3. At different times of day;

4. For different forms of the instructional stimulus (for example, for "put the books on the desk," the learner should also respond to "put the books away," "put them over there," and the like;

5. For different content such as "Get the 'x' " with "x" standing for any number of objects;

6. For varying immediacy of the reinforcement delivery; and

7. For different proximities between the learner and the teacher.

F. Selecting Behaviors

Engelmann and Colvin (1983) recommend satisfying two criteria in selecting behavior to bring under instructional control in their generalized compliance training program. The first is that the behavior be incompatible with whatever behavior problems the learner is exhibiting and the second is that it be enforceable. For a discussion of incompatible behavior we refer to Chapter V. In the rest of this section we shall discuss the concept of enforceable behavior withing the context of a non-aversive approach to compliance training.

In the context of this book, the criterion of enforceability does not directly apply since it implies active resistance and the forced responding necessary to counteract that resistance. At another level, however, it does relate to an important consideration, i.e., that the behavior can be prompted to occur. If the response never occurs, there will be no opportunity to reinforce it after the presentation or in the presence of the instructional stimulus. If it occurs unprompted at all, of course, a simple schedule of differential reinforcement may suffice to establish instructional control. Some behaviors lend themselves to prompting and some do not, particularly when we focus on physical prompting, as in compliance training. For example, motor responses are easier to prompt than verbal responses. Accordingly, we might initially focus on behavior that includes such actions as "giving," "putting," "getting," and "taking," rather than behavior that includes such actions as "saying," "chewing," or "reading," since it may be difficult to effectively prompt the latter. Therefore, we suggest that behavior meets the criteria of incompatibility *and* promptability to be selected as a target in a compliance training program.

G. Demand Giving Style

In addition to form and content, we suggest that attention be paid to demand giving style in any compliance training programs. We discussed these variables earlier in the chapter. They include tone of voice, body language, and other non-verbal covariables in the situation. This aspect can be particularly difficult in application when the person delivering the program does not have a natural style which conveys confidence and a firm expectation of compliance. If coaching and feedback are not sufficient for that person to communicate the important non-verbal messages to the learner, it may be necessary to assign the responsibility for the compliance training program to somebody else.

H. Written Instructions

As we mentioned previously, learners are often under the instructional control of written words to a greater extent than they are under the control of spoken words. This suggests that we take full advantage of written contingency contracts, posted rules, and the like when appropriate. More research is needed to investigate the written word versus the spoken word as the medium for instruction-

al control (LaVigna, 1976). One set of functional variables may have to do with critical differences in the stimulus properties between the two. For example, the spoken word is an auditory, temporal, transitory stimulus while the written word is a visual, spatial, concrete stimulus. There is some reason to believe that the latter qualities may be more facilitative than the former (Premack, 1970, 1971; Premack & Premack, 1974) for some learner populations.

As a case in point, we worked with one young boy considered severely handicapped and living in a small group home. His behavior problems included breaking such house rules as not playing with electrical outlets, not using the stereo, record player, or radio without supervision, and not opening closed doors. He could not read or speak. In establishing instructional control, i.e., in teaching him to follow the house rules, the rules were posted for him in picture form. Pictures are not only visual, spatial, and concrete, they are also representational compared with written words, which are symbolic. The first time he broke a rule each day, the corresponding picture was removed from the wall. At the end of the day, he earned tokens based on the number of pictures left. Tokens were actually placed on the pictures so that he could see that the more rules he followed the more tokens he could earn. The tokens were exchangeable for special opportunities selected for him on the basis of a reinforcement survey. In this way, instructional control was gradually established.

I. Natural Settings

Most accounts available in the literature of methods to establish instructional control involve clinic or classroom settings and contrived teaching arrangements (Russo et al., 1981; Engelmann & Colvin, 1983). We would like to suggest an additional model we have found effective for establishing compliance in a variety of natural settings. We refer to it as "discrete trial compliance training." The first step is to develop an a priori list of requests or directions the learner is to follow. The requests should be typical of the things an adult would normally ask a person of the learner's age to do, and should be presented in their functional, natural context. The practitioner should present the learner with each of these requests or directions at least once a day, using the discrete trial format (Donnellan-Walsh et al., 1976). That is, the learner's attention should be obtained and the instructional stimulus should be presented clearly and distinctly. The exact or closely similar wording as is on the a priori list should be used and the "teacher" should wait for compliance

without repeating the request. If the "learner" complies within the specified time frame, a significant positive reinforcer should be delivered. If the learner does not comply, the teacher should walk away without saying anything. Many times this simple process of differential reinforcement is effective in establishing instructional control and, therefore, in eliminating non-compliance. If this approach is not effective, a prompt/prompt-fading component can be added, as discussed earlier.

We have provided several suggestions for implementing instructional control procedures in this chapter under the headings of basic student assessment, prompts and correction procedures, timing of the prompt, type of prompt, generalization, selecting behaviors, demand-giving style, written instructions, and natural settings. Engelmann and Colvin (1983) will be a rich resource for additional suggestions as well, but the reader should keep in mind the caution concerning forced responding as an aversive event.

To summarize, instructional control can be used in a number of ways to solve behavior problems. First, it can directly decrease non-compliance when this, itself, is a presenting problem. Second, through behavioral covariation, the development of compliance can reduce those behavior problems with which it has inverse relationships. Third, once instructional control has been established over responses that are incompatible with the presenting behavior problems, it can be introduced into those settings in which these behavior problems would ordinarily occur, in an effort to reduce their frequency.

V. Research Ideas

Instructional control and generalized compliance training as a set of strategies for the control of behavior problems in natural settings is in its research infancy. While the preliminary work we have discussed is exciting and promising, a host of questions remains, the answers to which will add treatment potency to this approach. A number of such research ideas are listed below for those interested in controlled investigations in this area:

1. What are the necessary conditions for establishing generalized instructional control, i.e., where the learner will comply with novel instructions without training?

2. If a learner cannot obtain generalized instructional control in the above sense because of cognitive limitations, what parameters

determine the extent to which limited instructional control can be established?

3. In what ways can written words and pictures be used to enhance instructional control and generalized compliance training?

4. How can response classes be identified or established which will tell us what behaviors will covary in a program of instructional control and generalized compliance training?

5. Under what conditions can instructional control have a functional relationship with the effectiveness, speed, generalizability, and other dependent variables when combined with DRO, DRL, and the other non-aversive intervention strategies described in this book?

6. What factors have a functional relationship with the social validity of instructional control as an intervention strategy?

7. With reference to different populations and different behavior problems, under what conditions can instructional control be used as a non-aversive intervention strategy?

Footnotes

1. The "instruction" may not, in fact, even be under the "control" of an instructor. In an effort to help a severely impaired learner become more independent, for example, we might specifically teach the learner to attend to the natural cues in her environment which give "instructions." These could be "Walk-Don't Walk" signals, referee's signals, a lifeguard's whistle, or the warning label on a piece of machinery. As with many of the other examples in this chapter, these are limited cases of stimulus control, as discussed in Chapter VIII.

2. By "prompt" we mean offering sufficient guidance (not necessarily physical) to bring about a correct response. We are making a distinction between prompting and forced responding, which assumes coercive intervention. If the necessary level of prompting were, in fact, aversive, we would choose another intervention strategy first. See the discussion on compliance training in this chapter.

CHAPTER X

STIMULUS CHANGE

I. Introduction

In 1958, Azrin carried out an experimental study with human subjects which we believe has important implications for the reduction of behavior problems in applied settings. In investigating some effects of noise on human behavior, he found that the non-contingent introduction or termination of noise temporarily disrupted (i.e., reduced) responding. Further, he concluded that the noise stimulus did not have to have aversive properties to produce this effect, but rather, that this result could most parsimoniously be attributed to the phenomenon of stimulus change.

As a behavior change strategy, we define stimulus change as the non-contingent and sudden introduction of a novel stimulus or a dramatic alteration of the incidental stimulus conditions which results in a transitory period of response reduction. To satisfy this definition, the stimulus being introduced, terminated or altered must not function as a discriminative stimulus, a response-contingent stimulus, or any other variable in the operant paradigm which plays a functional role in the contingency rules affecting the behavior. Such other variables include: the verbal explanations to the learner of the contingency rules, potentiating variables influencing the effectiveness of the consequences, or the program by which the behavior in question is originally established, e.g., with errorless training, or with variable schedules of reinforcement. Stated more simply, the stimulus change variable must be one which is otherwise unre-

lated to the target behavior or contingency rules governing the behavior.

In an extension of the earlier work, Holz and Azrin (1963) studied the disruptive effects of the sudden presentation of such a novel, unrelated stimulus, in this case, the effects of a color change on key pecking. When the original white response disc stimulus was suddenly changed to green, the pigeon abruptly stopped responding. As demonstrated in this study, stimulus change effects are typically dramatic but temporary. It is the non-functional role that the novel stimulus plays in the contingency rules governing the behavior that accounts for the temporary nature of the effect and subsequent later recovery of the response.

Although the literature on stimulus change is sparse, this temporary effect of a novel stimulus, often called the "honeymoon effect," is a common clinical observation. We have all observed a learner enter a new program, classroom or group home and "behave" for a short period of time before the honeymoon effect wears off and the behavior problems reported from his previous setting reappear. When this occurs, a stimulus change effect may be operating. That is, in addition to its temporary effects, the novel (honeymoon) setting meets another criterion of stimulus change in that it is typically unrelated to the basic variables controlling the behavior.

It is ironic that some very good strategies may sometimes preclude a stimulus change effect even as we attempt to minimize problems. That is, we may transfer a learner into a new environment so slowly or make environment B so like A that there is no stimulus change effect. In fact, when a person goes to a new environment, we typically do not develop a specific strategy to deal with a behavior problem before we have taken baseline observations on the behavior in the new setting. Thus, by design, we inadvertently ensure that the initial changes we see in new program placements are only temporary (honeymoon) effects of stimulus change as we delay interventions for permanent change until there is a response recovery of the problem behavior.

The term "stimulus change" has unfortunately been used inconsistently in the literature. It served to label the systematic manipulation of discriminative stimuli in instructional programs of various kinds (e.g., Touchette, 1968) as well as the systematic manipulation of response-produced stimuli, i.e., consequences (Sailor, et al., 1968). We reiterate that following Azrin (1958) and Holz and Azrin (1963), our definition of stimulus change involves the non-contingent and sudden introduction of a novel stimulus or a

dramatic alteration of the incidental stimulus conditions. "Incidental" refers to the non-functional role the stimulus plays in the contingency rules governing the target behavior. Utilizing this definition, "stimulus change" is an underutilized procedure.

Although the "honeymoon effect" is widely recognized, we are unaware of any controlled study which attempted to examine this or any other form of stimulus change in an application to the solution of human behavior problems. Nevertheless, our own clinical and classroom experience and the anecdotal reports of others (e.g., Goldiamond, 1965) provide examples of how stimulus change could be used. The procedure typically results in a general reduction of many of the responses in a learner's repertoire including, most importantly for our purpose, the undesired one. Of course, this reduction of the undesired response is only transitory. If the original contingencies are maintained, the behavior will reestablish itself. If the period of transitory response reduction is used to establish a new contingency or set of contingencies, however, the behavior can often be prevented from returning to its previous strength. Therefore, it appears that stimulus change is most effective in controlling undesired behavior when paired with new contingencies.

In fact, in some situations stimulus change may be used just to establish a lull in what seems to be an unending stream of undesired behavior in order to implement any other procedure. A residential school in southern California serving delinquent, seriously acting-out boys faced this problem. A new director had just been hired and the immediate task before him seemed impossible. The boys had been entirely out of hand for weeks. Seriously destructive acts took place daily, including window, wall, and furniture-breaking; the facility was literally being broken apart. The director's plan was to establish a token economy which would positively reinforce a host of competing behaviors, including study behaviors, housekeeping behaviors, and recreational behaviors. It was impossible, however, to introduce the new system in the midst of the moment-to-moment fights and riots that were occurring.

The solution was stimulus change. An announcement (novel stimulus) was made that there would be a major announcement (novel stimulus) in three days. Concurrent with that, all the windows and doors of the administrative offices and recreational lounge were locked and sealed off from the students' entry or view (altered stimulus). No explanation was given for this novel set of stimuli except that an announcement would be made in three days. The property destruction stopped almost immediately. For three days there was cautious anticipation. On the third day, the lounge

was reopened, newly decorated (altered stimulus), and the new token economy was announced, incorporating new games and equipment in the lounge as reinforcers. The token economy proved very successful. While behavior problems continued to occur from time to time, they never approached the level of intensity and frequency that existed before the stimulus change (LaVigna & Donnellan, 1976).

Another application of stimulus change took place in a group home and involved an adolescent with the problem of autism whose problem behaviors included severe aggression. Despite a series of attempts to bring the behavior under control, aggression was increasing to the point that staff were being injured. Some staff, in fact, were beginning to believe that the resident was inappropriately placed and incapable of benefitting from the program. To prevent the necessity of removing this young man from the program, an all-out effort was planned to reassess the problem, bring in outside consultation, and brainstorm with staff on possible strategies which had not yet been tried to reduce the problem to more acceptable levels. This reassessment and planning process, however, would take time in the face of an increasingly urgent situation in which people were getting hurt.

An interim strategy was necessary, and stimulus change fit the bill. Accordingly, a series of novel stimulus introductions and dramatic alterations was scheduled to bridge the one-week period that was anticipated for the reassessement and planning process. These changes included several rearrangements of furniture in the group home, major stylistic changes in staff attire, and dramatic alterations in staff/client interactional patterns. As a result of the stimulus change strategy, the reassessment and planning process was completed with no additional staff injuries. Further, the learner's program was totally revamped as a result of this process, and the new program and contingencies were successful in extending the temporary effects of the stimulus change procedure into a permanent change for the better. This learner is now considered to be one of the major successes of this group home program. Without the temporary benefits of a stimulus change strategy, he might have been omitted from the program as a danger to others before the major reassessment and planning process was completed.

In a third clinical application, a young man with autism had become so prompt-dependent that he would not even eat without such prompts as, "Put the food in your mouth, chew, etc." His teacher and parents became alarmed at his substantial weight loss, which also precluded such potential interventions as "waiting him out" or attempting to extinguish his requests for prompts. A sys-

tematic program of intervention was greatly enhanced by the use of a stimulus change procedure. He was given his lunch in a totally novel environment, removed from the people with whom he typically ate. His behavior changed dramatically and he ate his lunch without prompts from the first day. He was systematically reinforced for his eating, his classmates were gradually faded back into the eating area and finally he was returned to the regular cafeteria. Additionally, utilization of the discrete trial format (Donnellan-Walsh, et al., 1976) and systematic utilization of other interaction options prevented the return of this dependency, but it was the dramatic stimulus change which made the behavior amenable to the other intervention strategies.

Finally, in one of the few published case studies applying this strategy, Goldiamond (1965) reported the use of stimulus change in the self control efforts of an adult non-handicapped man. In this case, furniture rearrangement and other stimulus changes were introduced to disrupt the undesirable communication patterns which were contributing to marital discord. This approach was, of course, combined with other strategies to develop more permanent desirable communication patterns.

II. Advantages

A. Speed of Effects

Although stimulus change obviously has its limitations as a behavior change strategy, there are advantages as well. The first major advantage is the immediate effect it has on behavior. If stimulus change works at all in reducing a behavior problem, it works immediately. This is inherent in the nature of stimulus change as, by definition, we are not altering any of the functional elements in the contingency rules controlling the behavior. Once the behavior does occur, the other original maintaining variables act to reestablish and strengthen it very rapidly. Therefore, if the introduction of a novel, non-functional stimulus does not immediately disrupt the behavior, it is unlikely to do so at all.

B. Crisis Strategy

The immediacy of effect also gives stimulus change its second major advantage: its usefulness in crisis situations, such as when a

behavior represents a serious threat to health, safety, or property. In such situations, stimulus change may:

1. Provide a temporary reduction in the behavior problem, allowing time for a behavioral assessment and the development of an intervention plan;

2. Prevent injury or damage from occurring until a more permanent solution can be found;

3. Provide additional opportunities for alternative strategies such as DRO or Alt-R;

4. Facilitate rapid, permanent control over a behavior problem if used in combination with another intervention strategy; and

5. Provide an on-the-spot strategy for dealing with non-recurring behavior problems that may appear unexpectedly.

III. Cautions

A. Temporary Effects

The obvious caution and disadvantage of stimulus change is the temporary nature of its effect on behavior. A dramatically novel stimulus or alteration of the incidental stimulus conditions in a situation may startle the learner and cause a disruption in responding, but, if the old contingencies maintaining the behavior are intact, the behavior will recover and reestablish itself. If we desire a permanent reduction in a behavior problem, we must change the contingencies which control the behavior. Stimulus change as an intervention strategy is quite limited in what it can accomplish, therefore, and in most circumstances we need to use it in combination with other approaches. The possible exception to this could be in the application of stimulus change to the unexpected appearance of a non-recurring behavior problem such as an uncharacteristic temper tantrum, aggressive episode, or other atypical occurrence.

B. Adaptation

A second caution or disadvantage of stimulus change is that its utility may be limited for those who readily adapt to change and for whom the non-contingent introduction of a novel stimulus no longer has a disruptive effect on behavior. We can anticipate that if stimulus change is used repeatedly with a given individual, he may eventually "learn" that such changes are just apparent and not real as

they affect the contingencies maintaining behavior. Thus, he may eventually learn to disregard such changes. For example, if Brenda exhibits a "honeymoon effect" upon entering a new classroom but starts misbehaving after one week, the "honeymoon effect" is unlikely to repeat itself indefinitely with each classroom change if such were scheduled on a weekly basis. We could expect that eventually Brenda would adapt to change. As we discuss under this chapter's section on research ideas, we need to know more about the parameters of stimulus change and adaptation to such change on a given dimension. Additionally, we need to know how many changes across dimensions are possible before a generalized adaptation develops such that the effects of stimulus change cannot be produced regardless of its extremity or the dimension in which it occurs.

C. Evaluation

A third caution regarding stimulus change relates to the recommended practice of obtaining a baseline before intervention. By definition, to take full advantage of stimulus change as a lead-in to more permanent treatment efforts, it is necessary to start intervention before baseline information has been obtained. Yet, baseline rates of behavior are important data in evaluating the effectiveness of an intervention. Without such information, it may be difficult to know whether the observed change in the behavior is a function of the intervention or of unidentified variables in the situation.

Figure 10.1 portrays hypothetical data for the aggressive behavior of an adolescent who has the problem of autism and who has just moved into a group home setting. Condition A shows the "honeymoon effect," i.e., the effects of stimulus change. We can see that when the learner entered the group home, aggression occurred, but initially at low rates. As the novelty of the new surroundings decreases, we observe a corresponding increase in the rate of aggression until a steady state is reached and baseline measures begin. Condition B_1 represents a baseline condition of no treatment and we observe a relative high rate of behavior that occurs with variability but in an obviously steady state. At this point we begin our hypothetical treatment in condition C_1, and we observe a decrease in the rate of responding. To evaluate whether this reduction in rate is a function of our intervention, we briefly reinstitute our baseline conditions and then start treatment, condition C_2, once again. We observe a corresponding increase and decrease in responding respectively and may conclude that it is indeed our treatment which has caused the targeted behavior to decrease.

Figure 10.1
Hypothetical Data for Intervention After
Both a Stimulus change and a Baseline Condition

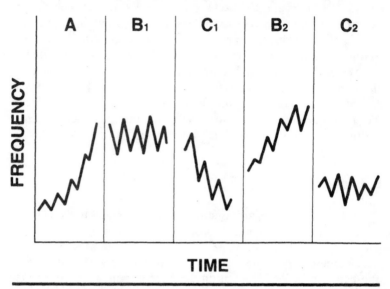

Under certain circumstances, however, it may be desirable to take advantage of the "honeymoon effect" produced by the stimulus change and begin treatment right away before the target behavior reappears in the new program setting. Figure 10.2 portrays another hypothetical set of data for the aggressive behavior of an adolescent who also has the problem of autism and has just moved into a group home setting. Using the terms from Figure 10.1, it illustrates the successful application of stimulus change (Condition A) in joint combination with a long-term intervention strategy (Condition B).

As shown, if such a combined approach is successful, the short-term attenuation of behavior we would expect as a result of stimulus change can be extended and made permanent with the combined addition of a long-term treatment strategy. The problem is that on the basis of data of these types, any conclusion must be tentative, for the lack of experimental controls leaves open too many alternative possibilities. Many factors other than the combined application of stimulus change and another intervention strategy may account for the treatment effects portrayed.

Figure 10.3 displays data from the same hypothetical case but this

Figure 10.2
Hypothetical Data for Intervention Which Takes Advantage of a Stimulus Change Effect without Experimental Controls

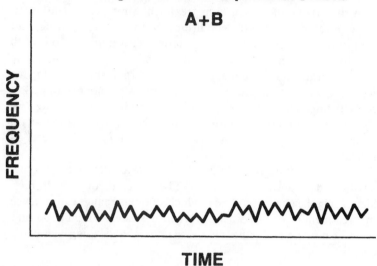

Figure 10.3
Hypothetical Data for Intervention Which Takes Advantage of a Stimulus Change Effect with Experimental Controls

time with some controls allowing more definite conclusions regarding the effects of the long-term treatment strategy. Condition B shows the frequency of aggression in the previous setting. Condition A + C shows the stimulus change effect of the new setting combined with the effects of a long-term treatment strategy. Condition B$_2$ shows a return to baseline conditions, but in the new setting, and then in A + C a return to the long-term treatment condition. With this format we have accomplished a number of things: First, we have integrated a new resident into the program while avoiding the high frequencies of aggression reported in his previous setting. Second, by implementing a brief baseline probe in the new setting, we are able to demonstrate more convincingly that it is the long-term treatment strategy which accounts for the long-term effects illustrated.

To pinpoint the role stimulus change played in bringing this behavior under control, we would need additional controls. In fact, identifying the conditions under which stimulus change can enhance the treatment effects of other intervention strategies is an important research need and is further discussed under that heading later in the chapter.

IV. Suggestions for Implementation

We have developed a list of suggestions regarding the utilization of stimulus change as a strategy for the reduction of human behavior problems. These include:

A. Naturally-occurring Opportunities

We should take advantage of naturally-occurring opportunities where we can anticipate a "honeymoon effect." The most obvious time this occurs is when a learner moves into a new program setting. When such a move is scheduled, it is usually accompanied by a stimulus change effect, and the learner is on his best behavior. When we are aware of a recent history of undesired behavior, it may be important to take advantage of the effects of stimulus change and to start an intervention before the problem appears in the new setting. For example, if the learner was aggressive in his previous setting on the average of once an hour, it may be wise to immediately implement a DROP schedule (Chapter VI) using a one-hour interval. Such an approach might preclude aggression from ever occurring in the new setting.

B. Dramatic Stimulus

As we move away from naturally occurring stimulus change and plan to use a contrived stimulus change strategy, the novel stimulus or stimulus alteration should be as dramatic as possible. In the past, we have used furniture rearrangement, red light bulbs in the lamps, staff costumes, and other major environmental changes.

C. Delaying Tactic

We have suggested that if serious behavior problems are occurring, a stimulus change strategy may be effective in establishing temporary control or in allowing time for a comprehensive assessment of the behavior and the careful development and implementation of an intervention plan (see Chapters III and IV). Without such temporary relief, there may be considerable pressure to act prematurely and, accordingly, with only marginal hopes for success. These are precisely the kinds of conditions that lead to decisions to punish because "nothing else worked." It may even be necessary to repeat the procedure with sequentially different novel stimuli or stimulus alterations in order to extend the effect sufficiently to allow all the preparations for long-term intervention to be completed.

D. Initial Boost

By combining stimulus change with other treatment strategies, we can get our intervention efforts off to a good, positive start. This provides an increased opportunity for the learner to come into contact with the reinforcement contingencies arranged for more appropraiate behavior. It also provides immediate reinforcement for staff through initial and rapid success for implementing and carrying through with an intervention strategy.

E. Crisis Intervention

Stimulus change may be a useful addition to the techniques currently employed for crisis intervention with aggressive, self-injurious or property-destructive behavior (Palotai, et al., 1982; Zivolich & Thvedt, 1983). The dramatic introduction of a novel stimulus may startle and produce enough disruption to the ongoing behavior that it precludes the necessity for physical intervention and thereby minimizes the possibility of further injury.

F. Respite Work

Those who provide respite services to families of persons exhibiting serious behavior problems often do not have time to develop long-term control stategies. Where there is no on-going control system that they can use, such as might be mediated by a token economy, respite workers may find stimulus change techniques their most effective recourse. In fact, the respite conditions themselves may produce a stimulus change effect which can be capitalized upon.

G. Substitute Teaching

Substitute teachers historically find it difficult to control student behavior, particularly at the middle and high school levels. Substitutes wishing to use reinforcement programs often do not have a chance to implement them because the students start to exhibit bad behavior in response to the mere presence of a substitute teacher. A stimulus change procedure might be just the strategy for "getting their attention" long enough to explain plans and the "contingency rules" for the period the substitute will be with the class.

For example, we imagine that substitute teachers would get their students' attention if they were to stand on a pedestal (or better yet, a desk), wear a mask and/or costume, walk into the classroom backwards, or do something similarly outrageous. Once attention is obtained, the non-aversive contingency rules which have been carefully designed for control during the substitute's tenure can be explained.

H. Planned Novelty

We know a teacher of students with severe behavior problems who regularly rearranges the furniture in her classroom and also changes the wall hangings and decorations every few weeks. She has learned that this stimulus change always produces a period of relatively good behavior and provides an ideal opportunity to implement any new long-term treatment strategies which may be necessary for some of the more serious behavior problems. Invariably, she says, this combined approach results in the permanent control of one or more of the long-standing problems with which she must deal.

I. Added Opportunity

The effects of stimulus change can create additional opportunities for the utilization of other non-aversive strategies. If, for example, a behavior is occurring at such high rates that a DRO procedure is not practical, a stimulus change introduction may make such an approach feasible. For example, an adolescent girl with autism was at risk of being institutionalized because of "nonsense talk," i.e., incessant nonsense verbalizations occurring up to 97% of her waking hours. Obviously, such continuous responding makes it extremely difficult to employ either a DRL or a DRO strategy which the teacher wished to attempt. A DRO schedule was designed and explained to the student at a teacher-student conference right after her arrival at school. However, the conference was held in the middle of the school parking lot on a brisk November day in a northern Midwestern city! The stimulus change of this novel setting caused an immediate disruption in the target behavior, allowing the student to experience immediate success in receiving reinforcement on the DRO schedule (Donnellan and LaVigna, in press).

J. Non-recurring Problems

Most treatment strategies are developed to deal with behavior over time. As such, they do not naturally lend themselves to application in the control of isolated, unexpected incidents or non-recurring behavior problems. A repertoire of stimulus change procedures might be valuable to deal, for example, with the aggressive outburst or temper tantrum of an adolescent boy who has not typically exhibited such behavior. Flicking the lights on and off and/or bursting into song are examples of the kinds of "dramatic" things that could produce a stimulus change effect.

V. Research Ideas

Given the lack of literature demonstrating the application of stimulus change under controlled conditions to behavior problems in natural settings, all the suggestions for implementation above are also offered as opportunities for applied research under controlled conditions. There is a need to investigate the applicability of stimulus change to a wide variety of populations, behaviors, settings and situations. These suggestions for implementation are also sug-

gestions for the initiation of controlled studies concerning this promising technique. There are other specific research inquiries we would support as well:

1. We need to know under what conditions the effects of stimulus change can be used to enhance the rapidity with which other procedures, such as DRO and DRL, establish control over behavior. One ongoing issue for many professionals concerns the relative rapidity with which control can be established and a behavior problem sufficiently reduced or eliminated via aversive and non-aversive intervention. Obviously, the more rapid procedures are the most desirable, at least on that dimension of rapidity. There are, of course, other dimensions on which effectiveness can and should also be measured, such as resistance to recovery under the old contingencies, response generalization, staff and resource feasibility, social validation, and so on. All such comparisons are premature at this point, however, and will only become valid after we have identified the ways of maximizing the rapidity of treatment gains using different techniques, both aversive and non-aversive. The application of stimulus change techniques in combination with other intervention strategies represents one such way that should be explored.

2. We need to develop assessment methodology to determine for any given person the most salient stimulus dimensions for stimulus change effects. For example, are isolated auditory or visual stimuli more effective than more pervasive stimuli, such as the arrangement of furniture or other given conditions in an actual treatment setting? These answers are likely to vary depending on the situation, behavior, and person. The real task is to identify those conditions under which a given stimulus change strategy could be used effectively to produce the desired results.

3. Research on adaptation is needed to identify how people adapt to stimulus change and ways adaptation can be avoided when it is desirable to maintain stimulus change as a treatment option for a given person.

4. Most clinicians and teachers have encountered particular problems which seem resistant to interventions. Each new intervention fosters an initial improvement, but then the behavior goes back to its previous level. This suggests that a stimulus change effect may be present, and that the intervention, though not affecting the basic contingencies controlling the undesired behavior, is possibly acting as a novel stimulus which produces temporary change. We believe it is important to investigate this phenomenon, to determine whether or not intervention strategies do, in fact, act as novel stimuli in such circumstances, and, if so, the nature of the contingencies maintaining the undesired behavior.

CHAPTER XI

RESPONDENT CONDITIONING PROCEDURES *

I. Introduction

While most procedures used to modify inappropriate behavior are based on operant conditioning principles (Skinner, 1938, 1953; Keller & Schoenfeld, 1950), a few such procedures have been derived from the classical or respondent conditioning paradigm (Pavlov, 1927; Watson, 1913). These techniques are based on the three fundamental principles of classical conditioning:

1. Associations are formed between events which occur together;
2. The strength of any association depends on the frequency with which the events are paired;
3. The strength of an association depends on the intensity of the feelings or sensations it evokes. (Leiberman, 1974).

Inappropriate behavior, then, is seen as originating from repeated and intense pairings of a conditioned stimulus and an unconditioned stimulus. Procedures based on this model are aimed at weakening this association and replacing it with a new association which elicits more desirable behavior. These procedures include several that are aversive, such as aversion therapy, implosion therapy, flooding, and thought stopping, which will not be discussed here. The primary non-aversive techniques which are respondent-based are progressive relaxation training, either with or without biofeedback assistance, and systematic desensitization.

* This chapter was written by Pat Mirenda, Ph.D.

II. Progressive Relaxation Training

A. Introduction

Progressive relaxation training (PRT) was first formalized by Jacobson (1938) as a technique for treating psychosomatic illness, which he believed to be stress-induced. The rationale for this procedure is that tension and anxiety are responses which involve the shortening or contraction of muscle fibers, whereas relaxation is a state in which these muscle contractions are absent. Progressive relaxation training seeks to teach the individual to consciously eliminate muscle contraction in a systematic way. The individual is taught to discriminate and attend to the sensations of tension and relaxation by deliberately tensing and releasing various muscle groups. Once this discrimination is made, the person can use the technique before, during and after anxiety-producing situations to prevent or eliminate tension.

The Jacobsonian method for PRT evolved over a period of several decades, and the basic procedure ultimately involved 15 muscle groups (Jacobson, 1964). Each group was dealt with for daily sessions ranging in length from one to nine hours, before proceeding to the next group. This necessitated a minimum of 56 sessions of training and often involved up to 200 to achieve some clinical results (Bernstein & Borkovec, 1973). The prohibitive amount of time required for Jacobsonian training led Joseph Wolpe (1958) to modify the procedure into a training program which involved direct instruction and even hypnotic suggestions to facilitate awareness of bodily sensations. Wolpe's training program could be completed in six 20-minute sessions with two 15-minute daily home practice sessions between training sessions, thus substantially reducing the amount of time required in therapy. Since then, several other researchers have designed alternative training programs which are variations of Wolpe's revisions (e.g., Bernstein & Borkovec, 1973; Cautela & Groden, 1978).

The short-term physiological effects of PRT have been demonstrated in several studies. Jacobson (1938) documented that pulse rate and blood pressure decreased as a result of his relaxation training, and a series of investigations by Paul and his colleagues (1969a, 1969b, 1969c, 1970) demonstrated a lowering of skin conductance, respiration rate, heart rate, and muscle tension. The long-term effects (i.e., beyond the immediate training session) of passive PRT therapy have been less impressive, however, unless self-controlled relaxation is taught as part of the treatment "package" (Chang-

Liang & Denney, 1976; Goldfried, 1977; Goldfried & Trier, 1974). It would appear, then, that when relaxation training is implemented and taught as an active coping skill, its effectiveness is increased over PRT presented in a more traditional, passive manner.

Mechanically-assisted relaxation training via biofeedback has also been used successfully to treat a wide range of problems. Biofeedback and instruments used for this purpose provide the individual with a concrete visual, auditory, and/or tactile signal that muscle contraction is decreasing. It is often used in conjunction with traditional relaxation training and, as such, can be considered to be the technologically glorified "sister" of relaxation procedures. The most common type of training involves electromyographic (EMG) biofeedback training, but electroencephalographic (EEG) and thermal biofeedback have also been used with both handicapped and non-handicapped individuals.

Much of the early biofeedback research was derived from learning theory, emphasizing the application of instrumental (Miller, 1969) or operant (Shapiro, Crider, & Tursky, 1964) conditioning procedures. More recently, however, a neurophysiological model has been used a the basis of biofeedback therapy. This model draws upon the early works of the French physiologist Claude Bernard in the last century and of Walter Cannon in his classic volume, *The Wisdom of the Body* (1939). These authors postulated that there is a biological necessity to maintain physiological variables within adaptive limits for the purpose of survival. This is accomplished through the process of homeostasis, an internal feedback mechanism which maintains the efficiency and integrity of the internal organs. If this protective feedback circuit is altered or made ineffective, the system will become unstable; this has been referred to as a "disregulation" (Schwartz, 1977). The purpose of biofeedback, then, is to supply external corrective feedback to the organism, in order to restore physiological control. Some of the responses which can be brought under self-control via biofeedback include systolic and diastolic blood pressure, heart rate, blood flow, sweat gland activity, skin and body temperatures, respiratory functions, stomach motility, fine skeletal muscle control, and various changes in the electrical activity of the brain (Schwartz 1977).

Relaxation training has been used both singularly and in combination with other procedures, including biofeedback, to reduce a variety of behavior problems apparently related to tension or anxiety. Some examples of successful application with able-bodied persons and with individuals having a variety of handicapping conditions will be presented in the following sections.

1. Research with Able-bodied Individuals.

Straughn and Dufort (1969) were among the first to investigate the effects of PRT alone on the verbal learning and recall abilities of adults. After assigning the subjects to either a low- or a high-anxiety group on the basis of Minnesota Multiphasic Personality Inventory scores, the authors administered four treatment conditions. Subjects were given 1) relaxation training before the learning trial, 2) relaxation training before the recall trial, 3) relaxation training before both learning and recall trials, or 4) no relaxation training at all. Half of each group was exposed to a learning trial of low difficulty paired asociates, and the other half was given a high difficulty test. Recall was tested immediately after exposure to the list and again 48 hours later. On both the immediate and delayed recall tests, relaxed high-anxiety subjects responded faster, and relaxed low-anxiety subjects responded slower than their non-relaxed counterparts. The results were greater for high difficulty tests than for low difficulty tests, and the effects were intensified when relaxation was administered before the learning trial rather than the recall trial. The study points out the importance of determining that the client's problem is anxiety-related before instituting PRT, and of reducing the anxiety level of clients before embarking on traditional verbal therapy.

A more clinically useful example of PRT which involved self-instruction training was offered in a case study by Weil and Gold-fried (1973) of insomnia in an 11-year-old child. The child was taught a self-cued relaxation program which successfully eliminated long standing insomnia. Self-cued PRT was also used in the treatment of a 14-year-old male student, whose problems included non-organic abdominal pain resulting in frequent school absenteeism and a high rate of violent arguments between the student and his father (Workman & Williams, 1980). Following the use of self-cued relaxation training, the student's rate of absenteeism was reduced by 92% and the frequency of violent arguments was reduced by 79%. Further, the gains demonstrated in this multiple baseline study were maintained over a nine-month follow-up period.

The potential for the combined use of PRT and social skills training was demonstrated in a case study report of an encopretic adolescent with behavior problems (Roberts & Ottinger, 1979). This 14-year-old boy had a seven year history of encopresis, poor social and study skills, low assertiveness, and inability to cope with anxiety. The intervention program was conducted over several months and involved PRT, assertiveness training, and skills training in other areas. The client and his parents reported improvement in his

toileting and overall life functioning at termination and at six-month follow-up.

The clearest evidence for the efficacy of biofeedback therapy as an adjunct to PRT can be found in research on the regulation of skeletal muscle activity in able-bodied adults. For example, several studies have demonstrated that biofeedback and PRT can result in the voluntary decrease of forehead tension, which in turn leads to reduction of the pain associated with tension headaches (Acosta & Yamamoto, 1978; Nowlis & Borzone, 1981; Stoyva & Budzynski, 1974). Another example of the use of biofeedback to control muscle tension is a study by Hanna, Wifling, and McNeill (1975), which found that relaxation of the laryngeal muscles reduced stuttering to less than 50% of baseline in a 19-year-old patient.

Additional areas of standard biofeedback research include investigations of feedback for electroencephalographic (EEG) activity of the brain, and for visceral and glandular responses regulated by the autonomic nervous system. Sterman and his colleagues (1977), for example, reported the successful reduction of seizure activity in otherwise able-bodied adults, through the use of EEG biofeedback training. Other researchers have employed biofeedback to regulate blood pressure in the treatment of essential hypertension (Benson, Shapiro, Tursky, & Schwartz, 1971; Kristt & Engel, 1975), and to train external sphincter control for the treatment of fecal incontinence (Engel, Nikoomanesh, & Schuster, 1974).

2. Research with Physically Handicapped Individuals.

The use of PRT and biofeedback to treat the problems of physically disabled persons has been both limited and diverse. A study by Ince (1976), for example, reported that the frequency of petit mal and grande mal seizures was substantially reduced through the use of PRT alone with a 12-year-old boy with epilepsy. LaGreca & Ottinger (1979) used PRT and self-monitoring as interventions to increase the frequency of medically ordered hip exercises in a 12-year-old girl with cerebral palsy who had a three-year history of avoiding the exercises. Because of the pain involved in the exercise routine, the girl had frequently cried and whined and refused to cooperate in the program. With treatment, the frequency of the child's participation in the routine increased from an average of one or fewer times per week to 5-7 times per week, and the gains were maintained at three and six-month follow-ups.

Biofeedback has also been employed with physically disabled individuals to treat a variety of other disorders. For example,

Stocker (1979) used biofeedback techniques to reduce the impeded blood flow caused by muscle tension in the arms, hands, legs, and feet of 32 blind persons in a 60-hour training program; and Inman (1976) demonstrated biofeedback control over tension in the spastic muscles of five physically handicapped persons. Other applications have involved various neuromuscular disorders such as hemiplegia due to stroke and Bell's palsy (see Blanchard & Young, 1974).

3. Research with Mentally Handicapped Individuals.

In an excellent review of the relaxation literature as applied to mentally retarded persons, Harvey (1979) noted that change strategies with such individuals have relied predominantly on more traditional operant procedures. Nonetheless, the application of respondent conditioning procedures to impaired populations has potential utility.

Several studies have explored the use of relaxation training strategies to treat various behavior problems in mentally handicapped individuals. In a rather unusual case study, for example, Shaw and Walker (1979) used PRT to treat an 8-year-old boy with moderate retardation for inappropriate and excessive sexual response in the presence of barefoot women. After one week of treatment, the response was significantly decreased; eventually it was eliminated. A more conventional application of the technique was reported by Graziano and Kean (1971), who used relaxation training with four young children with autism. The relaxation response was taught in a classroom program using reinforcement and physical manipulation. As the children acquired control over the relaxation response, "high excitement responses" such as violent outbursts, self-stimulation and aggression were seen less often; they, too, were virtually eliminated over a period of ten months. In addition, generalization of the relaxation training to the home environment was noted.

Another apparently successful application of PRT was reported by Steen and Zuriff (1977). Their study reported the elimination of high-rate self-injurious behavior in a 21-year-old profoundly handicapped woman who had been in full restraints for three years previous to the training. Food and social reinforcers were used to teach her the relaxation response while she was still in restraints, and the restraints were gradually removed during 17 hours of training spaced over several weeks. Though seemingly impressive, this study suffers from methodological flaws and has been criticized for fail-

ing to demonstrate a cause-and-effect relationship between relaxation and the subject's improvement (Marholin & Luiselli, 1979).

Several researchers have incorporated relaxation training into a therapeutic "package" to treat a variety of behavior disorders. In one such study, Bott (1979) demonstrated that relaxation plus verbal discussion effectively reduced aggression in 17 mildly and moderately retarded young adults. Similarly, Harvey, Karan, Bhargava, and Morehouse (1978) used time-out, DRO, self-monitoring, and relaxation training to eliminate violent temper tantrums in a 38-year-old woman with mental retardation and epilepsy. Since these two studies involved relaxation in combination with other procedures, the singular effects of the relaxation training could not be determined. The effects were more apparent, however, in an ABCB design study which demonstrated the use of medication plus relaxation to control psychomotor seizures in a mildly mentally handicapped 22-year-old woman (Wells, Turner, Bellack, & Hersen, 1978). The learner was taught to visually imagine her pre-seizure auras and subsequent seizures, and was then verbally cued by the therapist to "relax." The study is impressive in that the learner's seizures had been uncontrolled by medication alone for 19 years; at three-month follow up she was still seizure free.

Biofeedback-assisted relaxation training has also been used with mentally disabled individuals, primarily to decrease aggressive or self-injurious behaviors, though the results of these attempts at intervention have been mixed. Frankenberger (1980) and Hughes and Davis (1980) both reported that successful training in relaxation via biofeedback did not substantially affect the frequency or duration of aggressive behaviors in their mentally handicapped or autistic subjects. Equivocal results were also obtained by Schroeder, Peterson, Solomon, and Artley (1977), who used biofeedback training to treat self-injurious behavior in two severely retarded adolescents. Though little self-injurious behavior occurred during periods of deep muscle relaxation, the rate of self-injurious behavior did not decrease substantially enough for their subjects to be removed from long-standing restraints. Positive results were obtained, however, by Small, Giganti, and Steinberg (1978), who used a multiple reversal design to demonstrate the relationship between biofeedback-assisted relaxation and multiple aggressive behaviors in a mildly retarded young girl. Another successful study (Patton, 1978) utilized a "package" consisting of biofeedback relaxation training plus counseling to decrease aggressive behaviors in moderately handicapped adults. A related study by Harvey (1978) demonstrated that biofeedback relaxation training alone reduced anxiety

147

and increased self-esteem in four mildly mentally handicapped adults. This study, however, relied on self-reports by the subjects as the primary source of data.

Another area of investigation has involved the effects of bio-feedback-assisted relaxation training on academic performance. Jackson (1977) found that EEG biofeedback could be used to decrease alpha wave density in mentally handicapped adults; alpha decrease has been associated with increased attention. The subjects' accuracy in arithmetic computations increased during the periods of lowered alpha activity. A study using EMG biofeedback with eight educable mentally handicapped boys showed that this form of relax-ation training resulted in increased performance in cognitive, read-ing, coordination, memory and handwriting tasks (Carter, Lax, & Russell, 1979). The eight matched control subjects who participated in relaxation training without biofeedback evidenced gains as well, but only handwriting was significantly improved. This study was an expansion of an earlier investigation by Carter and Synolds (1974) of brain-injured children, which also showed that relaxation train-ing can improve handwriting ability.

B. Advantages

There are four primary advantages to the use of PRT over other procedures. First, the relaxation response is totally portable and re-quires no behavioral prosthetics (e.g., tokens, timing devices, etc.). Because of this, the relaxation responses can be initiated unobtru-sively in a variety of environments and situations. Second, the data indicate that the relaxation response is easily learned regardless of the client's age, intellectual ability, or physical condition (Strider & Strider, 1979). Third, modified PRT can be conducted in such a way that the client learns to self-cue the response, allowing for self-con-trol of the behavioral excesses. Finally, the relaxation response is thought to enhance both physical and emotional well-being in general.

The individual who learns to control her undesirable behavior through deep muscle relaxation is at the same time engaging in a positive program of self-improvement. Even "normal" persons given PRT often report that their new skill is useful to them on an everyday basis. A corollary advantage is that it is unlikely that PRT, properly conducted, will result in an increase or worsening of the behavior problem, since the procedure is non-intrusive and benign to begin with.

C. Cautions

PRT has been used to treat a wide variety of problem behaviors successfully, but the length and breadth of the list can be misleading for several reasons. Luiselli (1980) noted that many of the studies were informal case reports, did not compare the relaxation procedures with other interventions, or used relaxation as part of a treatment "package." In the few controlled studies which employed traditional relaxation training, the effects of this training were often no more effective than other interventions. In addition, though Paul (1969b) found that responsiveness to relaxation procedures was not related to the personality dimensions of extraversion or emotionality, other client characteristics *may* limit responsiveness. Berstein and Borkovec (1973) have noted, for example, that relaxation training should be used primarily for learners with high tension levels, and these authors caution that "where tension is not a major concern, the use of relaxation training can result in an unimpressed, if not hostile, client who experiences no noticeable change in an already low level of tension" (p.11). The practitioner should be sure to conduct a thorough analysis of the problem behavior before initiating PRT, to determine a priori if the procedure seems appropriate in light of these cautions.

Another drawback to the use of PRT, either with or without biofeedback, is related to the amount of training needed to acquire the relaxation response. Rapid elimination of problem behavior occurs infrequently with PRT, and this limitation should be anticipated.

D. Suggestions for Implementation

Bernstein and Borkovec (1973) suggest that the clinician explore three issues before deciding to include PRT in the treatment program. These are:

1. Is there medical clearance for the use of PRT? This involves ruling out an organic basis for the problem and ensuring that there are no contraindications for the learner (such as the inadvisability of having the learner tense certain muscle groups). In addition, the authors suggest that physician approval be obtained to discontinue the use of muscle relaxant medications before beginning PRT.

2. Is the learner's undesirable behavior tension-related, or does it stem from other, more basic problems (e.g., lack of attention, financial crisis, lack of skills, etc.)?

3. Is the learner's problem the result of anxiety which has been conditioned to specific environmental stimuli? If so, PRT (either with or without biofeedback) may be ineffective if used alone, and should be employed in combination with other procedures. The authors caution that the therapist should not expect PRT alone to be effective in every situation involving tension.

In general, PRT is best conducted in a quiet, softly lit room by a trained practitioner who has experience with the procedure both as client and as therapist. A good deal of individualization may be necessary to train persons with varying backgrounds and conditions, and the therapist should be sensitive to the individual's need for a thorough explanation of the rationale behind the procedure. Ideally, the learner should be seated in a well-padded recliner chair so that no exertion is needed to maintain body support. In addition, the learner should wear loose-fitting, comfortable clothing. Contact lens wearers should remove lenses before each training session.

The procedures used to teach deep muscle relaxation have been detailed in a number of articles and books (e.g., Bernstein & Borkovec, 1973; Brown, 1977; Jacobson, 1938, 1964; Schultz & Lathe, 1959). Though slightly different procedures are suggested by various authors, basic progressive relaxation training involves a six-step process:

1. The learner's attention is focused on a particular muscle group;

2. At a predetermined signal from the therapist, the muscle group is tensed;

3. Tension is maintained for three to seven seconds, during which time the learner is instructed to pay close attention to the sensation of tension;

4. The muscle group is slowly released at a predetermined cue, and the learner is instructed to attend to the difference in sensation as the muscles relax over a period of 30-60 seconds;

5. The cycle is repeated two or three times for the muscle group; then another group is introduced;

6. When all of the basic muscle groups have been systematically relaxed, the learner is instructed to perform a simple deep-breathing exercise designed to eliminate any residual tension.

In addition, several adaptations have been used with young children and with learners who are mentally, physically, or emotionally handicapped (e.g., Bruno, 1974, 1975; Cautela & Groden, 1978; Koeppen, 1974; Morris, 1973). Such adaptations include

teaching the learner to tighten and relax large muscle groups before more difficult groups such as the tongue and forehead; keeping sessions short and frequent; using tangible or social reinforcers; physically manipulating body parts to assist the learner to tense and relax; simplifying instructions; and using modelling, prompting, or shaping techniques to teach the responses.

When PRT is conducted with biofeedback, the procedure is modified because the learner is not required to self-monitor the sensations of tension and relaxation. Instead, sensors or transducers are attached to the muscle group(s) of concern, and information about the degree of muscle tension or relaxation is analyzed by the biofeedback instrument and displayed to the learner in concrete form. Other techniques are often used instead of PRT to teach voluntary muscle control with biofeedback; for example, reinforcers may be presented or removed contingent upon changes in the feedback display.

E. Research Ideas

Controlled empirical studies are still needed to determine at least the following points:

1. The relative efficacy of PRT and/or biofeedback compared to more traditional behavioral strategies;
2. The PRT protocol(s) which offer maximum results;
3. Verification of the usefulness of this strategy with impaired populations;
4. The predictable applied limitations of the procedure;
5. The degree to which PRT results in generalization and maintenance of behavior control;
6. Objective ways for determining relaxation in learners who are unable to verbally evaluate the degree of muscle tension; and
7. Personality, intellectual, or other variables which might be correlated with successful use of the procedure.

III. Systematic Desensitization

A. Introduction

In 1920, Watson and Rayner demonstrated that fear or anxiety can be learned in response to certain environmental stimuli. A few years later, Mary Cover Jones (1924) expanded on their work by

developing a simple procedure designed to weaken learned fear responses in children through simultaneous exposure to food and the feared stimuli. The psychological processes involved in this reversal of a conditioned response were later explored by Joseph Wolpe, who demonstrated in 1948 that conditioned fear reaction in cats could be eliminated by evoking an incompatible response while gradually presenting the feared stimulus. He found that anxiety could be efficiently eliminated by the incompatible response of relaxation, and developed a treatment procedure known as systematic desensitization (SDS) to treat phobic reactions in adults (Wolpe, 1958).

The techniques of SDS involves four separate sets of operations:

1. Training in deep muscle relaxation;
2. Establishment of the use of a scale of subjective anxiety for use by the subject;
3. Construction of anxiety hierarchies by the learner and the therapist; and
4. Counterposing of relaxation and anxiety-evoking stimuli from the hierarchies. In this final step, the learner is either exposed to (in vivo SDS) or asked to imagine one of the stimuli from the hierarchy until she feels anxious, and is then instructed to relax completely, which dissipates the anxious feeling. This is repeated for each step in the hierarchy until it no longer produces anxiety (Wolpe, 1973).

Imagined and in vivo SDS have been used primarily to treat phobic reactions in able-bodied adults, though the technique has also been used to treat such reactions in persons who are disabled and, less frequently, in children. The phobias have ranged from the mundane (e.g., claustrophobia, school phobia, agrophobia, etc.), to the exotic, such as fear of murder by the CIA (Weidner, 1970); fear of body hair (Rivenq, 1974) and fear of toilets (Wilson & Jackson, 1980). Unfortunately, many of these reports are in the form of case studies or single-subject clinical papers, which limit their empirical validity. Nonetheless, some examples will be offered here which span the range of the phobias with populations other than adult able-bodied persons.

One group with which SDS has been employed to treat phobic reactions is adults with schizophrenia. Interventions with this group have generally been aimed at decreasing anxiety related to hallucina-

tions (Siegel, 1975), recurring nightmares (Shorkey & Himle, 1974), or other fearful experiences such as dental examinations (Yamauchi, 1981). Though the interventions cited here successfully reduced the targeted sources of anxiety, it should be noted that the underlying schizophrenia was still present in all subjects. In fact, when SDS has been instituted to treat behaviors other than phobic reactions in schizophrenics, the results have been disappointing. These include attempts to increase assertiveness (Serber & Nelson, 1971; Weinman, Gilbert, Wallace, & Post, 1972) and to decrease auditory hallucinations (Slade, 1972).

Phobic reactions in persons with physically or mentally handicapping conditions also have been treated via SDS with some success. Rotondi (1978), for example, reported that SDS was superior to implosive therapy in the treatment of social anxiety in 51 physically handicapped subjects. The long-term alleviation of phobias also has been reported when SDS has been used with mentally handicapped or neurologically impaired subjects. These include treatment of dog phobias (Jackson & Hooper, 1981; Morisano, 1981; Obler & Terwilliger, 1970); toilet phobia (Wilson & Jackson, 1980); fear of riding in cars or public buses (Mansdorf, 1976; Obler & Terwilliger, 1970); fear of heights (Guralnick, 1973; Peck, 1977); fear of rats (Peck, 1977); and fear of body hair (Rivenq, 1974). Several of these studies (e.g., Obler & Terwillinger, 1970; Rivenq, 1974; Wilson & Jackson, 1980) were conducted with children who were handicapped, as were studies such as those by Miller (1972) and Tasto (1969) which demonstrated that SDS can be used to treat a variety of fears in non-handicapped children.

In addition to the treatment of problems which directly stem from anxiety and fear, SDS has also been used to treat a variety of tension-related disorders. One group with which SDS has been relatively well-researched includes persons who stutter. Typically, the subjects in these studies are asked to construct a fear hierarchy, listing situations which are fearful and, presumably, might elicit stuttering. They are asked to imagine each of these fearful scenes as the therapist describes it until it no longer elicits anxiety. Several reports have indicated that SDS compares favorably with pre- and posttreatment measures obtained on stutterers who had undergone different forms of treatment (Burgraff, 1974; Lanyon, 1969; Tyre, 1973; Webster, 1970).

In addition, SDS has been used with some success to treat a variety of other disorders, including sexual dysfunction (Wincze & Caird, 1976), alcoholism (Hedburg & Campbell, 1975), and anorexia nervosa (Ollendick, 1979). The use of SDS is not necessarily the

treatment of choice for such disorders, but ought to be considered if more conventional therapies fail. A case in point might be the extreme behavior problems exhibited by self-abusive individuals. Two studies (Cautela & Baron, 1977; Cunningham & Peltz, 1982) employed imagined and in vivo SDS, respectively, as part of treatment packages in the treatment of severely self-injurious behavior. Cautela and Baron (1977) incorporated SDS for a brief period of time, as part of a program which relied primarily on relaxation training, covert conditioning procedures, and contracting to eliminate life-threatening eye-poking and lip/tongue biting in a 20-year-old male college student. The study by Cunningham and Peltz (1982) also used SDS (this time, in vivo) in combination with shaping and the use of restraints as a reinforcer for periods of no self-injurious behavior (Favell, McGimsey, & Jones, 1978) to treat persistent face-slapping in a 10-year-old handicapped boy. The SDS procedure in this case involved requiring the boy to spend increasingly extended periods of time without his protective helmet; the non-helmet situations were selected according to an anxiety hierarchy constructed by his parents. This innovative application of the principles of SDS and other procedures resulted in elimination of the self-abuse and of the helmet within five and a half months; this was maintained at 15-month follow up.

B. Advantages

SDS is perhaps the most widely utilized and researched technique now available for the treatment of phobic reactions. Rapid alleviation of the fear often occurs, and the procedure has the added advantage of teaching an incompatible response—relaxation—which is a benign and useful skill and which enhances general physical and mental well-being.

C. Cautions

SDS is experienced by the learner as being a non-aversive intervention if the therapist evokes the relaxation response as soon as the learner reports feeling anxious. SDS can be misused if "forced" exposure to the feared stimulus is substituted for gradual, systematic exposure counterposed with relaxation. Such "forced" exposure should be avoided, particularly in the use of in vivo SDS, where the learner may have no way to escape from a feared object or situation if the therapist does not rigorously adhere to the proper SDS protocol.

Another caution involves the appropriateness of the procedure in relation to the problem behavior and learner characteristics. In keeping with the issues discussed in Chapter III, an evaluation of the symptom should be completed prior to treatment to establish the learned nature of the fear and that the fear is, in fact, out of proportion to the threat actually presented to the learner. There is only minimal evidence for the effectiveness of SDS in the treatment of other than anxiety/fear reactions, and any other applications should probably be considered to be experimental at the present time. Additionally, the extent to which SDS can alter undesirable behavior unrelated to phobias in very young children and other persons with extremely limited verbal and/or cognitive skills is still questionable (Firestone, Waters, & Goodman, 1978).

D. Suggestions for Implementation

Once the exact source and nature of the fear have been established, several sessions of PRT should be conducted prior to desensitization, to insure that the learner has sufficient control over the relaxation response. In addition, the verbally competent learner should be actively involved in establishing the fear hierarchy, since an accurate individualized hierarchy is crucial to success. Finally, the selection of the preferred procedure—either imagined or in vivo SDS—should be made on the basis of client age and imaginal ability, as well as the nature of the fear or anxiety.

SDS sessions are usually conducted for 15-30 minutes at a time. Starting with the lowest scene on the hierarchy, each scene is presented from three to ten times until it no longer elicits anxiety (Wolpe, 1973).The duration of a scene is usually 5-15 seconds, with up to one minute between scenes devoted to relaxation. Wolpe (1973) states that the spacing of sessions does not seem to matter greatly, though sessions are usually conducted once or twice a week.

Several revisions to the basic technique have been used to treat phobias and fears in persons who are chronologically very young or mentally handicapped. One revision eliminates the second step in the sequence; instead, the therapist closely observes the learner for behavioral indications of anxiety. These might include frequent and widespread movement or "fidgeting," laughter, facial muscle tension, arm or leg tension, clenched fists, or frequent verbal interruptions by the learner. Another revision allows the therapist to construct the anxiety hierarchy without client assistance; this is especially used with non-verbal learners. A third alternative is the use of in vivo rather than imaginined experiences during the actual SDS pro-

cess. In vivo SDS conducted in the actual setting in which the fear is likely to occur (e.g., in elevators for elevator phobia, in the learner's neighborhood for dog phobia, etc.) is often preferred for use with mentally handicapped learners who may have poor symbolic and/or generalization abilities. Finally, food and praise are often used to reinforce appropriate relaxation attempts by the learner.

E. Research Ideas

Controlled group comparisons are needed to establish the relative efficacy of SDS over other procedures in the treatment of behavior problems which are not phobic in nature. Of course, such studies are more difficult to control than single-subject studies, and both ethical and logistical factors make empirical control particularly difficult in research aimed at identifying "best practice" procedures for dealing with behavior problems. In addition, Firestone et al. (1978) have called for future work to determine the extent to which IQ, verbal or cognitive deficits, and social deficits may limit effectiveness.

CHAPTER XII

COVERT CONDITIONING *

I. Introduction

Generally speaking, there are three categories of behavioral responses (Cautela & Baron, 1977):

1. Overt processes;

2. Covert psychological responses, including thinking, imagining, and feeling; and

3. Covert physiological responses of body systems, organs, and cells.

Conventional behaviorism has focused on the first type of response, overt processes, and on altering these observable events through the manipulation of antecedents, consequences or other variables. More recently, some attention has been focused on the study and manipulation of the second response class, that of covert psychological processes. The term "covert conditioning" has been applied to a set of imagery-based procedures which alter response frequency by the manipulation of covert consequences. These procedures are based on three main assumptions (Cautela & Baron, 1977):

1. Homogeneity. There is continuity or homogeneity between covert and overt behaviors.

2. Interaction. There is interaction between covert and overt events, i.e., covert events can alter overt events, and vice versa.

3. Learning. Covert and overt events are similarly governed by the laws of learning. This means, for example, that covert positive

* This chapter was written by Pat Mirenda, Ph.D.

reinforcement follows the same procedural and functional laws (e.g., contingent application of a stimulus results in an increase in the response rate) as does traditional positive reinforcement.

Covert analogs to many operant procedures have been developed (see Upper & Cautela, 1979, for a complete survey of these procedures). Each of the procedures involves a basic two-step process. First, the therapist verbally describes a scene containing the target behavior, and the client is asked to imagine it vividly. This is followed by the description of a scene designed to reinforce, punish, or extinguish, the first stimulus, depending on the procedure being used. Though covert conditioning procedures based on punishment and extinction paradigms have been investigated widely, e.g., covert extinction (Cautela, 1971); covert punishment or sensitization (Cautela, 1967a); covert response cost (Cautela, 1967b), non-aversive procedures have also been developed. These include covert positive reinforcement (COR) (Cautela, 1970) and covert modeling (CM) (Cautela, 1976). Though the punishment-based and extinction procedures might be considered to be non-aversive in that the contingencies are administered in imagination only, these will not be included in the discussion here. Instead, the reinforcement procedures mentioned will receive attention, as will speculations regarding the possibility of adapting other non-punitive interventions to the covert model.

Covert procedures have been used primarily with able bodied adults to treat a variety of phobia or addiction-related and behavior problems. The techniques have been applied to children to a lesser extent, and to handicapped individuals even less frequently. However, the positive outcomes of some recent studies (e.g., Groden, 1978, 1982) suggest that covert conditioning procedures can be adapted to be quite suitable for use with children and even with persons who are cognitively limited.

Several studies have documented the succesful use of COR and/or CM to treat phobic reactions in both adults and children. The treatment in these cases often resembles that of systematic desensitization, in that the scenes may be constructed according to a fear hierarchy. An example of a CM scene used successfully with a woman who was afraid to speak in a group of people follows:

> Imagine that you are sitting in a lecture watching a woman of your age and looks. She is standing in front of the class and appears calm and relaxed. She is smiling and makes friendly comments to the students. A student asks a question and she listens intently. She then pauses to think of an answer, and responds in a

relaxed, non-defensive way. The class ends and you notice a student walks up to her and tells her that he really enjoyed the class, particularly her manner of answering questions in a calm, articulate manner. (Cautela, 1977, p. 62)

The technique of CM was also used successfully in a controlled study by Kazdin (1973) to treat snake phobia in 20 male and 40 female college undergraduates. Covert reinforcement scenes were effective in the treatment of rat phobia (Blanchard & Draper, 1973), and both techniques were successfully combined by Flannery (1972) to treat severe agoraphobia (fear of open spaces) and fear of becoming insane in a 46 year-old-woman. Both of the latter studies demonstrated that the phobia reductions were maintained at 4-1/2 and 4-month follow-up, respectively.

In addition, case studies reported by Cautela (1982) indicated that use of the COR procedure resulted in the long-term elimination of fears in two children within a 3 to 4 month period. One of the children exhibited extreme fear of novacaine injections related to essential dental work, and the other was terrified of being alone in any room in her own home. The COR procedures were administered by having the children imagine the feared situations in an ascending order from least to most fearful and interposing these scenes with covert reinforcement or, occasionally, in vivo reinforcement experiences. The author noted that the first child was injected and treated by the dentist without any apparent fear or even pain, and that the dental work was successfully completed. The second child's fears were also eliminated after a four-month period.

Another application of non-punitive covert conditioning has been for the treatment of various compulsions or addictions. These include compulsive overeating (Manno & Marston, 1972), obsessive-compulsive behavior (Hay, Hay, & Nelson, 1977), and chronic alcoholism (Hay et al., 1977).

Covert procedures have also been used to produce attitude changes related to perception of both self and others. Cautela, Walsh, and Wish (1971), for example, used COR over a period of three weeks to cause positive changes in the attitudes of 21 college undergraduates toward mentally retarded persons. Attitude change toward individuals with handicapping conditions has also been reported through the use of systematic desensitization (Haddle, 1974), but this technique has not been effective in many cases (Clark, 1978; Cohen, 1978). Covert reinforcement may be a viable alternative. In addition, increased assertiveness through the use of CM (Rosenthal & Reese, 1976) and improved self-concept through the use of COR

(Krop, Perez, & Beaudoin, 1973) have been reported in adults. The latter study, the subjects of which were adult male psychiatric patients, in fact, demonstrated that the COR procedure was more effective than an overt reinforcement procedure used with a comparison group.

Finally, non-punitive covert techniques have been applied, albeit infrequently, to treat disruptive behavior problems in both handicapped and non-handicapped children. Workman and Dickinson (1979a) reported empirical case studies involving two non-handicapped children treated with COR for aggression and encopresis, respectively. The aggressive child was given scenes in which he imagined himself performing an alternative, non-aggressive behavior whenever he felt like hitting someone, and then imagined a reinforcing event. Thus, covert reinforcement of alternative responses (COR/ALT-R) was used with apparent success. These same authors used a similar intervention with a nine-year-old hyperactive child whose problems included excessive noisemaking, rocking, and out-of-seat behaviors in the third grade classroom (Workman & Dickinson, 1979b). There was immediate reduction in all three target behaviors following implementation of COR/ALT-R, and a concurrent increase in incompatible behaviors.

The ALT-R version of COR was also used by Groden (1978) in a study involving a 15-year-old blind boy labelled trainable mentally retarded and a 13-year-old girl with Down's syndrome. Behaviors of concern for the first subject were loud and disruptive nose-honking, wrist-bending, and rocking; subject two exhibited disruptive head-lolling, nose-picking and tongue-chewing. After application of an ALT-R version of COR, a marked decrease was evident in all behaviors in both subjects. An example of the COR scene used with subject one to treat the loud honking noises follows:

> Imagine you are working on braille with your teacher. You feel your arm about to move toward your nose so that you can blow through your nose. You say to yourself, "No, I'm not going to make that sound with my nose, it's not good for my ears. I'd better just put my hand back on the braille." You feel your hand moving back to the braille and you feel the dots on your fingers. (Covert reinforcement follows): Now imagine you are eating your mother's sugar cookies right from the oven with a delicious cold glass of milk. Imagine biting into that cookie. Try to taste the cookie and that cold glass of milk. Think how good and cool it feels in your mouth! (Groden & Cautela, 1981, p. 177)

Covert positive reinforcement was also used by Groden (1982) as an intervention aimed at increasing social interaction and cooperative play skills in six individuals with autism, ages 9 to 21. This study used a multiple-baseline-across-subjects design, and demonstrated that, even with severely handicapped students, COR may be an effective intervention strategy. All subjects responded positively to the COR scenes, as evidenced by a sometimes dramatic increase in the frequency of self-initiated social and play contacts with the other children in a controlled playroom environment. Though covert procedures may require longer periods of time to be effective with learners who are mentally handicapped, it has the advantage of being totally non-aversive and potentially applicable to a wide range of behavior and social problems.

II. Advantages

The use of covert procedures offers several clear advantages compared with more traditional behavioral techniques. These advantages fall into the broad categories of practicality, flexibility, and self-control.

A. Practicality

Because the procedures are imagery-based, they can be used in settings remote from the actual environment where the problem behavior occurs. Therapy sessions can be conducted in the therapist's office or the learner's home, for instance, to deal with problems that usually occur in the community, office, or school. This was dramatically demonstrated in a study by Gotestam and Melin (1974) involving the use of covert extinction in the treatment of amphetamine addiction. Treatment sessions, in which the learners imagined injecting themselves with the drug and experiencing no "flash" or other effects, were carried out in a hospital setting over several weeks, and the effects of the sessions apparently generalized to non-hospital settings when the learners were AWOL. Most of the covert conditioning studies addressing problem behaviors have been carried out in remote settings, and generalization to real-life environments seems to be excellent. This eliminates the necessity for constant monitoring of the program across environments; when used in hospital or school settings, for example, the ward staff or

teachers are not required to administer the program consistently at all times of the day.

Another practical advantage is the relative cost effectiveness of covert procedures. The study by Rosenthal and Reese (1976), for example, compared covert and overt modeling to teach assertiveness to 36 female volunteers (18 subjects in each group). The subjects in the covert group were taught to imagine a number of scenes in which people other than themselves (i.e., models) were successfully assertive in difficult situations. The scenes were tailor-made for each subject to include individual experiences in which assertiveness was required and descriptions were vivid. The overt group watched live models act out the same types of situations. The covert modeling procedure produced assertion progress comparable to the overt modeling techniques, but required less time and expense and no staff assistance.

B. Flexibility

Substantial flexibility is possible in the application of the covert procedures involving contingency management. In covert positive reinforcement, a wide range of reinforcers which may be unavailable to the learner in real life are suddenly accessible in imagination. Typically, a Reinforcement Survey Schedule (Cautela & Kastenbaum, 1967; Cautela & Brion-Meisels, 1979) or other source is used to gather information about potential reinforcers, which are then used as scenes during treatment. One such scene was described by Cautela (1977):

> You are lying on the beach on a hot summer day. Concentrate on all the details around you. Notice all the sensations. Feel the hot sun beating down on you and the warmth from the blanket. Smell the refreshing air. Watch the waves come rolling up onto the beach. Be aware of how good your body feels now that you are swimming through the water (p. 56).

Obviously, this scene is less available to the learner in reality, but such scenes can be used effectively in imagery. This same flexibility is also possible in describing the target scene, and the therapist can often include many more vivid details in the description than might be available in role-play situations.

C. Self-control

A final advantage of covert procedures is that the learner can be taught to design and practice the scenes without therapist assistance, leading to self-control of undesirable behaviors. The learner can then practice the procedure in situations which ordinarily elicit such behavior. A learner using covert positive reinforcement to control excessive eating, for instance, might at a party need to practice a scene in which he wants to eat a forbidden food, refrains from doing so, and self-reinforces himself with a trip to the Bahamas! The self-control possibilities of covert procedures have not been demonstrated or investigated in children or persons with mental retardation, but there is evidence that able-bodied adults can effectively use the techniques in this way.

III. Cautions

The apparent ease of implementation for the covert procedures can be misleading, and appropriate cautions need to be observed to maximize success. A thorough functional analysis (see Chapter III) is necessary in order to operationally define the behavior, and to identify the antecedents and consequences presently operating as well as to fully understand the context in which it occurs and its possible message value. The procedure should be selected after analysis of these factors to determine the behavioral dynamics supporting the aberrant behavior, and the therapist should keep in mind that the usual laws of behavior apply to covert procedures as well. The therapist must be well-versed in the principles of and laws governing positive reinforcement, extinction, and so on, since the covert nature of these procedures apparently makes them no less powerful than traditional behavioral techniques. Accordingly, punishment, negative reinforcement, and extinction paradigms should not be used since they would likely produce the expected negative side effects. Once the procedure is selected, the general rationale for the use of covert conditioning should be explained to the learner; failure to do so could result in confusion or resistance. The learner should also be cautioned against expectations for immediate relief from the undesired behavior; on the average, 60 scenes are typically presented before a change in behavior occurs.

The necessity for individualization in the choice of the procedure, scenes, and reinforcers should be obvious, but the therapist needs to be particularly wary in this regard with designing programs for persons who have difficulty with imagery, such as children and persons with mental retardation. Cautela (1982) noted several guidelines which indicate that children or persons with special needs can appropriately manipulate imagery according to instructions. These include:

1. The ability to carry out verbal instructions;
2. The ability to learn by observing a live model;
3. The ability to describe past or future experiences accurately;
4. A language repertoire that includes the ability to make attributes and express emotional behavior;
5. Evidence of play involving pretending; and
6. The ability to report and describe dreams (p.21).

In this same article, procedural adjustments for use of the procedures with these individuals are outlined. Adults who are nonhandicapped may also have difficulty with imagery, and Cautela (1970) suggests that imagery training, relaxation training, and/or more vivid description of the scenes by the therapist may be useful in overcoming this problem.

IV. Suggestions for Implementation

A. Covert Positive Reinforcement (COR)

Before COR is implemented, a number of reinforcers should be identified for each learner, to be used on a rotating basis to avoid satiation (Ayllon & Azrin, 1968b). Cautela (1970) suggested that an item be included for use as a reinforcing stimulus if the following criteria are met:
1. The learner perceives it as highly desirable, pleasurable, or enjoyable; and
2. The learner is able to obtain a clear image of the stimulus almost immediately after its description, i.e., within five seconds (p. 72).
Once a reinforcement "menu" is established, a vivid description of a scene is given in which the learner is depicted engaged in appropriate behaviors which may be incompatible with the undesired response(s). The description should involve all the sense modalities,

i.e., the learner should be instructed to experience the sights, sounds, tactile sensations, tastes, and smells inherent in the behavior setting. The therapist describes this scene in small steps, and cues the learner to imagine a reinforcing scene at the end of each step; the reinforcing scene is also vividly presented, as described above. As many repetitions as possible of the entire scene are provided in each session, with at least one minute between trials. Reinforcement must occur immediately after each step of the presentation, and the learner is taught to use a non-verbal signal (e.g., raising a finger) to indicate clear visualization of the reinforcer. The reinforcement schedule should be gradually thinned from a CRF (continuous reinforcement) schedule to a ratio of one reinforcement to every five scenes (Cautela, 1970); such intermittent schedules are more resistant to extinction. The learner should be instructed to practice the scenes at home after periods when he has experienced some deprivation of the reinforcers being used. For example, if the reinforcing scene involves eating, the learner should practice the sequence when he is hungry; if the reinforcer is a swimming scene, the learner should practice when he is really hot, etc. This tends to increase the effectiveness of the reinforcers and maximize effectiveness of the procedure.

There are no data currently available regarding effectiveness, but the basic COR model could be easily extended to include other overt behavioral procedures such as stimulus control, DRO, and so forth. Covert stimulus control, for example, might first involve an imagined scene in which the learner feels the urge to engage in a particular behavior (e.g., masturbation), successfully resists the urge, and is reinforced covertly. Then, the learner might imagine a scene in which he finds himself in a place and at a time appropriate to the behavior (e.g., his own bedroom at night), engages in the behavior, and is covertly reinforced. Covert DRO might involve scenes depicting the learner as engaging in other behaviors but not the behavior(s) of concern for a specified period of time, and then receiving covert reinforcement. Other non-aversive analogs to the COR procedure are also theoretically possible (e.g., covert DRL), and research is certainly needed to determine the potential effectiveness of these extensions of the basic COR model.

B. Covert Modeling (CM)

The CM procedure was initially developed for learners who claimed that they could not imagine themselves performing behaviors in other covert conditioning techniques. In CM, scenes are

presented in which the learner imagines someone else performing the behavior and experiencing the consequence. Covert modeling can be used, therefore, to deliver scenes involving positive reinforcement.

An extensive body of research on CM has identified several important guidelines for its effective use. These include:

1. Treatment effects are better if the imagined model is perceived by the learner as being similar in appearance, personality, etc. The description of the model should be constructed with this in mind (Kazdin, 1974).
2. Several models should be presented in imagery, instead of a single model (Kazdin, 1975b).
3. A coping model is more effective than a mastery model (Kazdin, 1973, 1974). That is, scenes which depict the model as having to struggle to overcome the undesired behavior are more successful in reducing the behavior than are scenes in which the model experiences no difficulty in mastery.
4. Scenes in which the model experiences favorable consequences following performance of a desired behavior which is incompatible with the undesired behavior are more successful than are neutral scenes (Kazdin, 1975b).

C. Modifications for Children and Persons with Special Needs

Several adjustments need to be made for maximum results when using any of the covert procedures with children or handicapped individuals. The rationale for the procedure should be explained very simply, possibly by comparing it with "pretending." Fewer trials should be used in each session, and sessions should be shorter and more frequent. It is especially important to use extremely vivid scenes presented in short, simple sentences, and as many sensory modalities should be employed as possible. The therapist should watch for overt signs that the individual has a clear image; for example, learners may begin to assist with the narration, or may overtly react appropriately to scene description (e.g., pretending to lick an ice cream cone as it is described). It may be more difficult to isolate reinforcers if COR is to be used, and parents, teachers, etc., should be interviewed to elicit this information if the learner is unable to respond. Since more scenes may be required before behavior changes are noted, scenes for home practice may be recorded on tape so that the individual can practice with assistance.

V. Research Ideas

In a review of studies investigating the COR procedure, Scott and Rosenstiel (1975) noted that, though COR has been demonstrated to be effective in modifying a number of behaviors, many of the studies have not incorporated adequate design or control measures. Future research should employ more rigorous empirical procedures to investigate:

1. The validity of Cautela's assumptions (Cautela & Baron, 1977);

2. Unidentified variables which may be important to treatment outcomes;

3. More explicit parameters for selecting one procedure over another;

4. The negative side effect, if any, of the covert conditioning procedures which utilize aversive stimuli (e.g., covert sensitization, covert response cost, etc.). It is possible, for instance, that because of their covert nature, these procedures are experienced by the learner as being non-punitive even though they contain aversive imagined stimuli;

5. Further application of the use of covert conditioning procedures with children and persons with special needs. To date, there are no published reports of the use of the procedures with the latter group of individuals (Groden, 1982); and

6. A closer assessment of the generalization and maintenance effects of the various procedures.

STIMULUS SATIATION, SHAPING AND ADDITIVE PROCEDURES

I. Introduction

In writing this book, we have attempted to be as comprehensive as possible in examining the various alternatives to the use of punishment that are available in behavior management programs. These alternatives have included strategies which fit within the operant paradigm and a number of classical conditioning strategies. We also wish to discuss three other procedures which, for several reasons, do not warrant individual chapters. These procedures are stimulus satiation, shaping, and additive procedures. Within the operant paradigm, stimulus satiation and shaping may have more limited application than some of the alternatives we have previously explored. On the other hand, our suggestion regarding additive procedures has broad applicability within both the operant and respondent paradigms but represents a fairly easily stated strategy which can be helpful to those responsible for applied programs. In any event, this chapter is offered to round out the discussion of the operant and other non-aversive approaches to behavior change.

II. Stimulus Satiation

One of the classic studies in the applied behavioral literature involves the use of a stimulus satiation procedure to solve a problem, which included "towel hoarding" by a woman who was insti-

tutionalized with chronic schizophrenia (Ayllon, 1963). Stimulus satiation as an intervention strategy involves identifying the reinforcer maintaining the undesired behavior, making the reinforcer continuously and non-contingently available, and through that operation, weakening the behavior which was previously maintained by that reinforcer. In the Ayllon (1963) study, the learner hoarded towels during the baseline condition to the level of having an average of 21 + towels in her room at any given time. The identified reinforcer was the opportunity to hoard. Accordingly, she was continuously offered towels. She continued to hoard to the point where she had more than 600 towels in her room, at which time she began gradually returning them to the linen closet. This continued over a period of time, with the number of towels in her room gradually decreasing until they reached an average of one or two, a number which was considered appropriate and indicative of the absence of hoarding.

In previous chapters, we have emphasized the importance of limiting the amount of reinforcement available (assuming the learner's maximum performance) to a level somewhat less than the person would seek given free access to that reinforcer. The reason for this suggestion regarding DRO, DRL, Alt-R, and all the other procedures using positive reinforcement is that it establishes a level of deprivation which potentiates the efficacy of the reinforcer in strengthening the response upon which it is made contingent. If the occurrence of behavior "A" leads to the contingent availability of reinforcer "B," "A" will increase only if the learner is in some state of deprivation in relationship to "B." Stimulus satiation takes advantage of the converse of this relationship. Hence, if the person is given free, non-contingent access to a reinforcer which is maintaining an undesired response, we are eliminating the deprivation which potentiates that reinforcer and thereby undermining its effectiveness in maintaining that response.

A simple example will help illustrate the two sides of the deprivation/satiation coin, and the differential effect these variables can have on behavior. For example, most of us work 40 hours or more per week. This behavior is reinforced, i.e., maintained, by the money contingently received on a weekly or monthly basis. The reinforcement value of paychecks is largely a function of the extent to which the learner is in a state of deprivation in reference to the amount of money she has. It is likely that most of our readers have less money than they would seek, given free access. Accordingly, they have less money than they would want in order to buy items they would like to have. Suppose, though, that as the result of a lottery, one were to receive $5 million "non-contingently," that is,

non-contingent on any work done. This amount of money would remove most of us from the deprivation category and place us sufficiently within the range of satiation that paychecks would no longer be effective in maintaining work behavior. This would, therefore, increase the likelihood that we would quit our jobs. With reference to money, under a condition of deprivation we would work and under a condition of satiation we would elect not to.

Using this example, we can see that one strategy available to reduce the frequency of a given behavior is to "satiate" the person with the reinforcing stimulus with which it is being maintained. We have found this to be a fruitful approach with pica behavior, when that behavior is being maintained by "the opportunity to ingest." In such a case, satiation can be arranged by providing frequent opportunity to ingest edible items, thereby reducing the potency of ingestion as the reinforcer for the swallowing of inedible items. For example, a bowl of popcorn, peanuts, fruit and/or continuous access to the refrigerator, can be provided. If the setting renders this impossible, the learner can be offered something edible every 5, 10, 15 or so minutes depending on the baseline frequency of the pica behavior. If the opportunity to ingest is the reinforcing consequence maintaining the eating of inedible items, then the continuous or near-continuous opportunity to ingest edible items should result in satiation and thereby result in a weakening and corresponding reduction in the pica behavior. Note that for learners who are unable to discriminate edible and inedible items, a discrimination training program would be an important component to this approach.

A. Suggestions for Implementation

Pica behavior may be maintained by any number of possible consequences. If the behavior of eating non-edibles was being maintained by the social reaction and attention it attracted, the continuous opportunity to eat edible items would not be likely to have the same effect as that described in our example. In order for stimulus satiation to work, three conditions must be met: 1) we must identify the reinforcer maintaining the undesired response; 2) we must make it continuously available or at least give the learner greater access to it than she would freely seek, and 3) we must make such access non-contingent on the target behavior.

We are aware of a novel classroom use of stimulus satiation. The teacher's concern was the high frequency "out-of-seat" behavior of students in a modularized "loft school" setting who would peer through the moveable walls to see what students in the

other classes were doing. The solution was to remove the partition. Given unlimited opportunity to view the activities in the other classrooms, the students "satiated" and the out-of-seat behavior returned to acceptable levels (Grimaldi, 1972, personal communication).

It is important to distinguish stimulus satiation from negative practice overcorrection (Axelrod, Brantner, & Meddock, 1978). People often confuse the two. Typically, negative practice overcorrection involves requiring the learner to repeat the offending response over and over again, for an extended period of time, each time she is observed to engage in it. This procedure is very different from stimulus satiation for the following reasons: it involves forced responding, it is contingent upon the occurrence of the target behavior, and it neither identifies nor changes access to the operative reinforcer. Further, since negative practice overcorrection involves a component of forced responding, it would be considered an aversive procedure (Epstein, et al., 1974). (See Chapter IX, Instructional Control.)

B. Cautions

There is very little published research on the application of stimulus satiation as a strategy for reducing behavior problems. One reason, in our view, is that many persons responsible for behavior intervention do not bother to carry out a formal functional analysis which would identify the reinforcer maintaining the undesired response (see Chapter III). With such information, it may be possible to utilize a stimulus satiation strategy. However, some caveats should be observed. The first is that it is not always feasible to provide the identified reinforcer in an amount or over the period of time which would be sufficient for a satiation effect to occur. Second, the weakening of target behavior that occurs with satiation may continue only as long as the reinforcer is provided at the inflated levels. Thus, it may not be feasible to use stimulus satiation unless the reinforcer can be made naturally available at sufficiently high levels. This might be the case with pica behavior maintained by the opportunity to ingest. However, it is less likely to be so with pica behavior which serves a communicative-social interactive function for the person and is maintained by the responsiveness it elicits from others in the immediate environment. Having identified the operative reinforcer, in either situation the best strategy over time may be one of positive programming in which the person learns more socially acceptable ways to obtain the same results. In the former case, this

might be learning to go independently to the refrigerator for a piece of fruit, glass of milk or other nutritious snack. In the latter, it might be learning to use speech more effectively or, where speech is not present, to use an augmentative communication system to let others know what she wants.

C. Summary

Stimulus satiation may be used as a strategy for the reduction of behavior problems when the reinforcer maintaining the target behavior is identified and when it can be controlled. It is only feasible as an intervention when the reinforcer can be made non-contingently available on a continuous basis over an extended period of time or at least when access to it can be arranged at a level significantly greater than the learner would freely seek. Typically, the reduction in target behavior can be expected to last only as long as the previously contingent reinforcer can be made freely available. Therefore, the procedure is best used when it can be continued indefinitely as part of the natural behavioral ecology or when it can be combined with positive programming which effectively teaches the learner to obtain contingent access using a more acceptable form of behavior. Further research in this area should attempt to identify those problems and populations for which stimulus satiation may be a particularly useful strategy, should develop the procedures for determining how much free access will lead to the satiation effect on behavior, and should isolate the other independent variables that have a functional relationship to the effectiveness of this procedure.

III. Shaping

Shaping is a procedure familiar to those with even a modest familiarity with behavior modification. To our knowledge, however, it is rarely considered as an alternative to the use of punishment in the control of undesired behavior. Shaping is defined as the gradual modification of some property of responses (usually, but not necessarily, topography) by the differential reinforcement of successive approximations to some criterion (Catania, 1968). By definition, there is no reason why this procedure could not be used to gradually modify the topography, duration, or intensity of an undesired behavior by the differential reinforcement of successive approximations to some more desirable criterion. Conceptually, if the problem were tantrums, shorter, less intense, or less violent temper

tantrums could be reinforced in order to modify these properties of the tantrum in the desired direction.

Shaping is really a positive programming approach. While it may represent an investment of time, modification through shaping has the advantage of being long-lasting and a solid part of the learner's repertoire. It would be interesting to see this procedure investigated in various applied settings, particularly with behaviors that do not urgently require an immediate change. Some examples might be inappropriate dress, chronic tardiness or undesired verbalizations. Goldiamond (1974), for example, described how a shaping procedure was used to modify the psychotic verbalizations of a young woman diagnosed as having schizophrenia. The procedure was carried out by her parents during family conversation at dinner. The beauty of this intervention was that it was done in a natural context and the reinforcer used was selected on the assumption that the "behavior problem" served a legitimate communicative function for the person. That is, rather than using a contrived reinforcer to shape the verbalizations in an artificial setting, the parents assumed that the behavior served a social function for their daughter and that their reciprocal social responsiveness could be used to effectively shape the content of her conversation. This analysis turned out to be correct, and the desired change in behavior occurred.

A. Suggestions for Implementation

There may also be those situations where shaping can have rapid effects. This may occur in cases where the targeted problem is the last step in an escalating hierarchy of behavior. One of the many purposes of a behavioral assessment is to identify these behavioral precursors. Temper tantrums, for example, rarely happen "out of the blue." Earlier signs of "agitation" are almost always identifiable. These could include, for example, higher rates of stereotypic behavior, whining, loud vocalizations, and a sudden increase in activity. If we understand that a behavior problem serves a functional, communicative, social-interactive role (see Chapter III), we can time our responsiveness to follow the earlier, less troublesome links in the escalating hierarchy, thereby shaping their roles. In so doing, we possibly prevent and short circuit the typical pattern of escalation. An operative reinforcer shaping an earlier component of an escalating hierarchy may bring about a rapid reduction in behavior problems since the function served by that behavior would now be equally served by the earlier response. In fact, this analysis suggests that the etiology of the problem itself may be the extinction

(i.e., lack of reinforcement) previously available for the earlier links in the escalating hierarchy. Under such a condition, the problem behavior might very well have first occurred as part of an extinction burst. The behavior may have been shaped to serve a well established functional role by its effectiveness in eliciting the responsiveness from others in the environment where the earlier components of the evolving hierarchy failed (Ferster, 1961).

Let us take an example in which our functional analysis determines that whining vocalizations almost always precede temper tantrums for a ten-year-old boy who is considered to be mentally retarded. Let us further assume that tantrums in this situation serve a primary communicative function for this person and have come to be his way of requesting things such as food, the opportunity to go outside, access to a favorite toy, attention from an adult elsewhere in the room, etc. A shaping strategy for this problem could involve the decision to respond to the whining vocalizations before they escalate into a temper tantrum and to use our (reinforcing) responsiveness to shape this earlier response to include less whining and more explicitly verbal requests.

In those cases where the learner's "request" cannot always be complied with, an acknowledgement of the communicative response may be a sufficiently strong reinforcer to prevent escalation and to shape the earlier response. We believe that such "active listening" (see Gordon, 1970, and Chapter IV on Programming) in response to problem behaviors has great promise in the management of undesired responding and represents a fertile area for exciting research. We also believe that responsiveness to earlier elements in an escalating hierarchy would not necessarily lead to a significant increase in frequency of those elements, since the reinforcement available for the beginning of the behavioral chain (i.e., the escalating hierarchy) should not be much greater than the reinforcement previously available for the entire chain. While our clinical experience confirms this, it remains a question that should be empirically investigated.

B. Conclusion

Finally, shaping is an underutilized strategy for both positive programming and behavior management that could potentially avoid many of the problems inherent in some of the other approaches often used for instruction and behavior intervention. To be specific, using a free operant approach in natural settings, shaping avoids the utilization of contrived, artificial discriminative stimuli which often result in the "artificial" stimulus control of "treatment" gains (Donnellan, 1980b). This works against the generaliza-

tion of effects across settings, people, and other "natural" stimulus conditions. The application of shaping to a wide range of goals in positive programming and behavior management represents an area that is quite inviting to researchers.

IV. Additive Procedures

Additive procedures do not expand upon what has already been discussed. At the same time, they do represent a viable alternative to the use of punishment. We define this alternative as the combination of two or more procedures in order to reduce or eliminate an undesired behavior (LaVigna & Donnellan, 1976).

Of course, we advocate that all procedures be used in combination with positive programming. In addition to positive programming, however, a given procedure may be effective in reducing a behavior but not enough in itself to bring that reduction to the desired level. In such a case, adding another procedure may be more effective than substituting one. The cumulative record in Figure 13.1 demonstrates the effectiveness of such an additive approach. Covering about two years, it shows the course of treatment for the case of se-

Figure 13.1
A Cumulative Record of Behavior Under the Effects of an Additive Procedure.

vere destruction referred to previously in our discussion of DRO. Condition A is the baseline condition and shows the daily frequency of aggressive, destructive, or self-injurious behavior; Condition B shows the effects of a procedure that provided positive programming and which differentially reinforced competing behavior.

We can see that this strategy was effective in reducing the behavior to a certain extent but not to a satisfactory one considering its seriousness. Instead of "scrapping" the procedure and trying a new one, we decided to add a DRO schedule. The effect of this added procedure is shown under Condition C. While the frequency was not greatly affected with this additional procedure, it did regularize the behavior pattern mentioned during our discussion of DRO. Again, we decided to add a component. Rather than discontinuing the DRO procedure, we supplemented it with a progressive schedule (DROP). The effect of this procedure is shown under Condition D (LaVigna & Donnellan, 1976).

The satisfactory control over this behavior occurred with the simultaneous use of more than one procedure. Yet practitioners are often cautioned to use only one intervention at a time in order to demonstrate the efficacy of a particular procedure. While this may be desirable in experimental situations, it may be less so in applied practice. We suggest that an additive process instead may be useful in many cases where there is a partially, but not totally, effective result with just one procedure. A given procedure need not be totally effective but may contribute, along with other procedures, to the solution of a behavioral problem.

CHAPTER XIV

CONCLUSION

As with many effective but controversial technologies, behavior modification seems to be faced with the double burden of having unloving critics and uncritical lovers. We are neither. The studies referenced in this book testify to the power of behavioral psychology to dramatically and positively affect the lives of people with a wide variety of needs. The behavioral literature is overwhelmingly concerned with positive interventions to build skills, teach concepts, solve problems, repair relationships, and otherwise aid individual growth and development (Chapter IV, Positive Programming). Nonetheless, we cannot deny that, when the issue is reduction of behavior problems, the emphasis in the literature has provided an unnecessary bias towards aversive control. Books and articles on the topic may discuss and describe non-aversive techniques, yet leave the impression that, in many situations, alternatives are less effective than punishment (MacMillen, Forness, & Trumbull, 1973; Matson & DiLorenzo, 1984; Vockell, 1977). The major inference one draws from such material is that, at least for serious behavior problems, punishment is superior in its speed and durability of effects.

Nonetheless, this literature bias on aversive interventions to reduce problem behaviors is insufficient to explain the ubiquitous use of punishment in many settings in which behavior problems occur. We believe that the following factors also contribute to situations in which punishment is such a prepotent response: 1) Punish-

ment is the way we have been shown or taught to solve behavior problems; 2) aggression (including punishment) may be an elicited, unlearned response; 3) reinforcement histories tend to strengthen the use of punishment; 4) we see others do it; 5) the attention punishment has received has created the impression of greater efficacy than the facts warrant, and 6) non-aversive techniques have received less exposure than punishment and therefore have not been as available as a set of alternative responses when we are faced with behavior problems. Understanding these points may contribute to greater insight into our use of punishment, so let us examine them a bit further:

1. *Punishment is the way we have been shown and taught to solve behavior problems.* As children, most of us were spanked, sent to our room, put on "restriction" or otherwise punished for the "bad" things that we did. "Spare the rod and spoil the child" is a principle of child rearing that influences most families to one extent or another. (In the early stages of this book's preparation, we even considered the subtitle "Spare the Prod.") One purpose for a book dealing exclusively with non-aversive behavior management procedures is to communicate clearly our conviction that such a benign technology is available and effective.

2. *Aggression (including punishment) may be an unlearned, elicited response.* Even the early literature on punishment demonstrated that aggression may be elicited by punishment and that this response to an aversive stimulus or event appears to be unlearned (Hake, 1968; Hutchinson, Azrin, & Hake, 1966; Hutchinson & Pierce, 1971; Pierce, 1971; Proni, 1973). We suggest that in an important sense our punitive response to problem behavior may tap this same mechanism. That is, behavior problems are often functionally equivalent to conditioned or unconditioned aversive stimuli; and our punitive reactions are functionally equivalent to elicited aggression. This may be provocative to those who have built sophisticated cognitive rationales to justify the use of punishment. Notwithstanding our various rationales, our use of punishment may sometimes be a basic response to aversive stimulation. The hope is, of course, that societal contingencies teach control and suppression of the tendencies to be aggressive under aversive conditions. Understanding that punishment may be an elicited aggressive response may be an important step toward controlling that response and also encourage us to find other ways of dealing with the behavior problems which are aversive stimuli to us.

3. *Reinforcement histories tend to strengthen the use of punishment.* In our view, the use of punishment is reinforced and

strengthened in two ways. First, sufficiently often, punishment works and the presenting behavior problem is reduced. This variable schedule of reinforcement of course makes the use of punishment very resistant to extinction (Skinner, 1938; Ferster & Skinner, 1957). Second, if not effective in the long run, punishment is often effective in the short run in removing the aversive stimulus (i.e., behavior problem). That is, when punishment does not reduce the frequency and intensity of a behavior problem over time, it may still be effective in suppressing the continuation of a problem behavior at the moment of application. Hence, a child may stop tantrumming when he is placed in a time-out room and an adolescent may stop tearing his clothes when he is put through an overcorrection procedure. This does not necessarily mean, however, that these problem responses will be reduced in frequency over time. Therefore, use of these punitive procedures can inadvertently be negatively reinforced (Catania, 1968) by temporary cessation of the target behavior. In this way, our use of punishment can also be strengthened and continue at a high rate even though we are not successful in obtaining our treatment objective of behavior reduction over time.

4. *We see others do it.* Neophytes entering a field are likely to emulate their peers and colleagues (Donnellan, 1980a; Schien, 1968). If those around them are using aversive techniques to reduce behaviors, the pattern is likely to continue. Moreover, if the models are respected writers in the field, it may be that the widespread use of punishment is at least partially a function of the modeling effect documented by social learning theory (Bandura, 1965; Bandura & Walters, 1963).

5. *The attention punishment has received has created the impression that it is more effective than it may really be.* There is no doubt that the preponderance of behavior reduction investigations reported in the literature involve the use of aversive intervention procedures (Benasi, 1976; Gardner & Cole, 1983) and that more is known about them (Kazdin, 1975a). The conclusion that aversive procedures are more effective than their alternatives, however, does not logically follow from the greater presence of the former in the scientific journals. While the number of studies reporting non-aversive strategies may be relatively small, we would counter with two points: First, researchers are influenced by many of the same variables that influence practitioners. If the factors we are discussing here account, at least partially, for the significant use of punishment in applied settings, they may also account for the degree of attention researchers have paid to that category of intervention procedures. Second, we believe that the preponderance of punishment

179

research has contributed to certain myths about non-aversive intervention, e.g.:

Myth #1: Non-aversive strategies do not work as rapidly as the aversive strategies for behavior management.
 Comments:

 a. A substantial number of studies show that non-aversive procedures can be effective in reducing behavior problems to near zero rates within one treatment session (e.g., Deitz, et al., 1976; Repp, et al., 1974; Repp, et al., 1976).

 b. While non-aversive strategies do not always lead to the immediate reduction of behavior problems, neither do the aversive strategies (e.g., Wolf, Risley & Mees, 1964). In addition to references to the literature, we ask readers to refer to their own experience to confirm the validity of this statement. As we have discussed in regards to the alternative approaches, the effective use of punishment also requires the careful consideration of many parameters and thoughtful designs (Favell, 1977; Johnston, 1972).

 c. We believe that comparative research is premature at this time. To paraphrase Homer and Peterson (1980), it may not be possible at this time to do research comparing different (aversive and non-aversive) procedures. A fair comparison would require that both procedures be designed to be optimally effective. Not only do we lack the information to do this, but many of the comparative studies reported to date set up one or another of the procedures as a "straw man." The fact is, we do not have sufficient data to make any meaningful comparative statements. Further, we do not regard our task at this time as performing comparative research but rather to perform research which attempts to identify the conditions which must be met to optimize procedural effectiveness. Our hope is that, in the spirit of affirmative action, such efforts focus on the optimization of our non-aversive technology.

Myth #2: Non-aversive strategies are not practical and do not work as well as aversive strategies for the most serious behavior problems.
 Comments:

 a. Non-aversive strategies have been successfully employed to reduce a wide range of behavior problems, as documented by many of the references in this book. In response to the specific myth cited above, we refer the reader to Touchette's

(1983) effort to intervene with probably one of the most severe cases of self-injurious behavior on record. In this case, the learner had practiced self-biting that was so severe and so protracted that he suffered permanent muscle damage and required surgery to replace the veins he had torn out with his teeth. Touchette successfully employed a non-aversive stimulus control strategy to bring this problem under satisfactory control.

b. In the Touchette (1983) case, previous attempts to solve the problem of self-injurious behavior using a range of traditional punishment procedures had not been successful.

c. See comment "c" under Myth #1 concerning comparative statements.

d. To reiterate an earlier point (Chapter I, Ethical Considerations), though minimally problematic behaviors may justify only minimal intervention, the data do not support the notion that highly dangerous behaviors justify highly intrusive interventions.

Myth #3: Non-aversive strategies are more difficult to implement than the aversive strategies.

Comments:

a. A number of studies have reported the ease with which relatively naive staff were taught non-aversive strategies and later successfully implemented them (Allen & Harris, 1966; Deitz & Repp, 1973, 1974; Deitz, et al., 1976; Frankel, et al., 1976; Hall, et al., 1968; Zimmerman & Zimmerman, 1962).

b. Some reports indicate that traditional punishment procedures can be quite difficult and time consuming for direct care personnel and require costly and time consuming administrative safeguards and oversight (Axelrod, et al., 1978; Englemann & Colvin, 1983).

c. See comment "c" above concerning comparative statements.

Myth #4: Non-aversive intervention is simply not as effective as aversive intervention.

Comments:

While we have discussed speed of effects above, effectiveness also involved other considerations. Regarding these:

a. Non-aversive procedures have been shown to generalize their effects across:

1) time (Bostow & Bailey, 1969; Garcia & DeHaven,

1976; Iwata & Lorentzson, 1976; Mulick, et al., 1976; Pacitti & Smith, 1977; Repp & Deitz, 1974; Uhl & Garcia, 1969; Uhl & Sherman, 1971);

2) stimuli (settings), (Barkley & Zupnick, 1976; Garcia & DeHaven, 1976; Peterson & Peterson, 1968; Weiher & Hariman, 1975); and

3) responses (e.g., Russo, et al., 1981).

b. Generally, reports of durability and generalization have not been encouraging for aversive intervention (Azrin & Holz, 1966; Henrickson & Doughty, 1967; Lovaas & Sim mons, 1969; Martin & Siegel, 1966).

c. See comment "c" above about comparative research.

6. *Non-aversive techniques have not received the exposure that punishment has and therefore have not been as available to us as a set of alternative responses when we are faced with a behavior problem.* We do not expect practitioners to reduce their use of aversive intervention techniques until they have a set of non-aversive techniques available to them, i.e., until they can view non-aversive technology as a viable alternative to the use of punishment and other aversive intervention strategies. The primary purpose of this book is to offer a comprehensive compendium of viable and fully available non-aversive techniques for use in behavior management programs in applied and research settings.

Those who are irrevocably wedded to the use of aversive intervention will dismiss our position out of hand. Aside from this minority reaction, however, our experience at workshops and presentations on the topic of non-aversive behavior management indicates most readers of this book will have one of two reactions.

The first group is represented by those who will adopt the information presented here without losing stride. Working from the strong conviction that behavior problems can be solved non-aversively, the suggestions offered in this book will stimulate them to generate dozens, if not hundreds, of specific ideas on how to solve the behavior problems they deal with on a regular basis. Rarely, if ever, will they have to resort to an aversive strategy.

The second reaction will come from those whom we might characterize as being skeptical realists. While they are not wedded to the use of punishment, they do not entirely see how the non-aversive strategies presented here can be applied in all situations. They would *like* to solve all behavior problems non-aversively, but can think of one or two cases which make them hesitant and doubtful. These are the people who in all good faith will say, "yes, but..."

Upon reading this manuscript, a colleague familiar with our work had the latter reaction. The concerns expressed in his letter closely parallel what we have heard before and what we believe may be raised by this book. For this reason, we have included this edited letter below. It should be noted that the writer is well-trained and competent in applied behavior analysis and certainly has demonstrated a clear commitment to using interventions which meet the "least intrusive means" test.

...I have one major concern: it is not clear how we would apply any of the non-aversive interventions that you describe to some of the extreme behavior problems we all too frequently encounter. Just last week, for example, I was asked about the following problem: A teacher must deal with a 12-year-old child who begins head-banging upon being brought to school unless she is immediately permitted to watch T.V. (There is virtually no opportunity to differentially reinforce other behaviors because of the extremely high rates of head-banging and aggressiveness toward others.) She does not engage in the dangerous behaviors while watching T.V., but when she is asked to do anything else, she immediately begins the self injurious and/or aggressive behaviors again.

Unfortunately, the teacher has had difficulty avoiding giving her T.V. contingent upon severe head-banging because, as I noted, the child begins the behaviors immediately upon her arrival. There is such grave danger that this child will seriously injure herself with the head banging that non-punitive approaches, which are usually slower acting, would be very risky.

You note that instructional control can suppress behavior rapidly. However, she is totally non-compliant with verbal direction. Moreover, shaping successive approximations of appropriate behavior by reinforcing her with T.V. has not worked because as soon as the teacher tries to end the reinforcing event, she begins the head-banging to protest.

There is no question about her communicative intent. She's saying that she doesn't like school, that she does like T.V., that she refuses to be influenced by others, and that she insists on having total control. The question that the teacher reasonably asks, however, is, "How do you prevent the head-banging without simply having her constantly watch T.V.? Is there a non-aversive way of dealing with this type of problem?" Although I have not yet seen this child, this is so typical of the problems we are facing right now that we look forward to evaluating empirically the non-

aversive solution that you recommend. We hope that you will consider this an interesting and worthy challenge...

While we do not give specific clinical advice on the basis of a letter or phone call of this nature, we are comfortable recommending the first and foremost step in solving a behavior problem such as this: "Carry out a full functional analysis" (See Chapter III). In this case, as part of a full functional analysis, we would want detailed answers to specific questions in order to design a specific intervention program. These would include, but would definitely not be limited to, the following:

1. What communication skills does she have? Is she capable of asking for what she wants in socially acceptable ways? The answer to this question may provide useful information for positive programming and for differential reinforcement.

2. What does she like besides T.V.? If other reinforcers could be identified, they could be systematically used to strengthen behaviors other than T.V. watching.

3. Words such as "immediately" always invite close scrutiny. Does she start self-abusive behavior literally as she crosses the classroom threshold? If there is any variability in response latency, opportunities for differential reinforcement could exist.

4. Specifically, what are the response latencies and rates of the problem behavior? Precise answers to these questions would be necessary for the careful design of an intervention program.

5. The description of the student being totally non-compliant also invites close questioning. Does this mean that she will not come to lunch or snack when called, or that she will not get ready to go home when the school bus comes at the end of the day? If there are areas in which she is at least somewhat compliant, these might give some direction to an intervention effort.

6. Does she have favorite T.V. shows? If so, perhaps some of these could be taped. Access to the tapes would then be used to reinforce alternate responses. Her favorite shows may also give some clues for finding other reinforcers and ideas for high interest (i.e., intrinsically reinforcing) instructional activities.

7. Does she *literally* watch T.V. 100% of the time or does she engage in some other activities such as lunch, snack time, playground, restroom, community outings, and the like without watching T.V. and without engaging in problem behavior? Answers to this question could provide information for positive programming, and differential reinforcement strategies.

Specific recommendations for intervention would have to await the results of a functional analysis and the answers to questions such as those posed above. While awaiting this information, however, we were able to generate the following possibilities for intervention:

1. Functional, age-appropriate, instructional activities could be developed in non-school, community based settings (positive programming, stimulus control).

2. More functional, high interest programming could be developed, e.g., teaching her to cook favorite foods, buy favorite items, be more independent in ordering and paying for food at her favorite restaurant, learning a vocational task at a T.V. repair shop, etc. (positive programming).

3. A coin operated T.V. could be installed and the student could earn the necessary coins by meeting initially easy but increasingly more demanding instructional requirements (Alt-R; shaping).

4. The student could be given free access to a black and white T.V., but required to earn access to a color T.V. (Alt-R).

5. She could be taught to ask for T.V. via a more socially acceptable method of communication, e.g., speech, word cards, picture books, signs, etc. (positive programming).

6. The problem behavior may be under stimulus control of the T.V. If a screen were placed in front of the T.V. so the student could not see it, problem behavior might be significantly reduced (stimulus control).

7. The T.V. could be placed in a separate room. If the options were watching T.V. alone or in a room absent of other extraneous stimuli, or to be in the classroom with other people for snack time, lunch time, and the opportunity to engage in a variety of instructional activities which resulted in the delivery of a range of interesting and powerful reinforcers, she might decide that T.V. was not worth the lack of everything else (stimulus control).

8. Other reinforcers could be identified and she could be reinforced for watching less T.V. each day (DRL).

9. The teacher might prepare video tapes to provide the student with instructional task demands through T.V. (stimulus control).

10. The teacher could meet the student at the door in a clown costume (stimulus change) and reinforce her for following simple requests (instructional control) and for carrying out initially very simple, instructional activities (Alt-R).

11. The student could initially be brought to a different class-

room (stimulus change) without a T.V. (stimulus control) and asked to engage in some (initially simple and brief but increasingly complex and lengthy) instructional tasks which would be differentially reinforced (Alt-R). As each day's assignment was completed, she could be given contingent access to the T.V. room (Alt-R).

12. Assuming some variability in the number of seconds (if not minutes) that pass without problem behavior when the student first enters the classroom, she could be reinforced for going longer and longer without problem behavior (escalating DRO).

13. The same strategy could be applied to other times of day when she does not engage in problem behavior when the T.V. is off, e.g., snack time, lunch time, bathroom time, playground time, etc. (escalating DRO).

14. Times when problem behavior does not occur could be identified (e.g., snack time, lunch time, bathroom times, playground time, etc.) and these activities elongated and scheduled to take up most (if not all) of the day, and instructional demands could be gradually introduced (stimulus control).

15. She could be given free access to T.V. at school and at home for an extended period of time (stimulus satiation).

16. She could then be allowed to watch T.V. all day but required to do increasingly more school work before she gets on the bus to go home, working backwards from the end of the school day (Alt-R).

17. The T.V. could be clicked off, then immediately back on (stimulus change). If the student does not engage in target behaviors, positive reinforcement would be provided. Very gradually the time between click-off and click-on would be increased (escalating DRO).

18. The T.V. watching could be brought under the control of some presently neutral stimulus and the student made to earn access to that stimulus (stimulus control).

19. Any combination of two or more of the above strategies could be used in a comprehensive, coordinated intervention effort (additive procedures.)

We hope that our suggestions give some indication of the wealth of resources that exists for solving behavior problems non-aversively. We expect that a full functional analysis will spark dozens of other possibilities for intervention. Of course, we expect skepticism to exist until practitioners become accustomed to working with non-aversive strategies. We believe this process is analogous to learning to drive a stick shift car. Do you remember the first time you stopped for a red light on a hill? The difficulty you

had learning to maneuver the car belied the fact that you "knew" exactly what you had to do; that is, you knew the basic principles involved. Learning to solve behavior problems non-aversively involves an analogous process. What you have learned from reading this book and your other instructional experiences involving behavior modification should give you a fairly good command of the basic principles. Arriving at the point where you can solve behavior problems in a way comparable to the ease with which you may now drive that stick shift car will require effort. Talking and thinking about it will not do it. You must "get behind the wheel" and try it. Your development as an accomplished practitioner of non-aversive behavior management techniques requires:

a. That you have a reasonable command over the basic principles and procedures involved. (If you have read and understood this book, you should already have accomplished this first step.)

b. That you firmly decide to solve the behavior problems referred to you using one or another of the non-aversive strategies described in this book and thus dedicate your creativity to this direction. (This firm determination may be necessary to offset the high prepotency the use of punishment holds for many of us.)

c. That you start building a backlog of experiences in solving behavior problems using non-aversive techniques. Recognize, however, that you will experience some "bucking and stalling." This is part of the process, and should not discourage you from your efforts. Be determined!

d. That you not even consider a punishment procedure unless you have carried out a full functional analysis (see Chapter III), you have failed with no fewer than three carefully designed non-aversive attempts and you absolutely cannot think of any more non-aversive strategies to try.

Once accustomed to thinking about and working successfully with non-aversive techniques, you will find such an approach, like driving a stick shift car, effortless and natural. Moreover, we believe that your experience will persuade you that this is an approach which, by according greater dignity to the learner, enhances the practitioner as well. We invite you, our reader, to join us in this venture. Together we may reach the goal of having the emphasis placed on positive programming and having aversive intervention strategies relegated to an historical footnote.

References

Acosta, F. & Yamamoto, J. (1978). Application of electromyographic bio-feedback to the relaxation training of schizophrenic, neurotic, and tension headache patients. *Journal of Consulting and Clinical Psychology, 46,* 383–384.

Allen, K. E., & Harris, F. R. (1966). Elimination of a child's scratching by training the mother in reinforcement procedures. *Behaviour Research and Therapy, 4,* 79–84.

Allen, K. E., Hart, B. M., Buell, J. S., Harris, F. R., Wolf, M.M. (1964). Effects of social reinforcement on isolate behavior of a nursery school child. *Child Development, 35,* 511–518.

Allen, K. E., Turner, K. D., & Everett, P. M. (1970). A behavior modification classroom for Head Start children with problem behaviors. *Exceptional Children, 37,* 119–127.

Austin, N. K., Liberman, R. P., King, L. W., & DeRisi, W. J. (1976) A comparative evaluation of two day hospitals: Goal attainment scaling of behavior therapy vs. milieu therapy. *Journal of Nervous and Mental Disease, 163,* 253–262.

Axelrod, S., Brantner, J. P., & Meddock, T. D. (1978). Overcorrection: A review and critical analysis. *The Journal of Special Education, 12* (4), 367–391.

Ayllon, T. (1963). Intensive treatment of psychotic behavior by stimulus satiation and food reinforcement. *Behaviour Research and Therapy, 1,* 53–61.

Ayllon, T., & Azrin, N. H. (1968a). *The token economy: A motivational system for therapy and rehabilitation.* New York: Appleton-Century-Crofts.

Ayllon, T., & Azrin, N. H. (1968b). Reinforcement and instruction with mental patients. *Journal of the Experimental Analysis of Behavior, 7,* 327–331.

Azrin, N. H. (1958). Some effects of noise on human behavior. *Journal of the Experimental Analysis of Behavior, 1,* 183–200.

Azrin, N. H., & Holz, W. C. (1966). Punishment. In W. K. Honig (Ed.), *Operant behavior: Areas of research and application.* Englewood Cliffs, NJ: Prentice Hall, Inc.

Azrin, N., & Powell, M. (1968). Behavioral engineering: The reduction of smoking behavior by a conditioning apparatus and procedure. *Behavior Therapy, 6,* 525–534.

Baker, D. B. (1980). Applications of environmental psychology in programming for severely handicapped students. *Journal of the Association for the Severely Handicapped, 5,* 234–249.

Ball, T. S., McCrady, R. E., & Teixeira, J. (1978). Automated monitoring and cuing for positive reinforcement and differential reinforcement of other behavior. *Behavior Therapy and Experimental Psychiatry, 9,* 33-37.

Bandura, A. (1965). Behavioral modifications through modeling procedures. In L. Krasner & L. P. Ullman, (Eds.), *Research in Behavior Modification* (310-340). New York: Holt, Rinehart & Winston.

Bandura, A., & Walters, R. H. (1963). *Social learning and personality development.* New York: Holt, Rinehart & Winston.

Barker, R. G. (1968). *Ecological psychology.* Palo Alto, CA: Stanford University Press.

Barkley, R. A., & Zupnick, S. (1976). Reduction of stereotypic body contortions using physical restraint and DRO. *Behavior Therapy and Experimental Psychiatry, 7,* 167-170.

Becker, W. C., Madsen, Jr., C. H., Arnold, C. R., & Thomas, D. R. (1967). The contingent use of teacher attention and praise in reducing classroom behavior problems. *Journal of Special Education, 1,* 287-307.

Benasi, V. A. (1976). Punishment and its alternatives: A selective review. In G. W. LaVigna, Chairman, *Non-aversive techniques for the control of undesirable behavior.* A symposium presented at the Tenth Annual Meeting of the Association for the Advancement of Behavior Therapy, New York.

Benson, H. (1974). Your innate asset for combating stress. *Harvard Business Review,* July/August, 49-80.

Benson, H., Shapiro, D., Tursky, B., & Schwartz, G. E. (1971). Decreased systolic blood pressure through operant conditioning techniques in patients with essential hypertension. *Science, 173,* 740-742.

Bernstein, D.A., & Borkovec, T. D. (1973). *Progressive relaxation training: A manual for the helping professions.* Champaign, IL: Research Press.

Biklen, D. (1979). *The community imperative: A refutation of all arguments in support of institutionalizing anyone because of mental retardation.* Syracuse, N.Y.: Center on Human Policy.

Blanchard, E. G., & Draper, D. C. (1973). Treatment of a rodent phobia by covert reinforcement: A single subject experiment. *Behavior Therapy, 4,* 559-564.

Blanchard, E. G., & Young, L. D. (1974). Clinical application of biofeedback training: A review of evidence. *Archives of General Psychiatry, 30,* 573-589.

Blatt, B., Ozolin, A., & McNally, J. (1979). *The family papers—A return to purgatory.* New York: Longman Publishing Co.

Blau, J. S. (1980). Changes in assertiveness and marital satisfaction after participation in an assertiveness training group. In D. Upper & S.

Rose (Eds.), *Behavior group therapy, 1980: An annual review.* Champaign, IL: Research Press.

Boe, E. E. (1964). Extinction as a function of intensity of punishment, amount of training, and reinforcement of a competing response. *Canadian Journal of Psychology, 18,* 328–342.

Bolstad, O. D., & Johnston, S. M. (1972). Self-regulation in the modification of disruptive classroom behavior. *Journal of Applied Behavior Analysis, 5,* 443–454.

Bostow, D. E., & Bailey, J. B. (1969). Modification of severe disruptive and aggressive behavior using brief timeout and reinforcement procedures. *Journal of Applied Behavior Analysis, 2,* 31–37.

Bott, L. A. (1979). An investigation of the use of verbal discussion and relaxation training to control aggression in mildly and moderately mentally retarded adults. Doctoral dissertation, Ohio State University. *Dissertation Abstracts International, 40,* 1864B–1865B. (U. Microfilms No. 7922456)

Bronston, W. (1979). *California guidelines for behavioral interventions.* Sacramento, CA: Department of Education, Social Services, Health Services, and Developmental Services.

Brown, B. (1977). *Stress and the art of biofeedback.* New York: Harper & Row.

Brown, L., Nietupski, J., & Hamre-Nietupski, S. (1976). The criterion of ultimate functioning. In M. Thomas (Ed.), *Hey, don't forget about me: Education's investment in the severely, profoundly, and multiply handicapped.* Reston, VA: Council for Exceptional Children.

Brunner, J. S. (1975). The ontogenesis of speech acts. *Journal of Child Language, 2,* 1–19.

Bruner, A., & Revusky, S. H. (1961). Collateral behavior in humans. *Journal of the Experimental Analysis of Behavior, 4,* 349–350.

Bruno, B. (1974). Progressive relaxation training for children: A guide for parents and teachers, Part 1. *Special Children, 1* (2), 31–43.

Bruno, B. (1975). Progressive relaxation training for children: A guide for parents and teachers, Part II. *Special Children, 2* (1), 38–46.

Burgraff, R. I. (1974). The efficacy of systematic desensitization via imagery as a therapeutic technique with stutterers. *British Journal of Disorders of Communication, 9,* 134–139.

Butman, R. (1979). *The non-aversive treatment of self-injurious behavior with severe and profoundly retarded children.* Unpublished dissertation, The Fuller Theological Seminary, Pasadena, CA.

Callner, D. A., & Ross, S. M. (1978). The assessment of training of assertive skills with drug addicts: A preliminary study. *International Journal of the Addictions, 13,* 227–239.

Cannon, W. B. (1939). *The wisdom of the body.* New York: W. W. Norton.

Carr, E. G. (1977). The motivation of self-injurious behavior: A review of some hypotheses. *Psychological Bulletin, 84,* 800-816.

Carr, E. G. (1983). *Application of pragmatics to conceptualization and treatment of severe behavior problems in children.* Paper presented at the Annual Convention of the American Psychological Association, Anaheim, CA.

Carr, E. G., Newsom, C. D., & Binkoff, J. A. (1976). Stimulus control of self-destructive behavior in a psychotic child. *Journal of Abnormal Child Psychology, 4*(2), 290-306.

Carroll, S. W., Sloop, E. W., Mutter, S., & Prince, P. L. (1978). The elimination of chronic clothes ripping in retarded people through a combination of procedures. *Mental Retardation, 16,* 246-249.

Carter, D. E., & Bruno, J. J. (1968). Extinction and reconditioning of behavior generated by a DRL contingency of reinforcement. *Psychonomic Science, 11* (1), 19-20.

Carter, J. L., Lax, B., & Russell, H. (1979). Effects of relaxation and EMG training on academic achievement of educable retarded boys. *Education and Training of the Mentally Retarded, 14,* 39-42.

Carter, J. L., & Synolds, D. (1974). Effects of relaxation training upon handwriting quality. *Journal of Learning Disabilities, 7,* 226-231.

Catania, A. C. (Ed.) (1968). *Contemporary research in operant behavior.* Glenview, Il: Scott, Foresman and Company.

Cautela, J. R. (1967a). Covert sensitization. *Psychological Reports, 20,* 383-387.

Cautela, J. R. (1967b). Covert response cost. *Psychotherapy: Theory, Research, and Practice, 13,* 397-404.

Cautela, J. R. (1970). Covert reinforcement. *Behavior Therapy, 1,* 33-50.

Cautela, J. R. (1971). Covert extinction. *Behavior Therapy, 2,* 192-200.

Cautela, J. R. (1976). The present status of covert modeling. *Journal of Behavior Therapy and Experimental Psychiatry, 7,* 323-326.

Cautela, J. R. (1977). Covert conditioning: Assumptions and procedures. *Journal of Mental Imagery, 1,* 53-64.

Cautela, J. R. (1982). Covert conditioning with children. *Journal of Behavior Therapy and Experimental Psychiatry, 13,* 209-214.

Cautela, J. R., & Baron, M. G. (1977). Covert conditioning: A theoretical analysis. *Behavior Modification, 1,* 351-368.

Cautela, J. R., & Brion-Meisels, L. (1979). A children's reinforcement survey schedule. *Psychological Reports, 44,* 327-338.

Cautela, J. R., & Groden, J. (1978). *Relaxation: A comprehensive manual for adults, children, and children with special needs.* Champaign, IL: Research Press.

Cautela, J. R., Walsh, K., & Wish, P. (1971). The use of covert reinforcement in the modification of attitudes toward the mentally retarded. *Journal of Psychology, 77,* 257-260.

Cautela, J. R., & Kastenbaum, R. (1967). A reinforcement survey schedule for use in therapy, training, and research. *Psychological Reports, 20,* 1115–1130.

Center, D. B., Dietz, S. M., & Kaufman, M. E. (1982). Student ability, task difficulty, and inappropriate classroom behavior. *Behavior Modification, 6,* 3–11.

Chaney, R. F., O'Leary, M. R., & Marlatt, G. A. (1979). Skill training with alcoholics. *Journal of Consulting and Clinical Psychology, 46,* 1092–1104.

Chang-Liang, R., & Denney, D. R. (1976). Applied relaxation as training in self-control. *Journal of Counseling Psychology, 23,* 183–189.

Clark, E. J. (1978). The efficacy of systematic desensitization as a strategy to affect attitude change in teachers toward severely handicapped students. *U. Microfilms International, No. 7901215.*

Clurman, C. (1983). Tennessee parents seek end to school "time out" box. *U. S. A. Today, 3A.*

Cohen, S. F. (1978). The effect of systematic desensitization and information on attitudes toward the physically disabled. *U. Microfilms International, No. 7820580.*

Coleman, R. S., Whitman, T. L., & Johnson, M. S. (1979). Suppression of self-stimulatory behavior of a retarded boy across staff and settings: An assessment of situational generalization. *Behavior Therapy, 10,* 266–280.

Conroy, J., Efthimiou, J., & Lemanowicz, J. (1982). A matched comparison of the developmental growth of institutionalized and deinstitutionalized mentally retarded clients. *American Journal of Mental Deficiency, 86*(6), 581–587.

Corte, H., Wolf, M. M., & Locke, B. J. (1971). A comparison of procedures in the elimination of self-injurious behavior of retarded adolescents. *Journal of Applied Behavior Analysis, 4,* 201–213.

Cunningham, C. E., & Peltz, L. (1982). In vivo desensitization in the management of self-injurious behavior. *Journal of Behavior Therapy and Experimental Psychiatry, 13,* 135–140.

Curran, J. P. (1975). An evaluation of a skills training program and a systematic desensitization program in reducing dating anxiety. *Behaviour Research and Therapy, 13,* 65–68.

Curran, J. P., & Gilbert, F. S. (1975). A test of the relative effectiveness of a systematic desensitization program and an interpersonal skills training with date anxious subjects. *Behavior Therapy, 6,* 510–521.

Deitz, S. M., & Repp, A. C. (1973). Decreasing classroom misbehavior through the use of DRL schedules of reinforcement. *Journal of Applied Behavior Analysis, 6*(3), 457–463.

Deitz, S. M., & Repp, A. C. (1974). Differentially reinforcing low rates of misbehavior with normal elementary school children. *Journal of Applied Behavior Analysis, 7*(4), 622.

Deitz, S. M., Repp, A. C., & Deitz, D. E. D. (1976). Reducing inappropriate classroom behavior of retarded students through three procedures of differential reinforcement. *Journal of Mental Deficiency Research, 20,* 155-170.

Dixon, L. S. (1977). The nature of control by spoken words over visual stimulus selection. *Journal of the Experimental Analysis of Behavior, 27,* 433-442.

Donnellan, A. M. (1980a). *Functions of student teaching in special education.* Unpublished doctoral dissertation, University of California, Santa Barbara, CA.

Donnellan, A. M. (1980b). An educational perspective of autism: Implications, curriculum development and personnel preparation. In B. Wilcox & A. Thompson (Eds.), *Critical issues in educating autistic children and youth.* Washington, DC: U. S. Department of Education, Office of Special Education.

Donnellan, A. M. (1984). The criterion of the least dangerous assumption. *Behavior Disorders, 9,* 141-150.

Donnellan, A. M., and LaVigna, G. W. (in press). Non-aversive control of socially stigmatizing behaviors. *The Pointer.*

Donnellan, A. M., LaVigna, G. W., Zambito, J., & Thvedt, J. (in press). A time limited intervention program model to support community placement for persons with severe behavior problems. *The Journal of the Association for Persons with Severe Handicaps.*

Donnellan, A. M., Mesaros, R. A., & Anderson, J. L. (1984a). Teaching students with autism in natural environments: What educators need from researchers, *Journal of Special Education, 18*(4), 505-522.

Donnellan, A. M., Mirenda, P., Mesaros, R., & Fassbender, L. (1984b). A strategy for analyzing the communicative functions of behavior. *Journal of the Association for Persons with Severe Handicaps, 11,* 201-212.

Donnellan-Walsh, A., Gossage, L. D., LaVigna, G. W., Schuler, A. L., & Traphagen, J. D. (1976). *Teaching makes a difference.* Sacramento, CA: California State Department of Education.

Dostoyevsky, F. (1966). *Crime and punishment.* Middlesex: Penguin.

Durand, V. M. (1982). Analysis and intervention of self-injurious behavior. *Journal of the Association for the Severely Handicapped, 7,* 44-53.

Eason, L. J., White, M. J., & Newsom, C. (1982). Generalized reduction of self-stimulatory behavior: An effect of teaching appropriate play to autistic children. *Analysis and Intervention in Developmental Disabilities, 2,* 157-169.

Eisler, R. M., Miller, P. M., & Hersen, M. (1973). Components of assertive behavior. *Journal of Clinical Psychology, 29,* 295–299.

Engel, B. T., Nikoomanesh, P., & Schuster, M. M. (1974). Operant conditioning of the recto-sphincteric response in the treatment of fecal incontinence. *New England Journal of Medicine, 290,* 646–649.

Engelmann, S., & Colvin, W. (1983). *Generalized compliance training: A direct-instruction program for managing severe behavior problems.* Eugene, OR: E-B Press.

Epstein, L. H., Doke, L. A., Sajwaj, T. E., Sorrell, S., & Rimmer, B. (1974). Generality and side effects of overcorrection. *Journal of Applied Behavior Analysis, 7,* 385–390.

Epstein, L. H., Peterson, G. L. Webster, J., Guanieri, C., Libby, B. (1973). Comparison of stimulus control and reinforcement control effects on imitative behavior. *Journal of Experimental Child Psychology, 16,* 98–110.

Erickson, E. (1950). *Childhood and Society.* New York: W. W. Norton.

Etzel, B. C., & LeBlanc, J. M. (1979). The simplest treatment alternative: The law of parsimony applied to choosing appropriate instructional control and errorless-learning procedures for the difficult to teach child. *Journal of Autism and Developmental Disorders, 9,* 4–13.

Favell, J. E. (1977). *The power of positive reinforcement.* Springfield, IL: Bannerstone House.

Favell, J. E., McGimsey, J. F., & Jones, M. L. (1978). The use of physical restraint in the treatment of self-injury and as a positive reinforcement. *Journal of Applied Behavior Analysis, 11,* 225–241.

Ferster, C. B. (1961). Positive reinforcement and behavioral deficits of autistic children. *Child Development, 32,* 437–456.

Ferster, C. B., Nurnberger, J. I., & Levitt, E. B. (1962). The control of eating. *Journal of Mathetics, 1,* 87–109.

Ferster, C. B., & Skinner, B. F. (1957). *Schedules of reinforcement.* New York: Appleton-Century-Crofts.

Firestone, P., Waters, B. C. H., & Goodman, J. T. (1978). Desensitization in children and adolescents: A review. *Journal of Clinical Child Psychology, 1,* 142–148.

Flannery, R. B. (1972). Covert conditioning in the behavioral treatment of an agoraphobic. *Psychotherapy: Theory, Research, and Practice, 9,* 217–220.

Foxx, R., & Azrin, N. (1972). Restitution: A method of eliminating aggressive disruptive behavior of retarded brain damaged patients. *Behaviour Research and Therapy, 10,* 15–27.

Foxx, R. M., & Azrin, N. H. (1973). The elimination of autistic self-stimulatory behavior by overcorrection. *Journal of Applied Behavior Analysis, 6,* 1–14.

Frankel, R. (1982). Autism for all practical purposes: A micro-interactional view. *Topics in Language Disorders, 3,* 33-42.

Frankel, F., Moss, D., Schofield, S., & Simmons III, J. Q. (1976). Case study: Use of differential reinforcement to suppress self-injurious and aggressive behavior. *Psychological Reports, 39,* 843-849.

Frankenberger, W. R. (1980). Effects of progressive muscle relaxation and electromyographic feedback training on aggressive institutionalized mentally retarded adults. Doctoral dissertation, Ohio State University. *Dissertation Abstracts International, 40,* 3392B. (U. Microfilms No. 8001729).

Frederiksen, L. W., Jenkins, J. O., Foy, D. W., & Eisler, R. M. (1976). Social-skills training to modify abusive verbal outbursts in adults. *Journal of Applied Behavior Analysis, 9*(2), 117-125.

Galassi, J. P., & Galassi, M. D. (1974). Validity of a measure of assertiveness. *Journal of Counseling Psychology, 21,* 248-250.

Garcia, E. E., & DeHaven, E. D. (1976). Experimental analysis of response acquisition and elimination with positive reinforcers. *Behavior and Neurological Psychiatry, 7,* 71-78.

Gardner, W. I., & Cole, C. L. (1983). Selecting intervention procedures: What happened to behavioral assessment? In O. C. Karan & W. I. Gardner (Eds.), *Habilitation practices with the developmentally disabled who present behavioral and emotional disorders.* Madison, WI: Rehabilitation Research and Training Center in Mental Retardation.

Gold, M. W. (1980). *Try another way: Training manual.* Champaign, IL: Research Press.

Goldiamond, I. (1965). Self-control procedures in personal behavior problems. *Psychological Reports, 17,* 851-868.

Goldiamond, I. (1974). Toward a constructional approach to social problems. *Behaviorism, 2,* 1-84.

Goldiamond, I. (1975). Singling out behavior modification for legal regulation: Some effects on patient care, psychotherapy, and research in general. *Arizona Law Review, 17*(1), 105-126.

Goldfried, M. R. (1977). The use of relaxation and cognitive relabeling as coping skills. In R. B. Stuart (Ed.), *Behavioral self-management: Strategies, techniques and outcomes.* New York: Brunner/Mazel.

Goldfried, M. R., & Trier, C. S. (1974). Effectiveness of relaxation as an active coping skills. *Journal of Abnormal Psychology, 83,* 348-355.

Goldsmith, J. B., & McFall, R. M. (1975). Development and evaluation of an interpersonal skill-training program for psychiatric inpatients. *Journal of Abnormal Psychology, 84,* 51-58.

Gordon, T. (1970). *Parent effectiveness training.* New York: P. H. Wyden.

Gotestam, K. G., & Melin, L. (1974). Covert extinction of amphetamine addiction. *Behavior Therapy, 5,* 90-92

Graziano, A. M., & Kean, J. E. (1971). Programmed relaxation and reciprocal inhibition with psychotic children. In A. M. Graziano (Ed.), *Behavior therapy with children.* Chicago: Aldine Publishing Co.

Grimaldi, E. (1972). Personal communication.

Groden, G., & Cautela, J. R. (1981). Behavior therapy: A survey of procedures for counselors. *The Personnel and Guidance Journal, 3,* 175-180. ·

Groden, J. (1978). *The use of covert procedures with students labeled trainable retarded.* Unpublished manuscript, Boston College.

Groden, J. (1982). *The use of imagery procedures to increase initiations of verbal behavior among autistic children and adolescents: A multiple baseline analysis.* Unpublished doctoral dissertation, Boston College.

Guralnick, M. J. (1973). Behavior therapy with an acrophobic mentally retarded young adult. *Journal of Behavior Therapy and Experimental Psychiatry, 4,* 263-265.

Haddle, H. W. (1974). The modification of attitudes toward disabled persons: The case for using systematic desensitization as an attitude-change strategy. *American Foundation for the Blind Research Bulletin, 28,* 91-110.

Hake, D. F. (1968). Actual versus potential shock in making shock situations function as negative reinforcers. *Journal of the Experimental Analysis of Behavior, 11,* 385-403.

Hall, R. V., & Broden, M. (1967). Behavior changes in brain-injured children through social reinforcement. *Journal of Experimental Child Psychology, 5,* 463-479.

Hall, R. V., Lund, D., & Jackson, D. (1968). Effects of teacher attention on study behavior. *Journal of Applied Behavior Analysis, 1*(1), 1-12.

Halle, J. W., Marshall, A. M., & Spradlin, J. E. (1979). Time delay: A technique to increase language use and facilitate generalization in retarded children. *Journal of Applied Behavior Analysis, 12*(3), 431-439.

Hanna, R., Wifling, F., & McNeill, B. (1975). A biofeedback treatment for stuttering. *Journal of Speech and Hearing Disorders, 40,* 270-273.

Harris, F., Johnston M., Kelly, C., & Wolf, M. (1964). Effects of positive social reinforcement on regressed crawling of a nursery school child. *Journal of Educational Psychology, 55,* 35-41.

Harris, F. R., Wolf, M. M., & Baer, D. M. (1964). Effects of adult social reinforcement on child behavior. *Young Children, 20*(1), 8-17.

Harvey, J. R. (1978). *The effect of electromyographic (EMG) biofeedback based relaxation training on frontalis muscle tension, anxiety, self-esteem, and locus of control in mentally retarded adults.* Unpublished doctoral dissertation, University of Wisconsin-Madison.

Harvey, J. R. (1979). The potential of relaxation training for the mentally retarded. *Mental Retardation, 17,* 71–76.

Harvey, J. R., Karan, O. C., Bhargava, D., & Morehouse, W. (1978). Relaxation training and cognitive behavior procedures to reduce violent temper outbursts in a moderately retarded woman. *Journal of Behavior Therapy and Experimental Psychiatry, 9,* 347–351.

Hawkins, R. P., Peterson, R. F., Sahweid, E., & Bijou, S. W. (1966). Behavior therapy in the home: Amelioration of problem parent-child relations with the parent in a therapeutic role. *Journal of Experimental Child Psychology, 4,* 99–107.

Hay, W. M., Hay, L. R., & Nelson, R. O. (1977). The adaptation of covert modeling procedures to the treatment of chronic alcoholism and obsessive-compulsive behavior: Two case reports. *Behavior Therapy, 8,* 70–76.

Hedburg, A. G., & Campbell, L. M. (1975). The use of the MMPI (Mini-Multi) to predict alcoholics' response to a behavioral treatment program. *Journal of Clinical Psychology, 3,* 271–274.

Henriksen, K., & Doughty, R. (1967). Decelerating undesired mealtime behavior in a group of profoundly retarded boys. *American Journal of Mental Deficiency, 72,* 40–44.

Hersen, M., & Bellack, A. S. (1976). A multiple-baseline analysis of social-skills training in chronic schizophrenics. *Journal of Applied Behavior Analysis, 9*(3), 239–245.

Holz, W. C., & Azrin, N. H. (1963). A comparison of several procedures for eliminating behavior. *Journal of the Experimental Analysis of Behavior, 6,* 399–406.

Homer, A. L., & Peterson, L. (1980). Differential reinforcement of other behavior: A preferred response elimination procedure. *Behavior Therapy, 11,* 449–471.

Homme, L. E., Csanyi, A. P., Gonzales, M. A., & Rechs, J. R. (1969). *How to use contingency contracting in the classroom.* Champaign, IL: Research Press.

Hughes, H., & Davis, R. (1980). Treatment of aggressive behavior: The effect of EMG response discrimination biofeedback training. *Journal of Autism and Developmental Disorders, 10*(2), 193-202.

Huguenin, N. H., & Touchette, P. E. (1980). Visual attention in retarded adults: Combining stimuli which control incompatible behavior. *Journal of the Experimental Analysis of Behavior, 33,* 77–86.

Hutchinson, R. R., Azrin, N. H., & Hake, D. F. (1966). An automatic method for the study of aggression in squirrel monkeys. *Journal of the Experimental Analysis of Behavior, 9,* 233–237.

Hutchinson, R. R., Azrin, N. H., & Hunt, G. M. (1968). Attack produced by intermittent reinforcement of a concurrent operant response. *Journal*

of the Experimental Analysis of Behavior, 11, 489–495.

Hutchinson, R. R., & Pierce, G. E. (1971). *Jaw clenching in humans: Its measurement and effects produced by conditions of reinforcement and extinction.* Paper presented at American Psychological Association.

Ince, L. P. (1976). The use of relaxation training and a conditioned stimulus in the elimination of epileptic seizures in a child: A case study. *Journal of Behavior Therapy and Experimental Psychiatry, 7,* 39–42.

Inman, D. P. (1976). Using biofeedback to establish stimulus control in spastic muscles. Ann Arbor, MI: *University Microfilms International, No.* 77-4726.

Intagliata, J. C. (1978). Increasing the interpersonal problem-solving skills of an alcoholic population. *Journal of Consulting and Clinical Psychology, 46,* 489–498.

Iwata, B. A., Dorsey, M. F., Slifer, K. J., Bauman, K. E., & Richman, G. S. (1982). Toward a functional analysis of self-injury. *Analysis and Intervention in Developmental Disabilities, 2,* 3–20.

Iwata, B. A., & Lorentzson, A. M. (1976). Operant control of seizure-like behavior in an institutionalized retarded adult. *Behavior Therapy, 7,* 247–251.

Jackson, G. M. (1977). Facilitation of performance on an arithmetic task with the mentally retarded as a result of the application of a biofeedback procedure to decrease alpha wave activity. Doctoral dissertation, Southern Illinois University. *Dissertation Abstracts International, 38,* 933B. (U. Microfilms No. 77-16, 627).

Jackson, H. J., & Hooper, J. P. (1981). Some issues arising from the desensitization of a dog phobia in a mildly retarded female: Or should we take the bite out of the bark? *Australian Journal of Developmental Disorders, 7,* 9–16.

Jacobson, E. (1938). *Progressive relaxation.* Chicago: University of Chicago Press.

Jacobson, E. (1964). *Anxiety and tension control.* Philadelphia: Lippincott.

Johnston, J. M. (1972). Punishment of human behavior. *American Psychologist, 27,* 1033–1054.

Jones, M. C. (1924). The elimination of children's fears. *Journal of Experimental Psychology, 7,* 382–390.

Kanfer, F. H., & Saslow, G. (1969). Behavioral diagnosis. In C. M. Franks (Ed.), *Behavior Therapy: Appraisal and status.* New York: McGraw-Hill.

Kapostins, E. E. (1963). The effects of DRL schedules on some characteristics of word utterance. *Journal of the Experimental Analysis of Behavior, 6*(2), 281–290.

Kazdin, A. E. (1973). Covert modeling and the reduction of avoidance behavior. *Journal of Abnormal Psychiatry, 81,* 87–95.

Kazdin, A. E. (1974). Covert modeling, model similarity, and reduction of avoidance behavior. *Behavior Therapy, 5,* 325–340.

Kazdin, A. E. (1975a). *Behavior modification in applied settings.* Homewood, IL: Dorsey Press.

Kazdin, A. E. (1975b). Covert modeling, imagery assessment, and assertive behavior. *Journal of Consulting and Clinical Psychology, 43,* 716–724.

Kazdin, A. E. (1977a). Assessing the clinical or applied importance of behavior change through social validation. *Behavior Modification, 1,* 427–451.

Kazdin, A. E. (1977b). Artifact, bias, and complexity of assessment: The ABCs of reliability. *Journal of Applied Behavior Analysis, 10,* 141–150.

Kazdin, A. E., & Erickson, L. M. (1975). Developing responsiveness to instructions in severely and profoundly retarded residents. *Journal of Behavior Therapy and Experimental Psychiatry, 6,* 17–21.

Keller, F. S., & Schoenfeld, W. (1950). *Principles of psychology.* New York: Appleton-Century-Crofts.

Koegel, R. L., & Covert, A. (1972). The relationship of self-stimulation and learning in autistic children. *Journal of Applied Behavior Analysis, 5,* 381–387.

Koegel, R. L., & Rincover, A. (1977). Research on the difference between generalization and maintenance in extra-therapy responding. *Journal of Applied Behavior Analysis, 10,* 1–16.

Koeppen, A. S. (1974). Relaxation training for children. *Elementary School Guidance and Counseling,* October 14-21.

Konarski, E. A., Jr., Johnson, M. R., Crowell, C. R., & Whitman, T. L. (1980). Response deprivation and reinforcement in applied settings: A preliminary analysis. *Journal of Applied Behavior Analysis, 13*(4), 595–609.

Kramer, T. J., & Rilling, M. (1970). Differential reinforcement of low rates: A selective critique. *Psychological Bulletin, 74*(4), 225–254.

Kristt, D. A., & Engel, B. T. (1975). Learned control of blood pressure in patients with high blood pressure. *Circulation, 51,* 370–378.

Krop, H., Perez, F., & Beaudoin, C. (1973). Modification of "self-concept" of psychiatric patients by covert reinforcement. In R. D. Rubin, J. P. Brady & J. D. Henderson (Eds.), *Advancement in behavior therapy* (Vol. 4). New York: Academic Press.

LaGreca, A. M., & Ottinger, D. R. (1979). Self-monitoring and relaxation training in the treatment of medically ordered exercises in a 12-year-old female. *Journal of Pediatric Psychology, 4,* 49–54.

Lanyon, R. I. (1969). Behavior change in stuttering through systematic desensitization. *Journal of Speech and Hearing Disorders, 34,* 253–260.

Laties, V. C., Weiss, B., Clark, R. L., & Reynolds, M. D. (1965). Overt "mediating" behavior during temporally spaced responding. *Journal of the Experimental Analysis of Behavior, 8,* 107-116.

LaVigna, G. W. (1976). *Communication training with autistic children using written words.* Paper presented at the Annual Meeting and Conference of the National Society for Autistic Children, Chicago, IL.

LaVigna, G. W. (1978). The behavioral treatment of autism. *Psychiatric Clinics of North America, 1,* 247-261.

LaVigna, G. W. (1980). Reducing behavior problems in the classroom. In B. Wilcox & A. Thompson (Eds.), *Critical issues in educating autistic children and youth* (pp 135–153). Washington, DC: U. S. Department of Education, Office of Special Education.

LaVigna, G. W., & Donnellan, A. (1976). *Alternatives to the use of punishment in the control of undesired behavior.* Paper presented at the 10th Annual Meeting of the Association for the Advancement of Behavior Therapy, New York.

LaVigna, G. W., & Donnellan-Walsh, A. (1976). *Alternatives to the use of punishment in the school setting.* Paper presented at the Eighth Annual Southern California Conference on Behavior Modification, Los Angeles, CA.

Lawson, R. (1965). *Frustration.* New York: MacMillan.

Leiberman, D. A. (1974). *Learning and the control of behavior.* New York: Holt, Rinehart & Winston.

Leitenberg, H., Burchard, J. D., Burchard, S. N., Fuller, E. J., & Lysaght, T. V. (1977). Using positive reinforcement to suppress behavior: Some experimental comparisons with sibling conflict. *Behavior Therapy, 8,* 168-182.

Leitenberg, H., Rawson, R., & Bath, K. (1970). Reinforcement of competing behavior during extinction. *Science, 169,* 301-303.

Liberman, R. P. (1972). Learning interpersonal skills in groups: Harnessing the behavioristic horse to the humanistic wagon. In P. S. Houts & M. Serber (Eds.), *After the turn on, what? Learning perspectives on humanistic groups.* Champaign, IL: Research Press.

Liberman, R. P. (1982). Assessment of social skills. *Schizophrenia Bulletin, 8,* 62-84.

Liberman, R. P., King, L. W., DeRisi, W. J., & McCann, M. (1976). *Personal effectiveness.* Champaign, IL: Research Press.

Liberman, R. P., Wallace, C. J., Falloon, I. R., & Vaughn, C. E. (1981) Interpersonal problem solving therapy for schizophrenics and their families. *Comprehensive Psychiatry, 22,* 627-630.

Lichstein, K. L., & Schreibman, L. (1976). Employing electric shock with

autistic children: A review of the side effects. *Journal of Autism and Childhood Schizophrenia, 6,* 163-173.

Logan, F. A. (1967). Variable DRL. *Psychonomic Science, 9,* 393-394.

Lovaas, O. I. (1982). Comments on self-destructive behaviors. *Analysis and Intervention in Developmental Disabilities, 2,* 115-124.

Lovaas, O.I., Freitag, G., Gold, V. J., & Kassorla, I. C. (1965). Experimental studies in childhood schizophrenia. I. Analysis of self-destructive behavior. *Journal of Experimental Child Psychology, 2,* 67-84.

Lovaas, O. I., Schaeffer, B., & Simmons, J. Q. (1965). Building social behavior in autistic children by use of electric shock. *Journal of Experimental Research in Personality, 1,* 99-109.

Lovaas, O. I., & Simmons, J. Q. (1969). Manipulation of self-destruction in three retarded children. *Journal of Applied Behavior Analysis, 2,* 143-157.

Lowitz, G. H., & Suib, M. R. (1978). Generalized control of persistent thumbsucking by differential reinforcement of other behaviors. *Behavior Therapy and Experimental Psychiatry, 9,* 343-346.

Luiselli, J. K. (1980). Relaxation training with the developmentally disabled: A reappraisal. *Behavior Research of Severe Developmental Disorders, 1,* 191-193.

Luiselli, J. K., Helfen, C. S., Colozzi, G., Donnellon, S., & Pemberton, B. (1978). Controlling the self-inflicted biting of a retarded child by the differential reinforcement of other behavior. *Psychological Reports, 42,* 435-438.

Luria, A. (1961). *The role of speech in the regulation of normal and abnormal behavior.* New York: Liveright.

MacMillan, D. L., Forness, S. R. & Trumbull, B. M. (1973). The role of punishment in the classroom. *Exceptional Children, 40*(2), 85-96.

Manno, B., & Marston, A. R. (1972). Weight reduction as a function of negative covert reinforcement (sensitization) versus positive covert reinforcement. *Behavior Research and Therapy, 10,* 201-207.

Mansdorf, I. J. (1976). Eliminating fear in a mentally retarded adult by behavioral hierarchies and operant techniques. *Journal of Behavior Therapy and Experimental Psychiatry, 7,* 189-190.

Marholin, II,D., & Luiselli, J. K. (1979). The question of cause and effect: A response to Steen and Zuriff. *Journal of Behavior Therapy and Experimental Psychiatry, 10,* 89-90.

Marholin, II, D., & Touchette, P. E. (1979). The role of stimulus control and response consequences. In A. P. Goldstein & F. H. Kanfer (Eds.), *Maximizing treatment gains: Transfer enhancement psychotherapy.* New York: Academic Press, Inc.

Martin, J. A. (1977). Effects of positive and negative adult-child interactions

on children's task performance and task preferences. *Journal of Experimental Child Psychology, 23,* 493–502.

Martin, G., & Pear, J. (1983). *Behavior modification: What it is and how to do it.* Englewood Cliffs, NJ: Prentice-Hall, Inc.

Martin, R. (1979). *Legal challenges in regulating behavior change.* Champaign IL: Research Press.

Martin, R. (1981) Legal issues in preserving client rights. In H. G. Christian & H. Clark (Eds.) *Preservation of client rights.* New York: Free Press.ˑ

Martin, R. R., & Siegel, G. M. (1966). The effects of response contingent shock on stuttering. *Journal of Speech and Hearing Research, 9,* 350–352.

Maslow, A. (1954). *Motivation and personality.* New York: Harper & Row.

Matson, J. L., & DiLorenzo, T. M. (1984). *Punishment and its alternatives.* New York: Springer Publishing Co.

Mayhew, G. L., & Harris, F. C. (1978). Some negative side effects of a punishment procedure for stereotyped behavior. *Journal of Behavior Therapy and Experimental Psychiatry, 9,* 245–251.

McFall, R. M., & Marston, A. R. (1970). An experimental investigation of behavior rehearsal in assertive training. *Journal of Abnormal Psychology, 76,* 295–303.

Meichenbaum, D. H., Bowers, K., & Ross, R. R. (1968). Modification of classroom behavior of institutionalized female adolescent offenders. *Behavior Research and Therapy, 6,* 343–353.

Menolascino, F. J., Wing, R., Casey, K., Pew, S., & McGee, J. (1983). *Report of the Encor ad hoc task force on serving mentally retarded citizens with allied mental illness.* University of Nebraska, Omaha.

Mesaros, R. A. (1982). *An analysis of prompt dependency in an autistic adolescent.* Unpublished manuscript, University of Wisconsin, Madison.

Mesaros, R. A. (1983). *A review of the issues and literature regarding positive programming and contingency management procedures for use with autistic children.* Unpublished manuscript, University of Wisconsin, Madison, WI.

Miller, L. (1978). Pragmatics and early childhood language disorders: Communicative interactions in a half-hour sample. *Journal of Speech and Hearing Disorders, 43,* 419–436.

Miller, N. E. (1969). Learning of visceral and glandular responses. *Science, 163,* 434–445.

Miller, P. M. (1972). The use of visual imagery and muscle relaxation in the counterconditioning of a phobic child: A case study. *Journal of Nervous and Mental Diseases, 154,* 457–460.

Moore, R., & Goldiamond, I. (1964). Errorless establishment of a visual discrimination using fading procedures. *Journal of the Experimental Analysis of Behavior, 7,* 269–272.

Morisano, E. R. (1981). A comparison of the effects of contact desensitization and symbolic modeling in the treatment of dog avoidant retarded persons. Doctoral dissertation, Syracuse University. *Dissertation Abstracts International, 42,* 2072B. (U. Microfilms No. 8123927)

Morris, R. J. (1973). Shaping relaxation in the unrelaxed client. *Journal of Behavior Therapy and Experimental Psychiatry, 4,* 353–354.

Mulhern, T., & Baumeister, A.A. (1969). An experimental attempt to reduce stereotypy by reinforcement procedures. *American Journal of Mental Deficiency, 74,* 69–74.

Mulick, J. A., Leitenberg, H., & Rawson, R. A. (1976). Alternative response training, differential reinforcement of other behavior, and extinction in squirrel monkeys (Saimiri Sciureus). *Journal of the Experimental Analysis of Behavior, 25,* 311–320.

Mulick, J. A., Schroeder, S. R., & Rojahn, J. (1980). Chronic ruminative vomiting: A comparison of four treatment procedures. *Journal of Autism and Developmental Disorders, 10*(2), 203–213.

Myers, D. V. (1975). Extinction, DRO, and response-cost procedures for eliminating self-injurious behavior: A case study. *Behaviour Research and Therapy, 13,* 189–191.

Navaco, R. W. (1975). Anger Control: *The development and evaluation of an experimental treatment.* Lexington, MA: Heath Publishing Co.

Nowlis, D. P., & Borzone, X. C. (1981). *Long-term psychosomatic effects of biofeedback vs. relaxation training.* Ontario, Canada: Department of National Health and Welfare.

Nutter, D., & Reid, D. H. (1978). Teaching retarded women a clothing selection skill using community norms. *Journal of Applied Behavior Analysis, 11,* 475–487.

Obler, M., & Terwillinger, R. F. (1970). Pilot study on the effectiveness of systematic desensitization with neurologically impaired children with phobic disorders. *Journal of Consulting and Clinical Psychology, 34,* 314–318.

O'Leary, K. D., O'Leary, S., & Becker, W. C.(1967). Modification of a deviant sibling interaction pattern in the home. *Behavior Research and Therapy, 5,* 113–120.

Ollendick, T. H. (1979). Behavioral treatment of anorexia nervosa: A five-year study. *Behavior Modification, 3,* 124–135.

Olley, J. G. (in press). Environmental structure for optimal learning

in autistic children. In D. Cohen & A. M. Donnellan (Eds.), *Handbook on autism*. New Jersey: John Wiley & Sons.

O'Neil, J. (1978). *Stimulus control of stereotypic responding in an autistic child*. Unpublished master's thesis, Southern Illinois University.

Pacitti, W. A., & Smith, N. F. (1977). A direct comparison of four methods for eliminating a response. *Learning and Motivation, 8,* 229–237.

Palotai, A., Mance, A., & Negri, N. A. (1982). *Averting and handling aggressive behavior*. South Carolina Department of Mental Health.

Patterson, G. R. (1965). An application of conditioning techniques to the control of a hyperactive child. In L. P. Ullman & L. Krasner (Eds.), *Case studies in behavior modification*. New York: Holt, Rinehart & Winston.

Patton, M. L. (1977). The use of biofeedback as a counseling tool to facilitate the assumption of responsibility for behavior in mentally retarded adults. Doctoral dissertation, North Texas State University. *Dissertation Abstracts International, 38,* 3455B–3456B. (U. Microfilms No. 77-29, 564)

Paul, G. L. (1969a). Physiological effects of relaxation training and hypnotic suggestions. *Journal of Abnormal Psychology, 74,* 425–437.

Paul, G. L. (1969b). Extraversion, emotionality, and physiological response to relaxation training and hypnotic suggestions. *International Journal of Clinical and Experimental Hypnosis, 17,* 89–98.

Paul, G. L. (1969c). Inhibition of physiological response to stressful imagery by relaxation training and hypnotically suggested relaxation. *Behavior Research and Therapy, 7,* 249–256.

Paul, G. L., & Trimble, R. W. (1970). Recorded vs. "live" relaxation training and hypnotic suggestion: Comparative effectiveness for reducing physiological arousal and inhibiting stress response. *Behavior Therapy, 1,* 285–302.

Pavlov, I. P. (1927). *Conditioned reflexes: An investigation of the physiological activity of the cerebral cortex*. Trans. G. V. Anrep. London: Oxford University Press.

Peck, C.L. (1977). Desensitization for the treatment of fear in the high level adult retardate. *Behaviour Research and Therapy, 15,* 137–148.

Pierce, G. E. (1971). *Effects of several fixed-ratio schedules of reinforcement and of extinction upon temporalis and masseter muscle contractions in humans*. Master's thesis, Western Michigan University.

Pendergrass, V. E. (1972). Time-out from positive reinforcement following persistent high-rate behavior in retardates. *Journal of Applied Behavior Analysis, 5,* 85–90.

Perlin, M. L., & Martin, R. (1980). *The impact of recent mental disability litigation*. Champaign, IL: Research Press.

Peterson, R. F., & Peterson, L. R. (1968). The use of positive reinforcement in the control of self-destructive behavior in a retarded boy. *Journal of Experimental Child Psychology, 6,* 351-360.

Pickering, J. W., & Topping, J. S. (1974). Comparison of six response-elimination techniques following VR reinforcement training in humans. *Bulletin of the Psychonomic Society, 3,* 264-266.

Poling, A., & Ryan, C. (1982). Differential reinforcement of other behavior schedules: Therapeutic applications. *Behavior Modification, 6*(1), 3-21.

Porterfield, J. K., Herbert-Jackson, E., & Risley, T. R. (1976). Contingent observation: An effective and acceptable procedure for reducing disruptive behavior of young children in a group setting. *Journal of Applied Behavior Analysis, 9,* 55-64.

Premack, D. (1959). Toward empirical behavior laws: I. Positive reinforcement. *Psychological Review, 66,* 219-233.

Premack, D. (1970). A functional analysis of language. *Journal of the Experimental Analysis of Behavior, 14,* 107-125.

Premack, D. (1971). Language in chimpanzees. *Science, 172,* 808-822.

Premack, D., & Premack, A. J. (1974). Teaching visual language to apes and language-deficient persons. In R. L. Schiefelbusch & L. Lloyd (Eds.), *Language perspectives-Acquisition, retardation, and intervention.* Baltimore: University Park Press.

Prizant, B. M. (1978). *An analysis of the functions of immediate echolalia in autistic children.* Unpublished doctoral dissertation, State University of New York, Buffalo.

Prizant, B. M., & Duchan, J. F. (1981). The functions of immediate echolalia in autistic children. *Journal of Speech and Hearing Disorders, 3,* 241-249.

Proni, T. J. (1973). *The effects of changes in response-independent pay upon human masseter EMG.* Master's thesis, Western Michigan University.

Prutting, C. A. (1982). Pragmatics as social competence. *Journal of Speech and Hearing Disorders, 47,* 123-134.

Pryor, K. (1977). Orchestra conductors would make good porpoise trainers. *Psychology Today,* 61-64.

Pumpian, I., Livi, J., Falvey, M., Loomis, R., & Brown, L. (1980). Strategies for generating curricular content to teach adolescent and young adult severely handicapped students domestic living skills. In L. Brown, M. Falvey, D. Baumgart, I. Pumpian, J. Schroeder, and L. Gruenewald (Eds.), *Strategies for teaching chronological age appropriate functional skills to adolescent and young adult severely handicapped students.* Madison, WI: University of Wisconsin-Madison and Madison Metropolitan School District.

Rachlin, H., & Baum, W. M. (1972). Effects of alternative reinforcement: Does the source matter? *Journal of the Experimental Analysis of Behavior, 18,* 231-241.

Rathus, S. A. (1973). A 30 item schedule for assessing assertive behavior. *Behavior Therapy, 4,* 398-406.

Repp, A. C., & Deitz, S. M. (1974). Reducing aggressive and self-injurious behavior of institutionalized retarded children through reinforcement of other behaviors. *Journal of Applied Behavior Analysis, 7,* 313-325.

Repp, A. C., Deitz, S. M., & Deitz, D.E.D. (1976). Reducing inappropriate behaviors in classrooms and in individual sessions through DRO schedules of reinforcement. *Mental Retardation, 14*(1), 11-15.

Repp, A. C., Deitz, S. M., & Speir, N. C. (1974). Reducing stereotypic responding of retarded persons by the differential reinforcement of other behavior. *American Journal of Mental Deficiency, 79*(3), 279-284.

Repp, A., & Slack, D. (1977). Reducing responding of retarded persons by DRO schedules following a history of low-rate responding. *Psychological Record, 3,* 581-588

Reynolds, G. S. (1961). Behavioral contrast. *Journal of the Experimental Analysis of Behavior, 4,* 57-71.

Rhodes, W. C. (1967). The disturbing child: A problem of ecological management. *Exceptional Children, 33,* 449-455.

Rincover, A. (1978). Sensory extinction: A procedure for eliminating self-stimulatory behavior in developmentally disabled children. *Journal of Abnormal Child Psychology, 6*(3), 299-310.

Rinvenq, B. (1974). Behavioral therapy of phobias: A case with gynecomastia and mental retardation. *Mental Retardation, 12,* 44-45.

Roberts, M. A., & Ottinger, D. R. (1979). A case study: Encopretic adolescent with multiple problems. *Journal of Clinical Child Psychology, 8,* 15-17.

Rogers-Warren, A., & Warren, S. F. (1977). *Ecological perspectives in behavior analysis.* Baltimore: University Park Press.

Rollings, J. P., & Baumeister, A.A. (1981). Stimulus control of stereotypic responding: Effects on target and collateral behavior. *American Journal of Mental Deficiency, 86*(1), 67-77.

Rose, S. D., Hanusa, D., Tolman, R. M., & Hall, J. A. (1982). *A group leader's guide to assertiveness training.* Interpersonal Skill Training and Research Project, University of Wisconsin, Madison.

Rosenthal, T. L., & Reese, S. L. (1976). The effects of covert and overt modeling on assertive behavior. *Behaviour Research and Therapy, 14,* 463-469.

Rotholz, D. A., & Luce, S. C. (no date). *The development of alternative reinforcement strategies for the reduction of self-stimulatory behavior in autistic youth.* Unpublished manuscript, May Institute, Chatham, MA.

Rotondi, J. M. (1978). The differential effectiveness of three methods of behavior therapy in reducing social fear in physically handicapped individuals. *Dissertation Abstracts International, 38,* 7238-7239A. (U. Microfilms No. 7808484)

Rowbury, T. G., Baer, A. M., & Baer, D. M. (1976). Interactions between teacher guidance and contingent access to play in developing preacademic skills of deviant preschool children. *Journal of Applied Behavior Analysis, 9,* 85-104.

Russo, D. C., Cataldo, M. F., & Cushing, P. J. (1981). Compliance training and behavioral covariation in the treatment of multiple behavior problems. *Journal of Applied Behavior Analysis, 14,* 209-222.

Russo, S. (1964). Adaptations in behavioral therapy with children. *Behavioral Research Therapy, 2,* 43-47.

Sailor, W., Guess, D., Rutherford, G., & Baer, D. M. (1968). Control of tantrum behavior by operant techniques during experimental verbal training. *Journal of Applied Behavior Analysis, 1,* 237-243.

Sailor, W., Wilcox, B., & Brown, L. (1980). *Methods of instruction for severely handicapped students.* Baltimore: Paul H. Brookes.

Sajwaj, T., Twardosz, S., & Burke, M. (1972). Side effects of extinction procedures in a remedial placement. *Journal of Applied Behavior Analysis, 5,* 163-175.

Schien, E. (1968). Organizational socialization and the profession of management. *Industrial Management Review,* 1-16.

Schreibman, L. (1975). Effects of within-stimulus and extra-stimulus prompting on discrimination learning in autistic children. *Jour of Applied Behavior Analysis, 8,* 91-112.

Schroeder, S. R., Mulick, J. A., & Rojahn, J. (1980). The de taxonomy, epidemiology, and ecology of self-injurious *Journal of Autism and Development Disorders, 10,*

Schroeder, S. R., Peterson, C. R., Solomon, L. J., (1977). EMG feedback and the contingent restrai behavior among the severely retarded: Tw *Behavior Therapy, 8,* 738-741.

Schuler, A. L., & Goetz, L. (1981). The assessme bilities: Communicative and cognitive *Intervention in Developmental Diso'*

Schultz, J. H., & Lathe, W. (1959). *Autor ic approach to psychotherapy.*

Schwartz, A., Goldiamond, I., & Howe, M. W. (1975). *Social casework: A behavioral approach.* New York: Columbia University Press.

Schwartz, G. E. (1977). Biofeedback and the self-management of deregulation disorders. In R. B. Stuart (Ed.), *Behavioral self-management.* New York: Brunner/Mazel.

Scott, D. S., & Rosenstiel, A. K. (1975). Covert positive reinforcement studies: Review, critique, and guidelines. *Psychotherapy: Theory, Research, and Practice, 12,* 374-384.

Scott, M. (1980). Ecological theory and methods for research in special education. *The Journal of Special Education, 4,* 3.

Segal-Rechtschaffen, E. F., & Holloway, S. M. (1963). Timing behavior in rats with water drinking as a mediator. *Science, 140,* 888-889.

Serber, M., & Nelson, P. (1971). The ineffectiveness of systematic desensitization and assertive training in hospitalized schizophrenics. *Journal of Behavior Therapy and Experimental Psychiatry, 2,* 107-109.

Shapiro, D., Crider, A. B., & Tursky, B. (1964). Differentiation of an autonomic response through operant reinforcement. *Psychonomic Science, 1,* 147-148.

Shaw, S. F., Bensky, J. M., & Dixon, B. (1981). *Stress and burnout.* Reston, VA: Council for Exceptional Children.

Shaw, W. J., & Walker, W. C. (1979). Use of relaxation in the short-term treatment of fetishistic behavior: An exploratory case study. *Journal of Pediatric Psychology, 4,* 403-407.

Sherman, J. A. (1965). Use of reinforcement and imitation to reinstate verbal behavior in mute psychotics. *Journal of Abnormal Psychology, 70*(3), 155-164.

Shorkey, C., & Himle, D. P. (1974). Systematic desensitization treatment of a recurring nightmare and related insomnia. *Journal of Behavior Therapy and Experimental Psychiatry, 5,* 97-98.

Sidman, M. (1960). *Tactics of scientific research.* New York: Basic Books.

Sidman, M., & Stoddard, L. (1967). The effectiveness of fading in programming a simultaneous form discrimination for retarded children. *Journal of the Experimental Analysis of Behavior, 10,* 3-15.

Siegel, J. M. (1975). Successful systematic desensitization in a chronic schizophrenic patient. *Journal of Behavior Therapy and Experimental Psychiatry, 6,* 345-346.

Skinner, B. F. (1938). *The behavior of organisms.* New York: Appleton-Century-Crofts.

Skinner, B. F. (1953). *Science and human behavior.* New York: MacMillan.

Skinner, B. F. (1957). *Verbal behavior.* New York: Appleton-Century-Crofts.

Skinner, B. F. (1968). *The technology of teaching.* Englewood Cliffs, NJ: Prentice Hall.

Slade, P. D. (1972). The effects of systematic desensitization on auditory hallucinations. *Behaviour Research and Therapy, 10,* 85-91.

Small, M. M., Giganti, M., & Steinberg, D. (1978). A comparison of thermal biofeedback and relaxation training with a behavioral management treatment program: A controlled single-subject experiment. *American Journal of Clinical Biofeedback, 1,* 68-70.

Smith, R. L. (1982). An evaluation of the effectiveness of graduated phase modeling in improving communication skills and self-perceived relationship quality among dating couples. *Dissertation Abstracts International, 42(8-B),* 3404.

Spradlin, J., Cotter, V., & Braxley, N. (1973). Establishing a conditional discrimination without direct training: A study of transfer with retarded adolescents. *American Journal of Mental Deficiency, 77,* 556-566.

Stednitz, L. L. (1982). The effects of a systematic skills training model on communication skills of hospitalized adolescent psychiatric patients. *Dissertation Abstracts International, 42(9-B),* 3811.

Steen, P. L., & Zuriff, G. E. (1977). The use of relaxation in the treatment of self-injurious behavior. *Journal of Behavior Therapy and Experimental Psychiatry, 8,* 447-448.

Sterman, M. B. (1977). Clinical implications of EEG biofeedback training: A critical appraisal. In G. E. Schwartz & J. Beatty (Eds.), *Biofeedback: Theory and research.* New York: Academic Press.

Stocker, C. S. (1979). Biofeedback training in the rehabilitation process. *Journal of Visual Impairment and Blindness, 73,* 277-281.

Stoyva, J., & Budzynski, T. (1974). Cultivated low arousal— an antistress response? In L. V. DiCara (Ed.), *Limbric and autonomic nervous system research.* New York: Plenum.

Strain, P. S. (1983). Generalization of children's social behavior change: Effects of developmentally integrated and segregated settings. *Analysis and Intevention in Developmental Disabilities, 3,* 23-34.

Strain, P. S., Shores, R. E., & Kerr, M. M. (1976). An experimental analysis of "spillover" effects on the social interaction of behaviorally handicapped preschool children. *Journal of Applied Behavior Analysis, 9,* 31-40.

Straughn, J., & Defort, W. H. (1969). Task difficulty, relaxation, and anxiety level during verbal learning and recall. *Journal of Abnormal Psychology, 74,* 621-624.

Striefel, S., Bryan, K., & Aikens, D. (1974). Transfer of stimulus control from motor to verbal stimuli. *Journal of Applied Behavior Analysis, 7,* 123-135.

Striefel, S., & Wetherby, B. (1973). Instruction following behavior of retarded children. *Journal of Applied Behavior Analysis, 6,* 663-670.

Striefel, S., Wetherby, B., & Karlan, G. R. (1976). Establishing generalized verb-noun instruction-following skills in retarded children. *Journal of Experimental Child Psychology, 22,* 247-260.

Strider, F. D., & Strider, M. A. (1979). Current applications of biofeedback technology to the problems of children and youth. *Behavioral Disorders, 5,* 53-59.

Sulzer-Azaroff, B., & Mayer, G. R. (1977). *Behavior modification procedures for school personnel.* Hinsdale, IL: The Dryden Press, Inc.

Tarpley, H. D., & Schroeder, S. R. (1979). Comparison of DRO and DRI on rate of suppression of self-injurious behavior. *American Journal of Mental Deficiency, 84*(2), 188-194.

Tasto, D. L. (1969). Systematic desensitization, muscle relaxation and visual imagery in the counterconditioning of a four-year old phobic child. *Behaviour Research and Therapy, 7,* 409-411.

Terrace, H. (1963a). Discrimination learning with and without "errors". *Journal of the Experimental Analysis of Behavior, 6,* 1-27.

Terrace, H. (1963b). Errorless transfer of a discrimination across two continua. *Journal of the Experimental Analysis of Behavior, 6,* 223-232.

Thomas, D. R., Becker, W. C., & Armstrong, M. (1968). Production and elimination of disruptive classroom behavior by systematically varying teacher's behavior. *Journal of Applied Behavior Analysis, 1,* 35-45.

Topping, J. S., Graves, A. J., & Moss, J. D. (1975). Response elimination in elementary and special education school children. *Psychological Record, 25,* 567-572.

Touchette, P. E. (1968). The effects of graduated stimulus change on the acquisition of a simple discrimination in severely retarded boys. *Journal of the Experimental Analysis of Behavior, 11*(1), 39-48.

Touchette, P. E. (1978). Mental retardation: An introduction to the analysis and remediation of behavioral deficiency. In D. Marholin II (Ed.), *Child behavior therapy.* New York: Gardner Press.

Touchette, P. E. (1983). *Nonaversive amelioration of SIB by stimulus control transfer.* Paper presented at the Annual Convention of the American Psychological Association, Anaheim, CA.

Turkington, C. (1983). Self-mutilation: Understand why, alter environment. *APA Monitor, 14*(8), 18.

Tyre, T. E. (1973). The use of systematic desensitization in the treatment of chronic stuttering behavior. *Journal of Speech and Hearing Disorders, 38,* 514-519.

Uhl, C. N., & Garcia, E. E. (1969). Comparison of omission with extinction in response elimination in rats. *Journal of Comparative and Physiological Psychology, 69*(3), 554-562.

Uhl, C. N., & Sherman, W. O. (1971). Comparison of combinations of omission, punishment, and extinction methods in response elimination in rats. *Journal of Comparative and Physiological Psychology, 74,* 59-65.

Upper, D., & Cautela, J. R. (1979). *Covert conditioning.* Elmsford, NY: Pergamon Press.

Vincent, L. J., Laten, S., Salisbury, C., Brown, P., & Baumgart, D. (1981). Family involvement in the educational processes of severely handicapped students: State of the art and directions for the future. In B. Wilcox & R. York (Eds.), *Quality educational services for the severely handicapped: The federal perspective.* Washington, DC: U. S. Department of Education, Division of Innovation and Development.

Vockell, E. (1977). *Whatever happened to punishment?* Muncie, IN: Accelerated Development, Inc.

Volkmar, F. R., & Cohen, D. J. (1982). A hierarchical analysis of patterns of non-compliance in autistic and behavior disturbed children. *Journal of Autism and Developmental Disorders, 12,* 1.

Wahler, R. G. (1975). Some structural aspects of deviant child behavior. *Journal of Applied Behavior Analysis, 8,* 27-42.

Wallace, C. J., Teigen, J. R., Liberman, R. P., & Baker, V. (1973). Destructive behavior treated by contingency contracts and assertive training: A case study. *Journal of Behavior Therapy and Experimental Psychology, 4,* 273-274.

Watson, J. B. (1913). Psychology as the behaviorist views it. *Psychological Review, 20,* 158-177.

Watson, J. B., & Rayner, R. (1920). Conditioned emotional reactions. *Journal of Experimental Psychology, 3,* 1-14.

Webster, C. D. (1977). A negative reaction to the use of electric shock with autistic children. *Journal of Autism and Childhood Schizophrenia, 7*(2), 199-202.

Webster, L. M. (1970). A clinical report on the measured effectiveness of certain desensitization techniques with stutterers. *Journal of Speech and Hearing Disorders, 35,* 369-376.

Weeks, M., & Gaylord-Ross, R. (1981). Task difficulty and aberrant behavior in severely handicapped students. *Journal of Applied Behavior Analysis, 14,* 449-463.

Weidner, F. (1970). In vivo desensitization of a paranoid schizophrenic. *Journal of Behavior Therapy and Experimental Psychiatry, 1,* 79-81.

Weiher, R. G., & Harman, R. E. (1975). The use of omission training to reduce self-injurious behavior in a retarded child. *Behavior Therapy, 6,* 261-268.

Weil, G., & Goldfried, M. R. (1973). Treatment of insomnia in an eleven-year-old child through self-relaxation. *Behavior Therapy, 4,* 282–284.

Weiner, H. (1964). Conditioning history and human fixed-interval performance. *Journal of the Experimental Analysis of Behavior, 7,* 383–385.

Weiner, H. (1969). Controlling human fixed-interval performance. *Journal of the Experimental Analysis of Behavior, 12,* 349–373.

Weinman, B., Gilbert, P., Wallace, M., & Post, M. (1972). Introducing assertive behavior in chronic schizophrenics: A comparison of socioenvironmental desensitization and relaxation therapies. *Journal of Consulting and Clinical Psychology, 39,* 246–252.

Wells, K. C., Turner, S. M., Bellack, A. S., & Hersen, M. (1978). Effects of cue-controlled relaxation on psychomotor seizures: An experimental analysis. *Behaviour Research and Therapy, 16,* 51–53.

Whitman, T., Zakarso, M., & Chardos, S. (1971). Effects of reinforcement and guidance procedures on instruction following behavior of retarded children. *Journal of Applied Behavior Analysis, 4,* 283–290.

Williams, C. D. (1959). The elimination of tantrum behavior by extinction procedures. *Journal of Abnormal Social Psychology, 59,* 269.

Wilson, B., & Jackson, H. J. (1980). An in vivo approach to the desensitization of a retarded child's toilet phobia. *Australian Journal of Developmental Disorders, 6,* 137–140.

Wilson, M. P., & Keller, F. S. (1953). On the selective reinforcement of spaced responding. *Journal of Comparative and Physiological Psychology, 46,* 190–193.

Wincze, J. P., & Caird, W. K. (1976). The effects of systematic desensitization and video desensitization in the treatment of essential sexual dysfunction in women. *Behavior Therapy, 7,* 335–342.

Winett, R. A., & Winkler, R. C. (1972). Current behavior modification in the classroom: Be still, be quiet, be docile. *Journal of Applied Behavior Analysis, 5*(4), 499–504.

Wolf, M. M. (1978). Social validity: The case for subjective measurement or how applied behavior analysis is finding its heart. *Journal of Applied Behavior Analysis, 11*(2), 203–214.

Wolf, M. M., Risley, T. R. & Mees, H. L. (1964) Application of operant conditioning procedure to the behavior problems of an autistic child. *Behaviour Research and Therapy.* (1) 305–312.

Wolfensberger, W. (1972). *The principle of normalization in human services.* National Institute on Mental Retardation. Toronto, Canada.

Wolfesnberger, W. (1975). *The origin and nature of our institutional models.* Syracuse, NY: Human Policy Press.

Wolpe, J. (1958). *Psychotherapy by reciprocal inhibition.* Stanford, CA: Stanford University Press.

Wolpe, J. (1973). *The practice of behavior therapy* (2nd ed.). Elmsford, NY: Pergamon Press.

Woods, T. S. (1980). Bringing autistic self-stimulatory behavior under S-Delta stimulus control. *B. C. Journal of Special Education, 4,* 61–70.

Woods, T. S. (1983). DRO and DRI: A false dichotomy? *The Psychological Record, 33,* 59–66.

Workman, E. A., & Dickinson, D. J. (1979a). The use of covert conditioning with children: Three empirical case studies. *Education and Treatment of Children, 2,* 245–259.

Workman, E. A., & Dickinson, D. J. (1979b). The use of covert positive reinforcement in the treatment of a hyperactive child: An empirical case study. *Journal of School Psychology, 17,* 67–73.

Workman, E. A., & Williams, R. L. (1980). Self-cued relaxation in the control of an adolescent's violent arguments and debilitating somatic complaints. *Education and Treatment of Children, 3,* 315–322.

Yamauchi, K. T. (1981). Dental fear in a chronic schizophrenic: A case report. *American Journal of Clinical Hypnosis, 24,* 128–131.

Yoder, D. (1980). Augmentative communication systems for severely speech handicapped children. In D. Bucher (Ed.), *Language development and intervention with the exceptional child.* New York: Jossey Bass & Company.

Young, J. A., & Wincze, J. P. (1974). The effects of the reinforcement of compatible and incompatible alternative behaviors on the self-injurious and related behaviors of a profoundly retarded female adult. *Behavior Therapy, 5,* 614–623.

Zeilberger, J., Sampen, S. E., & Sloane, Jr., H. N. (1968). Modification of a child's problem behavior in the home with the mother as therapist. *Journal of Applied Behavior Analysis, 1*(1), 47–53.

Zeiler, M. D. (1971). Eliminating behavior with reinforcement. *Journal of the Experimental Analysis of Behavior, 16,* 401–405.

Zeiler, M. D. (1976). Positive reinforcement and the elimination of reinforced responses. *Journal of the Experimental Analysis of Behavior, 26,* 37–44.

Zimmerman, E. H., & Zimmerman, J. (1962). The alteration of behavior in a special classroom situation. *Journal of the Experimental Analysis of Behavior, 5*(1), 59–60.

Zivolich, S., & Thvedt, J. (1983). *Assault crisis training: Prevention and intervention.* Special Education Consulting Service, Huntington Beach, CA.

Zlutnick, S., Mayville, W., & Moffat, S. (1975). Modification of seizure disorders: The interruption of behavioral chains. *Journal of Applied Behavior Analysis, 8,* 1–12.

Zodrow, R. J. (1982). The development and evaluation of a training program in interpersonal communication and problem-solving skills for premarital couples. *Dissertation Abstracts International, 92*(7–A) 3023.

Appendix A

Sample Format for a Behavioral Assessment Report and Intervention Plan*

Client Confidential

Date of Report:
Referral Date:
Period of Service:

Identifying Information
Name:
Date of Birth:
ID #:
Address:
Person(s) living with:
Relationship:
Program Settings:
Referral Source:

Reason(s) for Referral
A. This should be a brief statement identifying the source of the referral and the specific behaviors precipitating it. Note should also be made of any special considerations regarding the motivation of the key social agents and how these relate to the referral problems. Additionally, any negative consequences threatened as a result of the behavior; e.g., physical damage to the learner and/or others, placement in a more restrictive setting, etc. should be noted.
B. This should be a brief statement of the key social agent's reasons for requesting services. If the referral was made by an agency separate from the key social agent, some determination should be made concerning the coincidence between them as to the reasons for the referral.

Data Source
 This section should identify and list the methods used in conducting the assessment. This could include direct observation, interviews, questionnaires, evaluation reports prepared by other professionals, previous program data, etc.

Description of Services
 This section should list the settings in which the assessment was carried out. Times and dates should be indicated. Also included should be telephone conferences, program development and report writing time.

Background Information
A. *Brief learner description:* This should be a brief narrative description of client-identifying information such as age, sex, diagnosis, ability to comprehend and produce language, and any relevant results of formal or informal testing that may have been reported by other professionals.

B. *Living arrangement:* This should be a brief description of the learner's current living arrangement indicating who she lives with, by name and relationship, the type of residence and the name, age and contact of any (other) family members who may have regular contact with the learner.

C. *Program placement:* This should be a brief description of the learner's present program placement(s) including location, name, type of program, evaluation of program, staff contact person, address, and phone number.

D. *Health and medical status:* This section should decribe the general health of the learner, recent illnesses, operations, seizure activity, type of seizure, blank or staring spells, etc. It should also indicate frequency of seizures, most recent seizures, treatment for seizures, what medication or drugs the learner is presently taking and for what purpose.

E. *Previous or current treatment:* This section should describe any previous attempts to treat the current problems and the outcome of those efforts. This should include, for example, information concerning where, whom, and for what reason there were any in-patient referrals, and a brief description of previous behavioral intervention programs.

Functional Analysis of Presenting Problem(s)
A. *Description of Referral Problems:*
 1. Each behavior should be operationally defined.
 2. Each behavior should be classified as an excess or deficit.
 3. The frequency, intensity, duration, and/or percent occurrence of each behavior should be reported.

B. *History of the Problem:*

1. The onset and duration of the current problems should be indicated.

2. Any recent increases or decreases in the behavior should be indicated.

3. Indications and/or speculations should be reported regarding any events that may have contributed to an exacerbation of the problem(s).

C. *Ecological Analysis:*

This section should describe the system that surrounds the target behavior, including the physical characteristics of the environment, the behavioral attributes of roles and social rules, object props, the system of interpersonal behavior, and general contingency rules.

Factors to consider when conducting an ecological analysis should include:

1. The learner's expectations about the environment.

2. The expectations of others in the environment concerning the learner.

3. The nature of the materials and physical objects available to the learner.

4. The reinforcement and preference value of the materials/objects available.

5. The nature of the activities in which the learner is engaged in terms of difficulty, interest level, etc.

6. The number of people present in the learner's environment.

7. The behavior of other people in the learner's environment.

8. Environmental pollutants such as noise, crowding, etc.

9. Sudden changes in the learner's life, environment or reinforcement schedule.

10. Individual abilities such as general skills, communication skills, and adaptive ability.

11. The level of program difficulty.

12. The efficiency of reinforcers in effect.

13. The variety of materials/activities available.

14. The variety of grouping arrangement used.

15. The opportunities for interaction with others.

D. *Antecedent Events:*

1. Specific antecedents which typically precede the problem behaviors should be described.

2. This should include consideration of specific activities, time of day, location, people, task and other (e.g., social) demands, etc.

E. *Consequent Events:*

1. The reactions of others to the behavior should be described.

2. Past methods used to manage the problem, and the results of those efforts, should be described.

3. Events that may act to maintain or reinforce the current problems should be described.

F. *Pragmatic Analysis (See tool for analyzing communicative function, Chapter III):*

1. Hypotheses concerning what function and/or communicative role the behavior may be serving for the learner should be indicated in this section.

2. The above hypotheses should suggest some general strategies for intervention which should be described in this section of the report.

Reinforcement Survey

This section should identify and prioritize potential positive reinforcers for the learner. Included should be predictably occurring behaviors, likes and dislikes, and verbal requests.

Mediators

This section should describe the parents, teachers and other key social agents who will act or who may act as mediators of the programs. Their strengths and weaknesses should be described as well as the potential effects of these on the course of intervention. A realistic estimate should be made of the mediators' ability to carry out programs given the demands on time, energy, emotions, and the constraints imposed by the specific program settings.

Recommended Intervention Programs

A. *Long-range goals:* This section should describe the long-range goals for intervention and positive programming.

B. *Short-term behavioral objectives:* This section should indicate time limited measurable objectives for each of the referral problems and targets of the intervention and positive program. Specifically, in regard to the referral problems, this should indicate in quantitative terms the changes that are being targeted in comparison to baseline levels and when those targets are expected to be reached.

C. *Data collection:*

1. The procedures and forms to be used for data collection should be described.

2. The methods used to ensure the reliability of observations should be described.

D. *Procedures:*
1. *Positive programming:*

 a. General: The general program to provide the context for intervention should be described. This should include a schedule of instructional or training activities in which the learner will acquire increased competency in a broad range of functional domestic, vocational, recreational and general community setting skills.

 b. *Specific:* Programming to teach more socially acceptable skills to provide the same function of the problem behavior should be described.

 2. *Additional interventions:* Other intervention procedures to be included in the intervention package should be described, including the specific contingency rules for reinforcement, the types of reinforcement to be used, the persons responsible for intervention, and so on.

 3. *Staff development:* This section should describe any possible staff training that would facilitate the delivery of the program described above.

Comments and Recommendations

A. Any difficulties that may be anticipated in the proposed intervention should be described.

B. Additional resources or services that may be available and helpful to the key social agents in carrying out the program should be specified.

C. Strategies for evaluating treatment outcome should be described.

Signature of person doing the assessment.
Title:
Affiliation:

* This format has benefited from the suggestions of many people. We would like to thank in particular Sylvia Young, Ph.D., Kathy Reuter, Ph.D., and the other behavioral psychologists associated with the Regional Center System in Southern California as well as Al Kubat, Ph.D., and especially Tom Willis, M.A..

Appendix B

Reinforcement Inventory

Individual's Name_____ Date_____
Date of Birth_____

The items in this questionnaire refer to things and experiences that may give a
person joy, satisfaction, or pleasurable feelings. Check each item in the column
that describes how much the client enjoys the things described.

	NOT AT ALL	A LITTLE	A FAIR AMOUNT	MUCH	VERY MUCH
FOOD:					
1. Candy What kind?_____					
a. _____					
b. _____					
c. _____					
2. Ice Cream What kind?_____					
a _____					
b _____					
3. Nuts					
4. Potato Chips					
5. Cake					
6. Cookies					
7. Beverages What kind?_____					
a. _____					
b. _____					
8. Other Foods					
a. _____					
b. _____					
TOYS:					
1. Racing Cars					
2. Electric Trains					
3. Bicycle					
4. Dolls					

Reinforcement Inventory...page 2

	NOT AT ALL	A LITTLE	A FAIR AMOUNT	MUCH	VERY MUCH
5. Other Toys					
a.					
b.					
c.					
6. Games					
Legos					
Uno					
Cards					
Other Games					
a.					
b.					
ENTERTAINMENT:					
1. Watching Television					
Favorite Programs?					
a.					
b.					
2. Movies					
3. Listening to Music					
Favorite Programs?					
a.					
b.					
4. Plays with Toys					
5. Plays with Others					
6. Other Entertainment Activities					
a.					
b.					
c.					
SPORTS AND GAMES:					
1. Playing football with other kids					
2. Playing football with parents					
3. Swimming					
4. Bike Riding					
5. Skating					

Reinforcement Inventory...page 3

	NOT AT ALL	A LITTLE	A FAIR AMOUNT	MUCH	VERY MUCH
6. Skiing					
7. Horseback Riding					
8. Tennis					
9. Hiking					
10. Chess					
11. Checkers					
12. Fishing					
13. Baseball					
14. Ping Pong					
15. Pool					
16. Other					
a.					
b.					
c.					
MUSIC, ARTS, AND CRAFTS:					
1. Playing a musical instrument (which?)					
2 Singing					
3. Dancing					
4. Drawing					
5. Building Models					
6. Painting					
7. Working with Tools					
8. Working with Clay					
9. Other					
a.					
b.					
EXCURSIONS:					
1. Ride in car					
2. Going to work with father or mother					
3. Visiting grandparents or relatives					

Reinforcement Inventory...page 4

	NOT AT ALL	A LITTLE	A FAIR AMOUNT	MUCH	VERY MUCH
4. Visit beach					
5. Family picnic					
6. Vacation with family					
7. Airplane ride					
8. Going out to dinner					
9. Visiting a friend					
10. Visiting a city					
11. Visiting a museum					
12. Going to the store					
13. Going for a walk					
14. Other					
a.					
b.					
SOCIAL:					
1. Playing with others					
2 Being praised					
a. by father					
b. by mother					
c. by teacher					
d. by friends					
3. Being hugged and kissed					
4. Being touched					
5. Girl scouts, boy scouts, other clubs					
6. Going to friends					
7. Having friends sleep over					
8. Sleeping at a friend's house					
9. Talking with others					
10. Other					
a.					
b.					
c.					
d.					

Reinforcement Inventory...page 5

	NOT AT ALL	A LITTLE	A FAIR AMOUNT	MUCH	VERY MUCH
LEARNING AND SCHOOL WORK:					
1. Learning a new language					
2. Taking piano lessons					
3. Reading					
4. Being read to					
5. Looking at books					
6. Spelling					
7. Science					
8. Social Studies					
9. Physical Education					
10. Math					
11. Going to school					
12. Riding bus to school					
13. Doing homework					
14. Helping teacher					
15. Other					
a.					
b.					
c.					
d.					
HELPING AROUND THE HOUSE:					
1. Setting the table					
2. Making the bed					
3. Baking					
4. Repairing or building					
5. Working in the yard					
6. Going on errands					
7. Other					
a.					
b.					
c.					
d.					

Reinforcement Inventory...page 6

	NOT AT ALL	A LITTLE	A FAIR AMOUNT	MUCH	VERY MUCH
PERSONAL APPEARANCE:					
1. Getting new clothes					
2. Putting on makeup					
3. Dressing up in costume					
4. Dressing up in parents' clothes					
5. Getting a haircut					
6. Going to beauty parlor					
7. Other					
a.					
b.					
OTHER EVENTS & ACTIVITIES:					
1. Staying up past bedtime					
2. Earning money					
3. Having free time					
4. Having a pet					
5. Having or going to a party					
6. Getting an allowance					
7. Taking a bath					
8. Sleeping with parents					
9. Other					
a.					
b.					
c.					
d.					

Reinforcement Inventory...page 7

A. How much time does client spend in the following activities? (hours, minute

1. Watching TV_____
2. Listening to music_____
3. Playing with others_____
4. Playing with toys_____

B. What is client's bedtime?_____

C. List below those events that the client does or requests more than:

5 times a day? 10 times a day?

_____ _____
_____ _____
_____ _____
_____ _____
_____ _____

15 times a day? 20 times a day?

_____ _____
_____ _____
_____ _____
_____ _____
_____ _____

Appendix C

A Summary of Non-Aversive Intervention Strategies for Solving Behavior Problems

General Suggestions for Implementation

1. Carry out functional analysis., 18-28; 24; 29; 34; 35; 37; 39; 184; 215-218; Table 3.2
2. Design positive program., 29-40; 47-48; 173; 184-185; 218-219
3. Plan what to do if behavior problem occurs:
 a) extinction., 50
 b) innocuous consequences (including redirection)., 50; 80-81; 85-87
 c) emergency interventions., 2; 8; 131-132; 137
4. Plan evaluation strategy., 4-7; 49; 50-51; 133-136
5. Design effective schedules of reinforcement; ensure that reinforcement magnitude under maximum possible "earnings" is less than the person would seek given free access (unless stimulus satiation is being used)., 46; 52-53; 55-56; 69-70; 72-73; 87-88; 89-90; 169-170
6. Plan strategy for phasing out the specific interventions:
 a) thinning of reinforcement schedules., 47; 55-56; 70
 b) switching to other procedures., 56; 88; 175-176
 c) planning for permanent control by the natural contingencies to the greatest extent possible., 46; 49; 52
 d) striving for long-term, permanent effects through positive programming efforts., 29-40
7. Plan strategies to attract as little negative attention as possible in the community., 6; 13; 48; 104

Positive Programming

1. *Variations:*
 — based on environmental analysis., 30-32; 184-186
 — based on antecedent/consequent analysis., 21-22
 — Based on pragmatic analysis, 30; 22-26
 a) teaching alternative communication., 30-31; 25
 b) attributing meaning., 30-31
2. *Advantages:*
 — positive and constructive., 32; 173; 184-185
 — long-term effects., 33-34; 7

The Differential Reinforcement of Alternative Behaviors (Alt-R)

4. *Suggestions for Implementation:*
 —select alternative responses to be reinforced which are:, 52
 a) dissimilar., 52
 b) incompatible., 52
 c) presently occurring if possible., 52
 d) meet (or in combination, approximate) the 100% rule., 43-46; 53-54; 68; Table 5.1
 e) likely to be reinforced by contingencies in natural environments., 52-53
 —consider the use of a token system to mediate reinforcement delivery, particularly if a number of alternative responses have been specified., 53-55; 66; 129-130
 —operationally define the schedules of reinforcement., 55-56
 —use in combination with positive programming and other intervention procedures., 56; 29-41; 70-71; 185-186

The Differential Reinforcement of Other Behavior (DRO)

1. *Variations:*
 —reset vs. a priori intervals., 58-60; Table 6.1
 —fixed vs. variable intervals., 59
 —escalating vs. non-escalating intervals., 59-60; 69
 —differential reinforcement of other behavior-progressive (DROP) schedule.,65-66
2. *Advantages:*
 —lack of behavioral contrast., 62-63
 —no known negative side effects., 63
 —good generalization., 63
 —potentially rapid effects., 64
 —social validity., 64
3. *Cautions:*
 —non-specificity of reinforced response., 64-65
 —inadvertent reinforcement., 65
 —reinforcement delivery as a discriminative stimulus., 65-66; 69; 19; 20; 26-27; 92-93
 —non-constructive., 64; 70-71; 14; 29-40
4. *Suggestions for Implementation:*
 —select priority problems as target behavior or group two

or more responses into single response class, 66-67
—select DRO interval (we recommend a DRO interval of 50%, some prefer to start with a smaller interval)., 68-69
—select DRO variation (we prefer a fixed DRO schedule or a fixed DROP schedule, others prefer an escalating schedule)., 68-69
—use a limited hold function to avoid the inadvertent reinforcement of a non-targeted, undesirable response., 67
—the non-constructive nature of this procedure requires that it be used in combination with positive programming and other constructive strategies., 65; 70-71; 29-41
—once control is established, attempt to phase out the DRO schedule by moving to an escalating variable interval schedule., 70; 186

The Differential Reinforcement of Low Rates of Responding (DRL)

1. *Variations:*
 —reinforcement of long IRTs., 74-75
 —reinforcement of low response rates., 76-78
2. *Advantages:*
 —particularly suitable for high rate behavior., 79; 88
 —flexibility of interval size., 79-80
 —non-interfering reinforcement delivery., 80
 —lends itself to a self-monitoring, tangible feedback system., 80-81
 —may result in rapid effects., 81
 —potential for group contingencies., 82
 —useful for reducing rate of behavior which does not have to be eliminated., 82
 —reported ease of implementation., 83
3. *Cautions:*
 —non-constructive., 83-84; 14; 29-40; 70-71
 —may develop non-functional mediating behavior., 84
 —social validity., 84-85
 —feedback systems may be aversive., 85
4. *Suggestions for Implementation:*
 —consider a tangible monitoring system to help concretize the intervention, especially for a learner who has more limited cognitive ability., 85

−if a tangible monitoring system is used, attempt to avoid building in aversive properties:, 85-86

 a) use a matter-of-fact tone of voice., 86-87

 b) learner, not practitioner, should control the monitoring media., 87

 c) avoid response cost paradigm., 87

 d) avoid response interruption., 87

 e) if learner responds to monitoring system as if it were aversive, discontinue., 87

−establish DRL criteria such that reinforcement criteria can be met 50ˆ of the time under baseline rates (consider different criteria for different environments)., 79-80; 87-88

−establish interval size to coincide with natural flow of events., 88

−as behavior improves, change criterion for reinforcement until behavior is at acceptable level or until a DRO or other strategy can eliminate the response., 88

−DRL is a non-constructive strategy. Use in combination with positive programming and other procedures., 88; 29-41; 70-71; 185

Stimulus Control

1. *Variations:*
 −stimulus control over target behavior., 92-93; 94-101
 −inhibitory stimulus control., 93-95
2. *Advantages:*
 −positive approach (sanctions learner and target behavior)., 101-102; 29-40
 −control without elimination., 102; 82
 −provides conditioned reinforcers., 102-103
 −may facilitate generalization., 103; 118; 122
 −can avoid inadvertent reinforcement of target behavior., 103
 −can be unobtrusive., 104
3. *Cautions:*
 −may be contraindicated for dangerous behavior problems., 104-105
 −limited research findings., 105
4. *Suggestions for Implementation:*
 −for dangerous behaviors, do not attempt to establish stimulus control:, 105

a) through a functional analysis, attempt to identify those stimuli which are already discriminative for the target behavior., 19-20; 21-22; 185-186

b) try to reduce the target behavior by limiting the learner's exposure to the identified discriminative stimuli., 106; 185-186

c) use a combination with positive programming and other procedures., 29-40

d) desensitization may provide a strategy for gradually re-introducing the stimuli which were previously discriminative for target behavior., 151-156

— for non-dangerous behaviors and behaviors that do not need to be eliminated but which need to occur under more limited conditions:

a) attempt to establish stimulus control by arranging for the reinforcement of the target behavior under specified stimulus (S^D) conditions., 92-101

b) select an S^D which is portable, unobtrusive, and to which you can control access., 104

c) if you are effective in establishing stimulus control, consider using the S^D as a conditioned reinforcer for your other intervention programs., 102-103

— once behavior is under stimulus control, use that control to determine when and where (if at all) the behavior will occur., 92-101; 102; 185-186

Instructional Control

1. *Variations:*
 — limited vs. generalized instructional control., 108-114; 122
 — spoken vs. written or other "verbal" stimulus., 108; 126

2. *Advantages:*
 — positive and constructive., 115
 — efficient (behavioral covariation)., 115-116
 — social validity., 116; 34
 — potentially rapid effects., 116-117

3. *Cautions:*
 — limited research findings., 117
 — physical prompting can be forced and therefore aversive., 117-118
 — generalization must be planned for., 118

4. *Suggestions for Implementation:*
 — assess learner:, 119-120; 21; Table 3.1

a) determine time needed to process request., 119

b) select responses that learner is capable of performing., 119; 122-123; 185

c) know what requests learner is presently compliant and non-compliant with., 120

— use differential reinforcement to strengthen compliance., 109-110; 123

— if necessary use prompts:, 110; 120

a) do not use correction procedures., 120-121

b) do not force responding., 118; 120; 126

— use a format such as discrete trial, being particularly careful of the placement and timing of the prompt., 110; 120

— generalize compliance across settings, people, etc., 118; 122

— select behaviors which are "enforceable" and which are incompatible with the target behavior., 122-123

— in making a request of the learner, use an instructional style conveying confidence and a firm but calm expectation of compliance. Pay attention to tone of voice, body language, and other non-verbal variables as well., 123

— use the written word or other concrete signal system wherever this will result in greater compliance., 123-124

— consider using contingency contracting, where appropriate, as an adjunct to all the other interventions described in this book., 123

— use natural settings and instructions as opposed to artificial settings and contrived instructions., 124-125

Stimulus Change

1. *Variations:*
 — naturally occuring., 127-131
 — contrived., 127-131
2. *Advantages:*
 — immediate effects., 131
 — useful for crisis intervention., 131-132
 — can increase speed of effects of other strategies., 132
3. *Cautions:*
 — temporary effects only, when used in isolation., 132
 — adaptation., 132-133
 — evaluation is difficult., 133
4. *Suggestions for Implementation:*
 — stimulus change can only be used to produce a temporary

reduction in response rate., 136

—take advantage of honeymoon effect to get other intervention procedures off to a positive start., 136

—consider using a contrived stimulus change strategy using dramatic stimulus., 137; 185

—use stimulus change as a strategy to buy time for more comprehensive assessment and intervention planning., 137

—use stimulus change as a crisis intervention strategy., 137

—capitalize on the stimulus change phenomenon in respite programs and in substitute teaching., 138

—use stimulus change for non-recurring behavior problems., 139

Respondent Conditioning

1. *Variations:*

 —progressive relaxation training (with or without biofeedback)., 141-142; 151

 —systematic desensitization (in-vivo or imagined)., 141; 151-156

2. *Advantages:*

 —relaxation response:

 a) portability., 148

 b) no prosthetics., 148

 c) easily learned., 148

 d) self control., 148

 e) positive side effects., 148

 —systematic desensitization:

 a) widely used and researched technique for phobic reactions., 154

 b) results can be rapid., 154

 c) positive side effects., 154

3. *Cautions:*

 —relaxation response:

 a) limited controlled studies., 149

 b) when tension is not a concern., 149

 c) when anxiety is conditioned to specific environmental stimuli., 149

 d) effects are not rapid., 149

 —systematic desensitization:

 a) "forced" exposure to feared stimuli should be avoided., 154

Covert Conditioning

e) use appropriate varations for children or for those who have handicapping conditions., 166

Stimulus Satiation

1. *Variations:*
 —continuous availability., 169
 —non-continuous but significantly greater than free access availability., 169-170; 69-70; 72-73; 227
2. *Advantages:*
 —can be easy to implement., 170-171
3. *Cautions:*
 —difficult to identify and provide critical reinforcer., 171-172
 —satiation effect may be function of continued, artificially high levels of reinforcer availability., 171
 —often confused with (aversive) overcorrection strategies., 171
 —limited research findings., 171
4. *Suggestions for Implementation:*
 —consider using when:
 a) reinforcer maintaining the target behavior is identifiable and controllable., 170
 b) it is practical to provide the reinforcer, non-contingently, in amounts significantly greater than the person would seek, given free access, over an extended period of time., 170-171
 —do not use with forced responding., 171

Shaping

1. *Variations:*
 —free operant., 174-175
 —discrete trial., 174-175
2. *Advantages:*
 —may avoid escalation of behavior problems., 174-175
 —free operant approach may avoid control by artificial stimuli and therefore promote generalization to non-treatment settings., 174-175
3. *Cautions:*
 —may increase frequency of target behavior precursors while

preventing escalation., 30; 174
— lack of research findings., 174-175

4. *Suggestions for Implementation:*
 — may be particularly useful when:
 a) target behaviors are preceded by clearly identifiable pre-cursors, and/or, 173
 b) behavior problem varies widely on some dimension of intensity or duration., 173-174

Additive Procedures

1. *Variations:*
 — unlimited., See chapters IV-XIV; 185-186
2. *Advantages:*
 — greater treatment potency of intervention pro-gram., 175-176
3. *Cautions:*
 — difficult to evaluate., 176
4. *Suggestions for Implementation:*
 — all procedures should be used in combination with positive programming., 29-40
 — use when a single intervention strategy in addition to positive programming has had measurable but not sufficient effect., 176

Appendix D

Footnotes to Table 3.2

Definitions of Functional Categories

I. Interactive Functions
 A. Requests: Expressed Desires
 for attention
 behaviors used to call attention to sender
 (e.g., showing off, teasing, flirting, etc.)
 for social interaction
 behaviors used to initiate a social exchange
 for play interactions
 behaviors that convey a desire on the part of
 the sender to engage in play with another
 person
 for affection
 behaviors that direct the receiver to engage in
 some physical activity specifically intended to
 convey a feeling of fondness
 for permission to engage in an activity
 behaviors that convey a desire on the part of
 the sender to engage in a particular action
 (e.g., bathroom, watch TV, etc.)
 for action by receiver
 behaviors that direct the receiver to cause an
 event to occur
 for assistance
 behaviors that direct the receiver to provide
 help
 for information/clarification
 behaviors that direct the receiver to provide
 information or clarification about an object,
 action, activity, location, etc.
 for objects
 behaviors that direct the receiver to provide
 an object to the sender (other than food)
 for food
 behaviors that specifically convey a desire for
 food or drink

B. Negations: Rejection of Stimulus Events
 protest
 > behaviors which express general objection to or
 > disapproval of an event, request, etc.

 refusal
 > behaviors which specifically express rejection
 > of an event initiated or suggested by another

 cessation
 > behaviors which specifically express a desire
 > to terminate an event which has already begun

C. Declaration/Comment: The Verbal and Non-verbal
 Expression of Fact or Opinion
 about events/actions
 > behaviors which are used to comment on an event
 > or occurrence (past, present or future)

 about objects/persons
 > behaviors used to comment about an object
 > including food, or about a person (e.g.,
 > compliments)

 about errors/mistakes
 > behaviors which convey acknowledgement that the
 > sender or another person has committed an error

 affirmation
 > behaviors which convey agreement about or
 > willingness to engage in an event or action

 greeting
 > behaviors which occur subsequent to a person's
 > entrance or appearance and express recognition

 humor
 > behaviors intended to entertain the receiver
 > and/or to evoke a response such as laughter

D. Declarations about Feelings
 anger
 > includes behaviors conveying rage, annoyance,
 > displeasure

 anticipation
 > includes behaviors conveying strong, positive
 > feelings regarding a future event

 boredom
 > includes behaviors conveying disinterest,
 > satiation, lack of motivation, etc.

confusion

> includes behaviors conveying the message that the sender is in a state of disorder or bewilderment

fear

> includes behaviors conveying reluctance to act upon, participate in, or view an event because of expectation of pain or danger

frustration

> includes behaviors conveying the message that the sender is unable to accomplish an objective

hurt feelings

> includes behaviors conveying that the sender feels offended, etc.

pain

> includes behaviors conveying that the sender feels physical discomfort

pleasure

> includes behaviors conveying happiness, enjoyment, etc.

II. Non-Interactive Functions

A. Self-regulation

> behaviors used for the purpose of monitoring one's own behavior (e.g., self-control, self-correction)

B. Rehearsal

> behaviors used to practice an event that has not yet occurred

C. Habitual

> behaviors set by regular repetition in a predictable sequence

D. Relaxation/Tension Release

> behaviors used for the purpose of self-entertainment or to calm oneself

Definitions of Behavioral Categories

Aggression:
> behavior, either physical or verbal, which results in discomfort/harm/pain to persons/objects/physical enviornment.

Bizzare verbalizations:
> behavior which consists of unconventional sounds emitted from the mouth/nose which are not words or parts of words.

Inappropraite oral/anal behavior:
> behavior involving the mouth and/or anus which is socially unacceptable (e.g., licking objects and smearing).

Perseverative rituals:
> a patterned set of repetitive behaviors occurring in the same sequence.

Self-injurious behavior:
> behavior characterized by actions directed at one's own body which cause physical damage either immediately or over time (e.g:, head banging).

Self-stimulation:
> stereotypic behaviors which can be kinesthetic (rocking) and/or tactile (finger flicking), visual (twirling an object in front of one's eyes), or auditory (vocal noises). They do not necessarily occur in the same sequence of pattern.

Tantrum:
> a cluster of aggressive behaviors which occur over a period of time and are not necessarily directed at a person/object. Two or more of the following usually occur together: screaming, hitting, biting, kicking, throwing, or destroying objects in the environment.

Gaze aversion:
> behavior which consists of a failure to look at a person or object or to maintain visual attention requested or expected, based on social norms.

Gazing/staring:
> behavior in which the eyes are focused on a particular object or person for a prolonged length of time.

Pointing:
> behavior in which the learner indicates the location of a person/object using the hands or arms.

Gesturing:
> behavior characterized by motion of the limbs or
> body to express or help express a particular
> message. The motions are not part of a formal manual
> language system.

Hugging:
> behavior in which the learner clasps or clings to
> another person with his/her arms.

Kissing:
> behavior in which the learner touches a body part,
> person or object with his/her lips.

Masturbation:
> behavior which consists of self-stimulation of the
> genital organs.

Object manipulation:
> behavior in which the learner moves or uses an object
> non-aggressively.

Proximity positioning:
> behavior in which the learner positions him/herself near
> or next to someone or something.

Pushing/pulling:
> behavior in which the learner moves or attempts to move
> an object/person through physical contact.

Reaching/grabbing:
> behavior in which the learner grasps or attempts to
> grasp an object or person.

Running:
> behavior involving movement on foot at a pace faster
> than a walk.

Touching:
> behavior which is characterized by non-aggressive
> physical contact which does not change the disposition
> or orientation of the person/object.

Facial expression:
> behavior characterized by movements of the facial
> musculature that express or help to express a
> particular message.

Laughing/giggling:
> behavior consisting of a series of inarticulate
> sounds with the mouth open in a wide smile.

Scream/yell:
> behavior characterized by long, loud piercing
> vocalizations.

Swearing:
> behavior characterized by the use of profane or
> vulgar verbalizations.

Verbal/physical threats:
> behavior consisting of actions or vocalizations which
> suggest the possibility of aggression.

Whining/crying:
> vocal behaviors using a childish, annoying voice
> pattern/intonation. Vocal behaviors characterized by
> inarticulate sobs or low plaintive calls.

Delayed echolalia:
> behavior consisting of verbal repetition of a past
> heard utterance such as a story, song, sentence, etc.
> The repetition may be only partial.

Immediate echolalia:
> behavior consisting of verbal repetition of an
> utterance (sentence, story, song, etc.) that has just
> been made by another person. The repetition may be
> only partial.

Picture/written word:
> behavior in which the sender utilizes a written word
> card, picture card, Blissymbol or flashcard of any
> type.

Complex sign/approximation:
> behavior that includes more than one representational
> manual movement, as above.

One word speech/approximation:
> behavior which consists of a representational
> vocal/verbal utterance. The appoximation may be a
> partial word, such as "ba" for ball or "wa" for water.

Complex speech/approximation:
> behavior which consists of representational
> vocal/verbal utterances that are more than one word
> structures.

One word sign/approximation:
> motor behavior in which the sender utilizes a manual
> movement that is representational in nature and is part
> of a formal manual language system, e.g., American Sign
> Language.

AUTHOR INDEX

A

Acosta, F. p. 145
Aikens, D. p. 109
Allen, K.E. pp. 42, 181
Anderson, J.L. pp. 23, 80
Arnold, C.R. p. 42
Artley, J.J. p. 147
Austin, N.K. p. 31
Axelrod, S. pp. 171, 181
Ayllon, T. pp. 54, 164, 169
Azrin, N.H. pp. 22, 54, 63, 94, 97, 127, 128, 164, 178, 182

B

Baer, D.M. pp. 23, 42, 100, 128
Bailey, J.B. pp. 63, 161, 181
Baker, D.B. pp. 20, 31
Ball, T.S. p. 61
Bandura, A. p. 179
Barker, R.G. p. 20
Barkley, R.A. pp. 63, 182
Baron, M.G. pp. 154, 157, 167
Bath, K. p. 44
Baum, W.M. p. 69
Bauman, K.E. p. 23
Baumeister, A.A. pp. 43, 93
Baumgart, D. p. 37
Beaudoin, C. p. 160
Becker, W.C. p. 42
Bellack, A.S. p. 147
Benasi, V.A. pp. 6, 72, 179
Bensky, J.M. p. 31
Benson, H. pp. 31, 145
Bernstein, D.A. pp. 142, 149, 150
Bhargava, D. p. 147
Bijou, S.W. p. 42
Biklen, D. p. 84
Binkoff, J.A. p. 23
Blanchard, E.G. pp. 146, 159
Blatt, B. p. 37
Blau, J.S. p. 31
Boe, E.E. p. 41
Bolstad, O.D. p. 76
Borkovec, T.D. pp. 42, 149, 150
Borzone, X.C. p. 145
Bostow, D.E. pp. 61, 63, 181
Bott, L.A. p. 147

Bowers, K. p. 63
Branter, J.P. pp. 171, 181
Braxley, N. p. 98
Brion-Meisels, L. pp. 55, 162
Broden, M. p. 42
Bronston, W. p. 12
Brown, B. p. 150
Brown, L. pp. 14, 37-39
Brown, P. p. 37
Bruner, A. p. 75
Bruner, J.S. p. 31
Bruno, B. p. 150
Bryan, K. p. 109
Budzinsky, T. p. 145
Buell, J.S. p. 42
Burchard, J.D. pp. 65, 71
Burchard, S.N. p. 61
Burgraff, R.I. p. 153
Burke, M. p. 111
Butman, R. pp. 111, 112

C

Caird, W.K. p. 153
Callner, D.A. p. 31
Campbell, L.M. p. 153
Carr, E.G. pp. 23, 30
Carter, J.L. p. 148
Casey, K. p. 27
Cataldo, M.F. pp. 111, 112, 116, 117, 124, 182
Catania, A.C. pp. 60, 68, 92, 93, 121, 172, 179
Cautela, J.R. pp. 39, 55, 142, 150, 154, 157-160, 162, 164, 165, 167
Center, D.B. p. 20
Chaney, R.F. p. 31
Chang-Liang, R. p. 142
Chardos, S. p. 109
Clark, R.L. pp. 75, 83, 159
Clurman, C. p. 6
Cohen, D.J. pp. 20, 120
Cohen, S.F. p. 159
Cole, C.L. pp. 6, 20, 22, 38, 179
Coleman, R.S. p. 62
Collozzi, G. p. 62
Colvin, W. pp. 108, 112, 113, 115, 117-119, 122, 124, 125, 181
Cotter, V. p. 98

245

246

R

Rachlin, H. p. 69
Rathus, S.A. p. 32
Rawson, R.A. pp. 41, 44, 49, 61, 182
Rayner, R. p. 151
Rechs, M.A. p. 114
Reese, S.L. pp. 159, 162
Reid, D.H. p. 39
Repp, A.C. pp. 23, 59, 61, 63, 64, 71, 76–78, 80–82, 84, 180–182
Revusky, S.H. p. 75
Reynolds, G.S. pp. 58, 61–63, 75
Reynolds, M.D. p. 83
Rhodes, W.C. p. 20
Richman, G.S. p. 23
Rilling, M. p. 75, 76
Rimmer, B. 113, 171
Rincover, A. p. 35
Risley, T.R. p. 180
Rivenq, B. pp. 152, 153
Robert, M.A. p. 144
Rogers-Warren, A. p. 20
Rohjan, J. pp. 23, 46
Rollings, J.P. p. 93
Rose, S.D. p. 32
Rosenthal, T.L. pp. 159, 162
Rosenstiel, A.K. p. 167
Ross, R.R. p. 63
Ross, S.M. p. 31
Rotholz, D.A. p. 82
Rotondi, J.M. p. 153
Russell, H. p. 148
Russo, S. p. 42
Russo, D.C. pp. 111, 112, 116, 117, 124, 182
Rutherford, G. pp. 100, 128
Ryan, C. pp. 61, 71

S

Sahweid, E. p. 42
Sailor, W. pp. 38, 100, 128
Sajwaj, T. pp. 111, 113, 171
Salisbury, C. p. 37
Sampen, S.E. p. 42
Saslow, G. pp. 19, 21
Schaeffer, B. pp. 46, 93
Schien, E. p. 179
Schofield, S. pp. 22, 61, 181
Schoenfeld, W. p. 141

Schreibman, L. pp. 63, 98
Schroeder, S.R. pp. 23, 46, 147
Schuler, A.L. pp. 23, 24, 35, 38, 46, 109 110, 120, 124, 131
Schultz, J.H. p. 150
Schuster, M.M. p. 145
Schwartz, A. p. 19, 21
Schwartz, G.E. pp. 143, 145
Scott, D.S. p. 167
Scott, M. p. 20
Segal-Rechtschaffen, E.F. pp. 75, 83
Serber, M. p. 153
Shapiro, D. p. 143
Shapiro, H. p. 145
Shaw, S.F. p. 31
Shaw, W.J. p. 146
Sherman, W.O. p. 182
Shorkey, C. p. 153
Sidman, M. p. 51, 98
Siegel, J.M. pp. 153, 182
Simmons, III, J.Q. pp. 22, 46, 61, 93, 181, 182
Skinner, B.F. pp. 35, 38, 47, 55, 74, 141, 179
Slack, D. pp. 59, 61
Slade, P.D. p. 153
Slifer, K.J. p. 23
Sloane, Jr., H.N. p. 42
Small, M.M. p. 147
Smith, N.F. p. 49, 182
Smith, R.L. p. 31
Solomon, L.J. p. 147
Sorrel, S. p. 113, 171
Speir, N.C. pp. 23, 59, 61
Spradlin, J. p. 98
Stednitz, L.L. p. 31
Steen, P.L. p. 146
Steinberg, D. p. 147
Stocker, C.S. p. 146
Stoddard, L. p. 98
Stoyva, J. p. 145
Strain, P.S. p. 39
Straughn, J. p. 144
Strider, F.D. p. 148
Strider, M.A. p. 148
Striefel, S. p. 109
Suib, M.R. pp. 62, 63
Sulzer-Azaroff, B. pp. 39, 41, 42, 45, 47, 48, 56, 60
Synolds, D. p. 148

SUBJECT INDEX

O

One hundred percent (100%) rule 43, 44–45, 46, 49, 53–54, Table 5.1, 68
Operant paradigm, 19–20, 22, 92, 127, 141

P

Personal effectiveness training, 30, 31
Positive Programming, Chapter IV, 29–40, 70–71, 219
 definition, 29
 research ideas, 39–40
 summary of strategy, 228–229
 variations, 29–32
Potentiating variables, 20
Prader-Willi Syndrome, 106
Pragmatic analysis, 22–26, 218
Precluding (preventing) behavior problems, 26–28, 33, 34, 45–46
Procedures
 continuum of acceptibility, 1, 5–7
 efficacy, 1, 5–7
 evaluation, 5–7
 functional value, 7
 intrusiveness, 6
 side effects, 5
 social validity, 1, 4, 6
 standards of acceptability, 2–3, 14
Progressive relaxation training (PRT), 141, 142–151
 advantages, 148
 cautions, 149
 definition, 142
 implementation, 149–151
 research ideas, 151
 research with able bodied individuals, 144–145
 research with mentally handicapped, 145–146, 150–151
 research with physically handicapped, 145–146, 150–151
Prompting, 109, 110, 113, 115, 116, 117–118, 120–122, 130
Punishment
 as a prepotent response, 177–182
 defined, introduction
 myths 180–182

R

Recovery and Rebound, 47, 49, 52, 63 128
Regulation by responsible external agencies, 9–12
Reinforcement
 as a discriminative stimulus, 65–66, 106
 conditioned reinforcers, 102–103
 covert reinforcement, 157–161
 fading, 55, 70
 free access to, 69–70, 72–73, 89–90
 frequency, 80
 identification and specification, 46, 52–53, 54–56, 69–70, 72–73, 80, 82–83, 87–88, 89–90, 106, 184. *See also* Free access to reinforcement.
 inadvertent, 65, 95, 96, 179
 inventory, 21, 55, 220–226
 IRT's (of), 74–75
 limited hold, 82
 low response rates (of), 76–78
 magnitude, 89–90. *See also* Free access to reinforcement.
 non-specific, 82–83
 satiation, 72, 80, 88. *See* free access
Research ideas
 comparative, 6, 56–57, 71–72, 90 107 125–126, 174, 179–180
 covert conditioning, 167
 differential reinforcement of alternative behavior (Alt-R), 56–57
 differential reinforcement of low rates of responding (DRL), 90–91
 differential reinforcement of other behavior (DRO), 71–72
 instructional control, 125–126
 positive programming, 39–40
 problems with, 72, 91, 180
 respondent conditioning, 144–148, 151, 156
 stimulus change, 139–140
 stimulus control, 107
Respondent Conditioning, Chapter XI, 141–156
 definition, 141
 progressive relaxation training (PRT) 142–151
 research ideas, 144–148, 151, 156
 research with special needs

ABOUT THE AUTHORS

Gary W. LaVigna. Dr. LaVigna received his Ph.D. degree in Clinical and Educational Psychology from the University of Chicago in 1975, ending a graduate program of study which emphasized applied behavior analysis. His experience over the last fourteen years has primarily involved the treatment of children, adolescents, and adults who exhibit the severe behavior problems typically associated with a handicapping condition. These include conditions such as autism, mental retardation, severe emotional disturbance, and psychosis. He has extensive experience working with group homes, public schools, and directly with families, as well as with state hospitals and other institutions. This experience has convinced him that isolation, segregation, and congregation of people with special needs is as much the cause of disordered behavior as it is its result. His major effort over the last eight years has, therefore, been to develop and support residential, educational, occupational, and recreational options: options which allow people who are faced with a developmental or mental challenge to participate in their community, with a lifestyle similar to and with the full opportunity to interact with their non-handicapped peers. It was with this goal in mind that, as the Executive Director of the Jay Nolan Center, he developed a community based system which continues to provide programs and services to approximately five-hundred "learners" who have the problems associated with autism or some other developmental disability. In 1981, he left the Jay Nolan Center to establish a new agency and to devote more time to research and writing. He and his associates provide a range of services. These include behavioral assessment and intervention, program design and consultation, and staff development and inservice training. Dr. LaVigna is an active consultant with a number of public and private agencies, both nationally and internationally. Correspondence can be directed to him at the address below.

Gary W. LaVigna, Ph.D.
Clinical Director
The Institute for Applied Behavior Analysis,
 A Psychological Corporation
1840 West Imperial Highway
Los Angeles, Calif. 90047

Anne Donnellan.

Professor Anne M. Donnellan is a member of the Department of Studies in Behavioral Disabilities at the University of Wisconsin-Madison. Her interest in autism began in 1970 when she founded Los Ninos Center in San Diego, one of the first programs in the country to work with pre-schoolers with autism. She is a long time member of the Professional Advisory Board of the National Society for Children and Adults with Autism (NSAC) and was the founder/director of the NSAC National Personnel Training project which developed inservice training capabilities in more than a dozen states and provinces.

Dr. Donnellan received her Ph.D. from the University of California at Santa Barbara. She is a member of Phi Beta Kappa, serves as an editor of several journals in the field of special education and is active nationally with the Association for Persons with Severe Handicaps (TASH). She has authored numerous articles on the topics of non-aversive behavior management, community based instruction, and teacher training. She is author of the *Rehabilitation of Persons with Autism: An analysis of the Literature and Research Needs* for the National Rehabilitation Information Center (NARIC); editor of *Classic Readings in Autism*, Teacher College Press; and co-editor with Donald J. Cohen of *The Handbook of Autism and Disorders of Atypical Development*, J. Wiley & Sons. She is currently continuing her research and demonstration work via a U.S. Department of Education, Office of Special Education and Rehabilitation Services grant developing non-aversive strategies to enable persons with severe communication problems to work in integrated employment.